BRITISH SCULPTORS AND SCULPTURE SERIES

Series Editor: Sir Alan Bowness

Pre-Raphaelite Sculpture: Nature and Imagination
in British Sculpture 1848-1914
Edited by Benedict Read and Joanna Barnes

The Sculpture of Phillip King
by Tim Hilton

The Sculpture of Robert Adams
by Alastair Grieve

The Sculpture of Austin Wright
by James Hamilton

The Sculpture of Frank Dobson
by Neville Jason and Lisa Thompson-Pharoah

Bernard Meadows: Sculpture and Drawings
by Alan Bowness

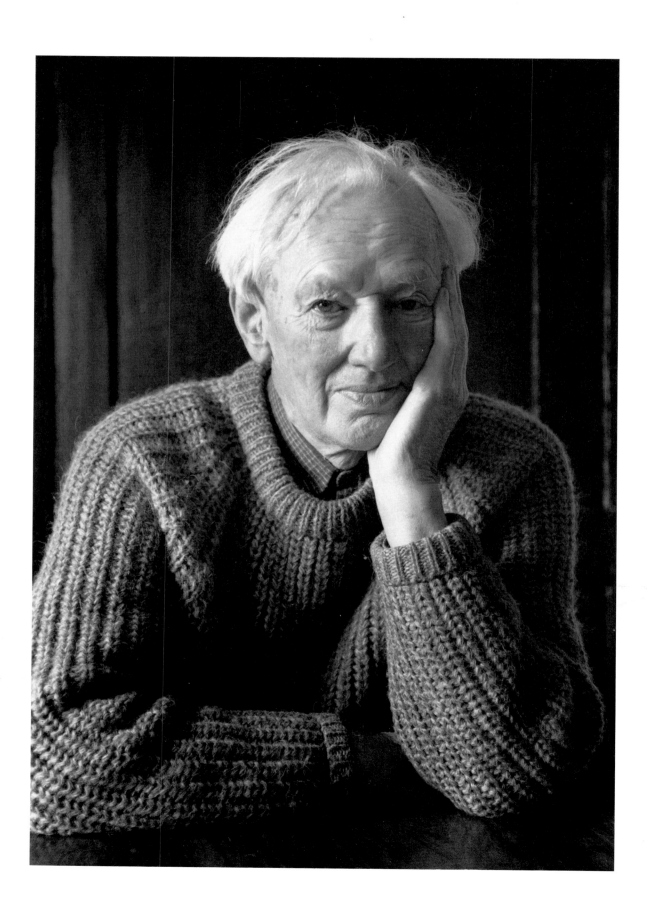

James Hamilton

The Sculpture of Austin Wright

The Henry Moore Foundation
in association with
Lund Humphries, London

For
Eric Busby, Sara Gilchrist, Helen Kapp, W.T.Oliver,
Robert Rowe
and
Susan Wright

First published in Great Britain in 1994 by
Lund Humphries Publishers Limited
Park House, 1 Russell Gardens
London NW11 9NN
in association with
The Henry Moore Foundation

British Library Cataloguing in Publication Data
A catalogue record for this book is available from the
British Library

ISBN 0 85331 651 1

Designed by Harold Bartram
Made and printed in Great Britain by
BAS Printers Limited, Over Wallop, Hampshire

FRONTISPIECE Austin Wright
Photograph by David Bocking 1991

Contents

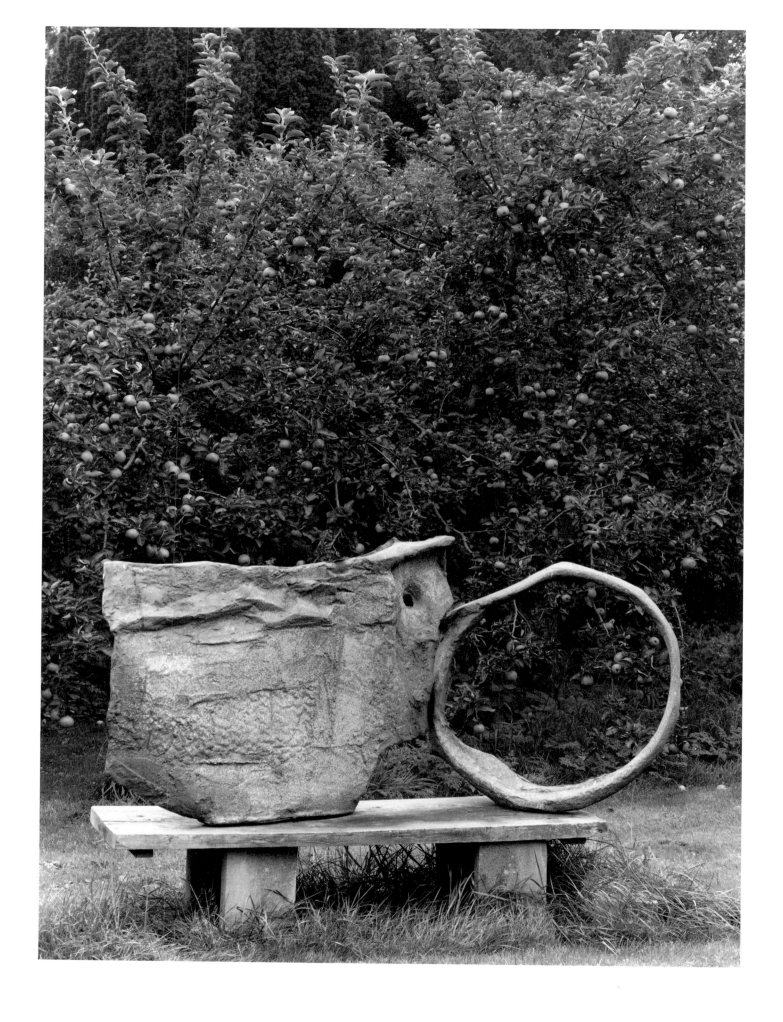

Acknowledgements

The sculpture of Austin Wright has for fifty years been an insistent background presence in the visual arts in the north of England. Championed and recognised in Yorkshire, Wright is a living exception to that wearisome maxim that a prophet is without honour in his own country. A wider, national, audience however has not yet had sufficient opportunity to know of Wright's achievements. It is the aim of this monograph that Wright's work should be fully recorded and presented, and his place in the history of British sculpture in the twentieth century be assessed.

I could not have written this book were it not for the kindness, friendship and generous hospitality that Austin and Susan Wright have shown to me and my family. I am most grateful to them, and to Sir Alan Bowness, retiring Director of The Henry Moore Foundation, Terry Friedman and Robert Hopper for their parts in commissioning this monograph, and to Sarah Davenport for her invaluable preliminary work on the catalogue. Sarah Davenport's contribution is further acknowledged elsewhere. I am grateful too to John Taylor, whose professionalism and skill has carried this book into existence, and to the photographer Jerry Hardman-Jones whose new photographs of Austin Wright's work are themselves a revelation.

Others who have been of great assistance both to me and Sarah Davenport in supplying information and recollections include Austin Wright's many friends and the many collectors of his work. It was warming for me to discover that those two categories almost completely coalesce. My thanks go to the owners of Wright's work who have kindly answered our enquiries, and to the Very Revd John Allen, Mrs Mary Andrews, Peter Anelay, Kenneth Armitage, Andrew Auster, Angie Bower, Donald Boyd, James Brown, Revd Leonard Childs, Sir David Cox, David Crease, Ben Dhaliwal, Hilary Diaper, Canon Bruce Duncan, Stuart Evans, Andrew Fairbain, Patrick George, Joe Graffy, Richard Green, Isobel Johnstone, Louise Karlsen, J. C. A. Landsberger, Tom Last, Rebecca E. Lawton, Dr Barry Leadbeater, Barbara Putt, Alexander Robertson, Tim and Eva Rogers, Judith Sanders, B. M. Schofield, Edwina Simpson, Nino Vella, Alan Wilkinson, Judith Wood and Sir Marcus Worsley. Sir Alan Bowness, Gillian Spencer and Professor Richard Verdi kindly and attentively read my text in typescript, and have improved it greatly through their comments. Thus also did my wife Kate, whose support and encouragement throughout the writing of this book has been total.

I should say a word about this book's dedicatees, all of whom have loved and supported Austin. The roles of four of them are made clear in the text. Two, however, Eric Busby and Sara Gilchrist, both now dead, were owners of two private contemporary art galleries in Yorkshire. Goosewell Gallery in Menston and Park Square Gallery in Leeds, run by Busby and Gilchrist respectively, gave Austin Wright regular exhibitions in the 1960s and 1970s. It was primarily through their work, perception and enterprise that Wright came to be so widely known and cherished within his adopted county, and to them we should be particularly grateful.

James Hamilton
Warwick, March 1994

OPPOSITE
Wall and Ring Aluminium 1961 (Cat.S196)

The Sculpture of Austin Wright

Austin Wright, born in Chester in 1911 of English parents, spent his childhood and youth in Wales. Although he decided to become a sculptor in his twenties, his early career was unusual, and his gestation as an artist slow. From school in Cardiff and Somerset, he went up to Oxford, to read Modern Languages, and subsequently trained to be a schoolmaster. He taught French, German, Maths and Art in Malvern, Tunbridge Wells and York, and it was only when he was forty-four that it finally became possible for him to make sculpture full time.

This long development away from metropolitan circles, and his own natural reserve, has led Austin Wright to grow in his own way, a rare plant happy beyond the garden wall. Some artists, for example J. M. W. Turner, John Singer Sargent and Henry Moore, have had their careers examined step by step from their earliest exhibitions, their work and development being commented upon with opprobrium or acclaim year by year. Others – Modigliani, Gertrude Hermes, Robin Tanner – recognised in their lifetimes by appreciative but narrow audiences, came upon the wider world fully formed. Austin Wright, too, is in this latter category of artists. As their years of productivity approached their conclusion, the rise in their reputations began.

Throughout his life, Wright has maintained the slim physique that he recorded in some early oil self portraits. He has retained the light, firm gaze, the polite, even diffident manner, and perhaps in old age a Welsh lilt and Welsh expressions have slipped back into his manner of speech. 'Let's have a look see', he will say as he flicks through a sketchbook in search of some of his ideas from the past. Despite having lived in York for fifty years, his lush white hair, firm hand and sparkling eye gives Austin Wright the aspect of a noble Welsh poet, observing with detachment from afar.

Wright's two grandfathers had been working craftsmen. His paternal grandfather, Edwin Wright, was an itinerant master plasterer and decorative sculptor whose only remembered, and surviving, work is the plaster ceiling decorations at Sheffield Town Hall. Wright's mother's father, George Keey, made fine furniture in Birmingham, and improved his limited education by attending Sunday classes. Austin Wright's father, William Wright (1872-1951, see fig.96), was a commercial traveller, first for Keiller's Marmalade and latterly for Farrar's Harrogate Toffee. William Wright soothed the stresses and frustrations of his work through reading prose and poetry and playing the violin, loves which he passed on to his son. Wright's mother, Ada (1875-1959), had trained to be a school

teacher in Birmingham, but, while she was bringing up Austin and his elder sister, did many years of voluntary work with miners' wives in the valleys north of Cardiff. The Wrights were Quakers, a calling that requires a commitment to non-violence and unobtrusive community service, and the ability to reflect quietly and with detachment upon the world.

Austin Wright's own artistic leanings emerged when he asked to be given a palette and some paints for his tenth or eleventh Christmas. His first painting was of a galleon in full sail on a stormy sea; but as he grew up this kind of subject gave way to self portraits, and to paintings touched by the liberating breath of modernism. Early pictures made at and around the family home at 53 Llanishen Street, Cardiff show a mixture of dawning modernist influences, combined with the careful following of scholarly rules by the young man who had won a First Class Certificate in Light and Shade at Cardiff Technical College in 1928. Wright's painting of the back of the family house, a brightly lit geometry of sunshine and shadow,[1] has the look of a Gilman or a Ginner; another, *Still Life with Yellow Jug*, rhymes with Braque and Picasso; and a third, *View over Cardiff Rooftops*, is a strange surreal composition with a sheet blowing away over the chimney-pots. Here is Magritte and De Chirico come to Cardiff in the late 1920s, and although Wright claims not to have heard of either artist at that time, he must surely have seen reproductions of their work, for Surrealism, like the sheet, was already in the air. Perhaps it may be possible to detect in these paintings a sculptor's interest in the volumes that crumpled forms adopt, for there are the beginnings here of a more than ordinarily curious schoolboy artist living in a far western provincial city.

These special interests and enthusiasms were fostered by two local amateur painters, Phyllis Bowen and Redvers Hitchens, who befriended Wright and took him on painting holidays to the Pembrokeshire coast. They encouraged him to look at modern French art, introduced him to Roger Fry's *Vision and Design*, and Hitchens also introduced Wright to the sculpture of Gaudier-Brzeska. Wright well remembers the peculiar surge of excitement that he felt when Hitchens pointed out to him the house, 29 Claude Road, Cardiff, where Gaudier lived in 1908 and 1909.

Sculpture and the sculptor's life was already beginning to make its claim on Austin Wright during his schooldays: he enjoyed hearing stories of his grandfather's work as a plaster craftsman, and how he modelled busts of Queen Victoria in the attic. The Wright family house in Cardiff was near the city cemetery, and the marble angels, urns and

broken columns that Austin saw there became for him a source of curiosity about the nature of carving. Particularly potent, and having an effect that in his eighties Wright still remembered, was his reading of *Jude the Obscure* on a dull holiday in the Wye Valley as a teenager. Hardy's evocation of the stone dust settling in Jude's hair, and of the sound of stone-mason's tools shifting in his bag as Jude walked, entranced the young man, and drew him nearer and nearer to a captive orbit around the practice of sculpture.

Despite all this insistent curiosity, Wright took the orthodox line in his schooling and, with the help of a Quaker scholarship, went up to New College, Oxford, to read Modern Languages in October 1930. The Oxford celebrated in *Brideshead Revisited* completely passed Wright by. Although Lady Ottoline Morrell's house parties at Garsington had ceased by the time Wright entered the University, he neither found, nor sought out, an alternative artistic 'set'. He listened to Eric Gill lecturing at New College on 'The Well-Making of What Needs Making', and he bought and read avidly Stanley Casson's *Some Modern Sculptors* (1928), with its lucid introductions to the sculpture of Bourdelle, Mestrovic, Gill and Gaudier-Brzeska. Despite the fact that Casson himself lived at the gates of New College, and Wright saw him coming and going, the young man never made any attempt to contact Casson or talk to him about sculpture. The dogged, self-denying, even damaging streak of diffidence and reserve that has been with Wright all his life, was present and active even at Oxford. He did, however, present himself regularly at the Ashmolean Museum, requesting that the then Keeper of Fine Art, Kenneth Clark, show him prints, drawings and illuminated manuscripts. He attended, too, the series of lectures that Einstein, exiled from Nazi Germany, gave at Oxford. He remembers nothing of the substance of the lectures, but the vision of Einstein's constant and unfading smile remains clear in Wright's memory. Another memory, of the point at which Wright knew that he could not avoid the insistence of sculpture, came during a University vacation in France, when he found a mason chipping a gargoyle out of a block of stone behind the bus station at Orleans. Then, at once, the old *Jude*-inspired urgings returned, and watching the action of the carving, the tools, the stone, the chips, the dust and smell, Austin Wright decided that he had, somehow, to become a sculptor.

After graduating from Oxford in 1933, and completing a year's teacher training course in Birmingham and at Bootham, the Quaker boys' school in York, Wright joined the staff of The Downs School at Colwall, near Malvern. The Downs was run on Quaker principles under the head-mastership of Geoffrey Hoyland, who attracted some remarkable members of staff. W. H. Auden taught English, and entranced the boys with his 'eccentricity, tireless energy and sense of fun. We called him Uncle Wiz'.[2] The art master was Maurice Feild, who ran a most progressive spare-time art club for his pupils, inspiring them not only with reproductions of the paintings of Constable, Camille Pissarro and Cézanne, but reading from these artists' writings too. Francis Hoyland, in his book *Alive to Paint*,[3] recalls the sentence of Constable that Feild quoted, and that stuck in his mind. And if his, then others': 'Painting is with me, but another word for feeling.' Feild also introduced the boys to the art of the past thirty years, and his knowledge of the art world, and his friendship with the director of the Redfern Gallery, Rex Nankivell, led him to arrange an exhibition of paintings by past and present members of the school at the Redfern in July 1937. The introduction to the catalogue was written by W. H. Auden:

The Downs is one of the very few preparatory schools where the boys are taught to paint in oils … though no doubt most of these boys will not become professional painters, the result of having painted in oils themselves is bound to give them a more intimate interest in and intelligent appreciation of the pictorial arts.

Among the exhibitors at the Redfern were three pupils who were to make important contributions to the visual arts in Britain: Patrick George, Lawrence Gowing and Andrew Forge. Patrick George has drawn a picture of a rare school régime, free of educational dogma, liberal and vibrant:

Things happened. Geoffrey Hoyland's brother came and gave a thunderous talk on the workers. We all went to see *Night Mail*. Auden, when he was not busy hammering out hymn tunes on the piano was directing a movie camera. We all took part in one of his plays at the end of term, I was a horse! Coldstream with the glamour of a real artist painted Auden's portrait in the staff lodge. Maurice Feild organised an exhibition of Dada (young boys are pretty good at Dada). A night club singer from London sang some slightly rude songs to tremendous applause. The staff were keen on cars which they apparently raced round the roads. The Bauhaus was in. We all believed in the modern. On Sundays we remembered we were at a Quaker school and sat in silence on rush covered chairs for what seemed a very long time.[4]

Austin Wright entered this invigorating milieu in September 1934 as a teacher of French, German and Maths. He shared a house near the school with Auden, and the two became friends. Wright unavoidably became a wry observer of Auden's love affairs, and also his confidante. Wright's understanding, and his ability to listen, was of great value to Auden during the period in 1935 when the latter was going through his marriage of convenience to

Thomas Mann's daughter, Erika.[5] During their period together at the Downs School, Wright painted a head and shoulders portrait of Auden, the poet's large, fleshy head presenting Wright with a naturally sculptural subject, one of volume, texture and weight, with small, high-set eyes. Wright's approach to Auden's portrait is that of a modeller, and at this time he was giving informal lessons to his pupils in sculpture in clay, as a complement to Feild's teaching of painting. Wright recalls summer afternoons spent sitting on the tennis court leaning with the Art Club members against the wire, each of them working on a clay sculpture.

During the school holidays, Wright visited Germany and France where he bought materials and made paintings.[6] He hunted for the landscapes that Cézanne painted, from l'Estaque and Auvers to Mont St Victoire, and in 1936 he went to Paris to see the Cézanne exhibition at the Orangerie. By this time, Wright had acquired an intimate knowledge of Cézanne's paintings, and knew 'where the paint ran, and how deeply the blue was buried underneath the apple'.[7] The following summer he was in Paris again, and saw Picasso's *Guernica* at its first shocking public appearance in the Spanish Pavilion at the Paris Exhibition. Now in his late twenties, with both the time and sufficient money saved from his salary, he was looking at modern art with a mature and educated eye.

Wright left the Downs School at the end of the summer term of 1936 for a new teaching post in Tunbridge Wells. The choice of school proved to be a mistake. During the period of rising political tension in Germany and the Spanish Civil War, Skinner's School set great store by training its pupils to be soldiers. With the boys in the OTC, Wright, too, was expected to drill and bear arms, an activity that as a Quaker he was unable to contemplate. Being close to London, however, Wright was able to travel up from Tunbridge Wells regularly to visit the galleries. He saw Picasso drawings at Zwemmer's, Picasso's recent work at Rosenberg and Helft, and in Cork Street saw drawings by Klee, Braque and Cézanne, 'incredibly exuberant things, compared to the standard art school fare'. Hating his post at Tunbridge Wells, however, Wright wrote to Bootham School, where he had felt so much at ease during his teacher training year, enquiring for a vacancy. There was one; he was given it; and Wright moved to York in 1937 in time for the beginning of the autumn term.

Although Wright had made sculpture at the Downs and in Tunbridge Wells, the earliest surviving work is later, made in 1939 and 1940, by which time he was happier as a teacher at Bootham School. There is a persistent duality in Wright's life at this period. Though earning his living

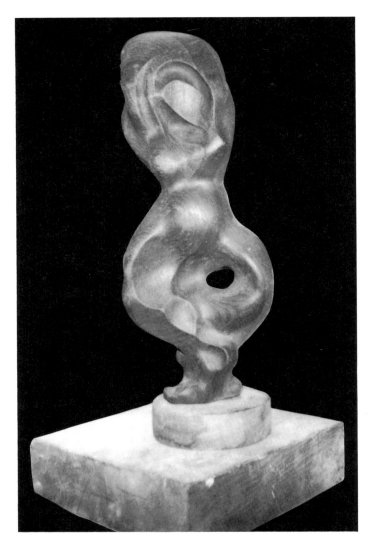

fig.1 *Dancing Figure* Pinewood 1939 (Cat.S1)

as a teacher of Modern Languages, he nevertheless still nursed his ambition to become a sculptor, and tentatively made personal contacts with the art world at large. He visited Henry Moore, thirteen years his senior, and by now determinedly working at his studio in Parkhill Road, Hampstead. By 1937, Moore was dividing his time between sculpture and teaching for two days a week at Chelsea School of Art. This was an extraordinarily productive period for Moore. He had already had three exhibitions in London at the Leicester Galleries (1931, 1933 and 1936), and his reputation had been underpinned by the publication in 1934 of Herbert Read's monograph on his work. Having seen Read's book at the Downs School, Wright found Moore's work to be 'supremely clean and powerful'. Moore, a young Yorkshireman who came to London to pursue his sculpture single-mindedly, had become conspicuously successful. He appeared to be the obvious person for Wright to approach for advice and encouragement, and Wright did so with high hopes.

Moore's response to Wright's call was to tell his visitor quite bluntly to get on with it. In particular he encouraged Wright in the practice of direct carving in wood and stone, and gave him the practical tip that the edge of a piece of

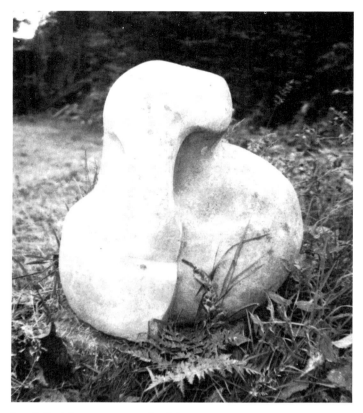

fig.2 *Angular Dancer* Limewood 1940 (Cat.S3)

fig.3 *Bollard* Limestone 1940 (Cat.S4)

broken glass was ideal for finishing curved surfaces. Moore also discussed with Wright the suitability of Hornton Stone and elmwood as carving materials. Perhaps he also advised Wright to come to London – Wright does not recall – but even if this were the case, the moment for him to do so had passed. Though a move to London would have been practical from Tunbridge Wells, having now settled himself into a teaching post in York, Wright's life seemed to be leading him in a different direction.

At Bootham, as at the Downs School, Wright's special interest led him inexorably towards the Art Room, and within a year or two he found himself taking classes in painting and sculpture both at Bootham and at York's Quaker girls' school, The Mount. At the start of the war, Wright registered as a Conscientious Objector, and as a consequence remained with the school when it was evacuated for the year 1939-40 to Ampleforth, near Helmsley on the Yorkshire Moors. It was here, and subsequently back in York, that Wright's first mature, surviving carvings were made.

The 1940s were crucial years, both for the world and for Wright. In 1945 he married a former pupil of his from The

Mount School, Susan Midgley. The couple settled at Green View, on the north edge of the Green at Upper Poppleton on the edge of York. The property, in which they have now lived for nearly fifty years, had attached to it the ploughed up remains of a market garden stretching one furlong behind the house to some fields beyond. In 1947, Wright and his work was discovered at Bootham by two highly perceptive Schools Inspectors, Helen Smailes and Dick Long. They passed word on to Dudley Holland, then Principal of York Art School, who was about to create a new post for the teaching of drawing and sculpture. Austin Wright was steered towards this, and took it up in September 1947. At last, at the age of thirty-six, Wright was earning his living through art. 'The change from Bootham to art school', Wright recalled, 'was a move into a completely different world. Art was expected from us. What we were there for was *art*.'

These important changes in Wright's life brought a unity and purpose to his sculpture. With the ending of the war his difficult and lonely period as a Conscientious Objector came to a close. He has recalled how, in becoming a Conscientious Objector, he felt absolutely cut off, with his isolation from the world of art being compounded with

an even deeper isolation from the beliefs of many of his fellow men. When Wright took up his post at York Art School, and the following year his and Susan's first child Crispin was born, these new beginnings signalled his change from onlooker to participant.

The first public expression of Wright's new professional engagement with art was the retrospective exhibition that he shared with Dudley Holland at York Art Gallery in 1950. It is appropriate for us to look back at the early stone and wood carvings from the standpoint of the exhibition. The exhibited works, and other carvings of the decade, divide themselves into five distinct groups. The first, which includes *Bollard* (Cat.S4) and *Compact Form* (Cat.S7), comprises sculptures which are associated with the human figure, but have further abstract amendments. The second group is of standing figures, recognisably human, with pronounced waists and profiles. They may be static, as in the holly *Figure* of 1942 (Cat.S14), or dancing with even more pronounced waists and upraised arms, as in *Dancing Figure* (Cat.S1) or *Angular Dancer* (Cat.S3). The third group was isolated in the exhibition catalogue as 'Five Variations on a Theme – Tunnelled Form', and includes *Emerging Form* (Cat.S25) and *Advancing Figure* (Cat.S26). These take the theme of dance a stage further, the human element of upraised arms, waists and legs being retained, alongside a further shift towards abstraction. In *Alert Form* the curve of the arms gives way to an uprising horizontal plane, and in *Emerging Form* to an encircling rim. In each case the head remains as a vestigial, though central, knob. The waists in the carvings in this group allowed Wright to explore deep three-dimensional undercutting, while each, be it through the arms, waists or legs, gave the artist the opportunity to tunnel, and make arches or holes through his material.

The fourth group of sculptures from the 1940s are, like the tunnelled forms, also bracketed in the catalogue, being grouped as 'Five Variations on Tall, Reaching Forms'. Here the medium is wood, the only practical medium for the direct carving of such figures. All the works in this group, including *Shriek*, and *Tall Figure* (Cats S33 and S30), transform the smooth lines of the sycamore branch into urgent, splintery bone-like forms, all still patently human. Where the 'Tunnelled Forms' are squat, with slow rhythmic movement contained within the forms themselves, the 'Tall, Reaching Forms' lunge upwards into other spaces.

The fifth group contains the carvings of 1949 and 1950, including *Savage Growth* (Cat.S44) and *Green Fuse* (Cat.S43), which move away from the human form towards sculptural explorations of the powerful forces unleashed in the growth of plants. The title *Green Fuse*, borrowed

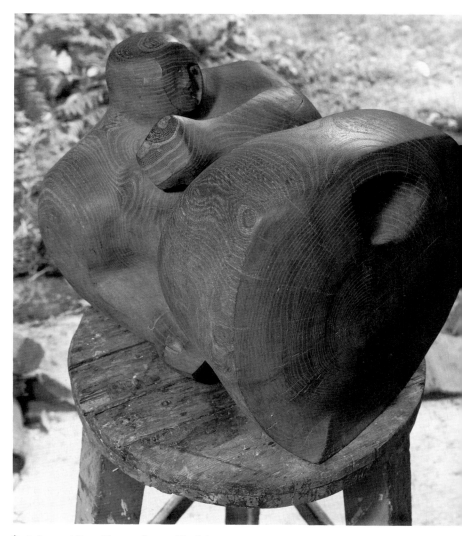

fig.4 *Compact Form* Elmwood 1941 (Cat.S7)

directly from the first lines of Dylan Thomas's poem, is given to a carving whose upward thrust is urgent and cutting, and whose edges are sharp and slippery like a wet knife. This work's title is at one not only with the violence explicit in the titles and the forms of each of the sculptures in this group, but also with the opening words of Thomas's poem itself:

The force that through the green fuse drives the flower
Drives my green age; that blasts the roots of trees
Is my destroyer.
And I am dumb to tell the crooked rose
My youth is bent by the same wintry fever.

There is a distinct and identifiable stylistic trend in Austin Wright's sculpture of the 1940s. First, its scale becomes larger, increasing from the 10 to 15 inches high figures of 1939 and 1940, to the bolder tall forms, up to 7 feet, of the later years of the decade. There is, too, a growing self-confidence in the work, as the artist searches during this productive period for a vocabulary of his own. *Compact Form*, though deliberately anonymous in its title, is clearly looking back to Henry Moore's elmwood reclining figures, with its double profile and tunnelled hole, and its emphasis

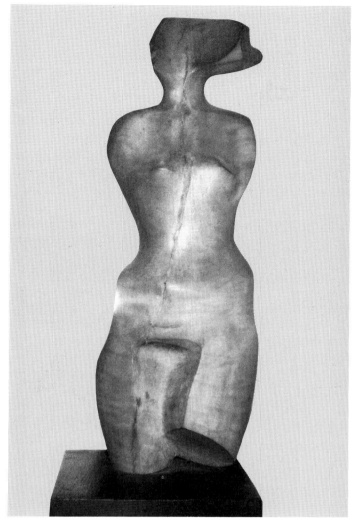

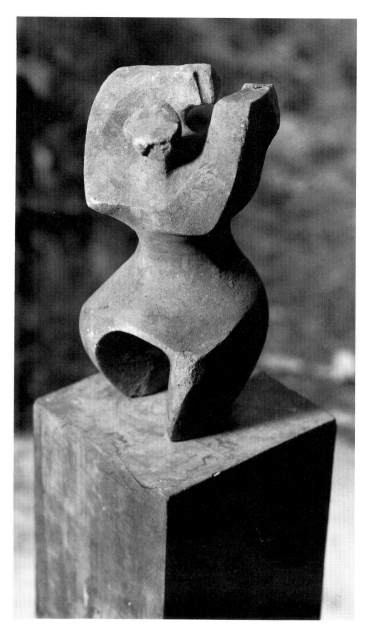

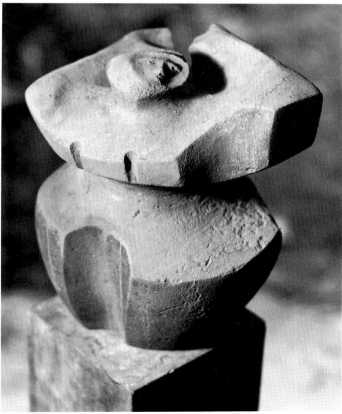

ABOVE LEFT fig.5 *Figure* Holly 1942 (Cat.S14)

LEFT fig.6 *Emerging Form* Hornton Stone 1945 (Cat.S25)

ABOVE fig.7 *Advancing Figure* Hornton Stone 1945 (Cat.S26)

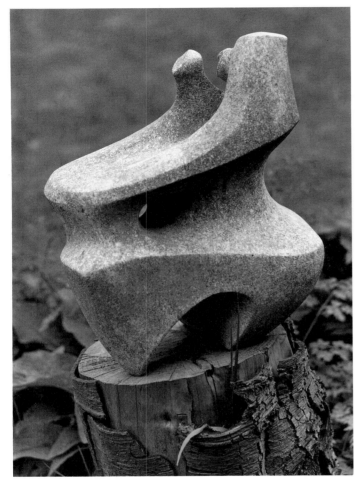

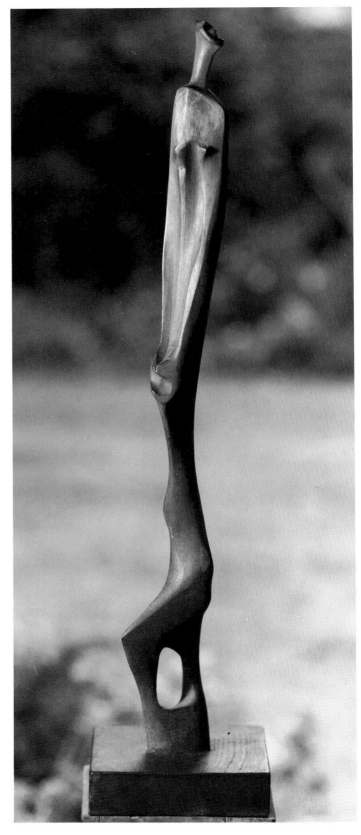

ABOVE fig.8 *Alert Form* Ancaster Stone 1946 (Cat.S29)

RIGHT fig.9 *Tall Figure* Sycamore 1947 (Cat.S30)

OPPOSITE LEFT fig.10 *Shriek* Sycamore 1947 (Cat.S33)

OPPOSITE RIGHT fig.11 *Angel* Sycamore 1948 (Cat.S34)

through its shape on the natural rhythm of the grain. There is an additional squatness in this work, the appearance of being earthbound that Wright decidedly escapes from in the sculpture of the later 1940s. He observed in 1993 that 'Moore looked to the earth for inspiration; I look to the sky'. Indeed, in works such as *Shriek* and *Angel* (Cat.S34), Wright moves quite suddenly to sculptures that leap out of their skins, springing upwards and reaching for other worlds.

Wright's early dancing figures have a sprightly affinity to Gaudier-Brzeska, in particular between *Angular Dancer* and Gaudier's *Redstone Dancer*. There are, however, none

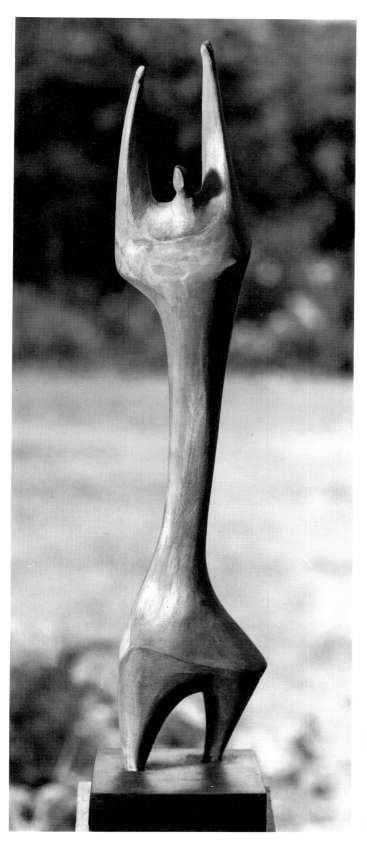
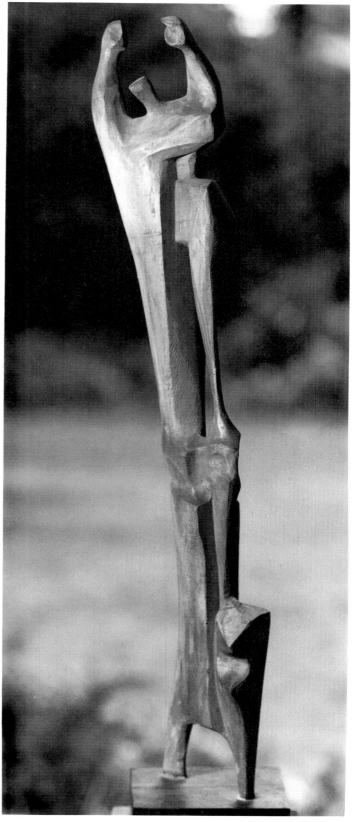

of the mechanical, ritualistic rhythms of Gaudier in Wright's piece. His rhythms are gentler, reflecting the measured yet inexact pulses of plant growth, rather than the precise and predictable movements of the piston engine. In a related sculpture, *Dancing Figure*, the wood assumes the quality of thumb-pulled clay. The nearest comparison to Wright's sculpture of the early 1940s is between his *Figures* of 1942 and 1943 (Cats S14 and S17), and Barbara Hepworth's standing figures such as those in sycamore (1931, Pier Gallery, Stromness, Orkney) and rosewood (1932, Wakefield Art Gallery) that Wright saw at the exhibition of Hepworth's sculpture at Temple Newsam House, Leeds, in 1943. The carved figures of both Hepworth and Wright share the boldly turned neck, sharply pronounced features, determined stance and a tough, muscular undertow. Other less specific parallels are with the sculpture that Gertrude Hermes, Maurice Lambert and Leon Underwood had been making in the 1920s and 1930s, although Wright was not familiar with the work of these artists.

In deciding how to place Austin Wright at this early stage in his career, one has to look backwards over a stretch of about fifty years, and consider the effect of his comparitive isolation from the art world. This had the inevitable effect of causing the influences upon him to telescope into one another. There are, therefore, anachronisms in the ebb and flow of influence. There is Moore and Hepworth; back further the sculpture of Gaudier-Brzeska and Umberto Boccioni, whose *Development of a Bottle in Space* (1912) or *Unique Forms of Continuity in Space* (1913) with their flanges, undercutting and unpeeling, is reflected in the sharp edges of Wright's sculpture and the splitting open of his forms, apparently by eruption from the inside. The elongated figures of Mestrovic, and the rhythmic, linear carving of Eric Gill, both of whom were introduced to Wright by Stanley Casson's book, also have echoes in Wright's carving of the late 1940s.

In the post-war wider world, ominous tendencies arose which British sculpture began gradually to reflect. The atom bomb, refugees and political prisoners all had their impact on the work of artists who were in their twenties and thirties as the war came to an end. In sculpture, reclining or seated figures gave way to figures standing. Moore's *Three Standing Figures* were a centrepiece of the 1948 Battersea Park sculpture exhibition. *Cypress* by Lynn Chadwick, Powell and Moya's *Skylon* and Reg Butler's *Girl and Boy* were three of the many vertical sentinels at the Festival of Britain in 1951. Butler's winning proposal for the *Monument to the Unknown Political Prisoner* (1953) was

intended to stand tall and spikily on a prominent site in West Berlin.[8] The experience of aerial warfare, watched from the ground by thousands of Britons, and articulated in the paintings of Paul Nash and Richard Carline, and the films of Powell and Pressburger, drew the sky down into human consciousness and made it a real dimension in space, rather than a backdrop. Although Constable had revealed in his cloud studies the experience of sky, it took hardship, pain and battle to drive it into collective memory for the first time in human history. In direct response, sculpture stood up and kept watch, as did radar masts, early warning systems and rockets. Robert Adams, Kenneth Armitage, Geoffrey Clarke and Austin Wright responded like their contemporaries to this change in stance and attitude, although Wright's verticality at this time was the verticality not of masts and pylons, but of plants and people.

During the late 1940s and early 1950s York Art Gallery was considered to be a most progressive regional gallery, one of the few in Britain that responded perciently to the new stirrings. In his address at the opening of Austin Wright and Dudley Holland's exhibition, the Director of Leeds City Art Gallery, Ernest Musgrave, made this point forcibly.[9] That this was so was due specifically to the work of York Art Gallery's then Director, Hans Hess (1908-75), a German émigré who revitalised the gallery after the war. As an obituary notice records, Hess: 'cleared out ... cumbrous relics, sealed and underdrew the [60 feet high cast iron] roof and introduced a standard of neatness and cleanliness ... which collectively drove out the musty and intrigued the picture-lover.'[10]

Hess's mission was to open the eyes of his public to the *uses* of museums and to the excitements of modern art. Introducing Wright's sculptures in the exhibition catalogue, he urges his reader to 'meet a stone carving by Wright and look at it not as an imitation of a woman, which it is not, but as a stone which has discovered its shape'.

Hess, Holland and Wright did remarkable and important work in guiding modern art into their region of provincial Britain. Hess, however, was modest about his achievements. He told the guests at the opening of the exhibition: 'I feel like a suffragette who fights a battle which has long been won. The battle for modern art has been won in Paris for 50 years, in London 30 years and in Wakefield [sic] 20 years, but in York the battle is still on.'[11]

For their part, Holland and Wright felt that they had to diverge from the old way of art teaching as it had been practised in York under Holland's predecessor as Principal, Reg Cotterill. With the active support of Hess at the art

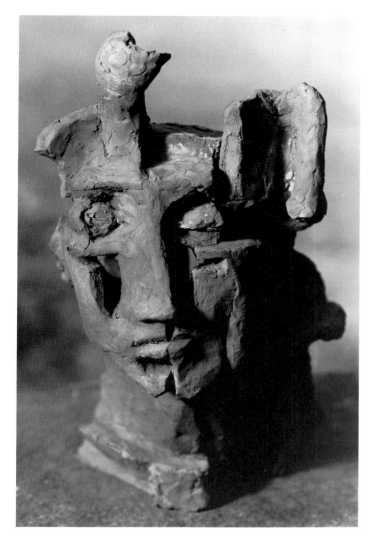

fig.12 *Head* Terracotta 1948-50 (Cat.S38)

gallery, Holland and Wright brought a knowledge of
Cézanne, Matisse and Picasso to their pupils, and through
public lectures by distinguished invited speakers such as
Herbert Read, to a wider audience. They organised life clas-
ses, lectures and exhibitions, and in 1951 Wright produced
Cocteau's *Orphée* at the Art School. What Wright admired
about Picasso and Matisse in particular, and what he
endeavoured to convey to his pupils, was their breath-
taking graphic genius:

The accurate linear quality of the drawing, Matisse with a brush, Picasso
with a very sharp point. The graphic quality of the line. It's knowing
where to begin; *where* to do the middle; *where* to end. And in the move-
ment from A to Z they were so sure of what they were looking at, so
assured; the eye was so gifted, and the arm so responsive to the eye.
It inspired my drawing.

The influence of Holland, who was a painter on the fringes
of Neo-Romanticism, waned in the city after 1950, for at
the end of that year he moved away to become Principal
of Guildford Art School. In the case of Austin Wright,
however, his determination to remain, and not to be drawn
down the orthodox route of moving to London as had
Yorkshire-born artists Moore, Hepworth, Armitage,

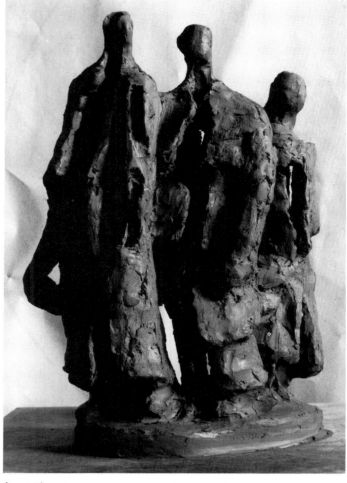

fig.13 *Three Figures* Terracotta 1948-50 (Cat.S42)

George Fullard and Kenneth Martin, led him to be seen
throughout the 1950s as York and Yorkshire's own
resident Modern Artist. His status as a well-rooted incomer
to Yorkshire, his mature years, his happy marriage and
growing family responsibilities had already made any
move unthinkable.

The creativity that Hess, Holland and Wright generated
in York encouraged Wright to seek out yet more fields of
expression. In the period 1948 to 1950 he made a group
of sculptures in terracotta, of which six are known (Cats
S37–S42). Wright modelled these heads and figures from
slabs of brick clay which he later fired in the stove in his
own barn workshop and at a brickworks nearby. The
forms, with their heavily undercut and flanged features, are
rooted in Cubist sculpture, and, more specifically, in the
work of Zadkine which Wright saw at the artist's 1950
retrospective in Paris. These pieces, in which Wright

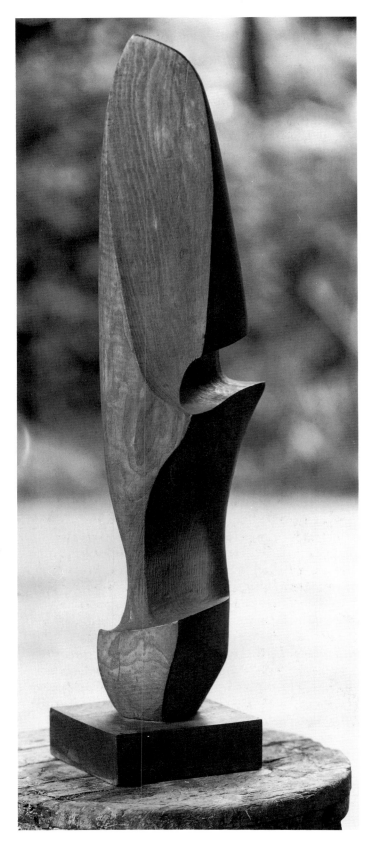

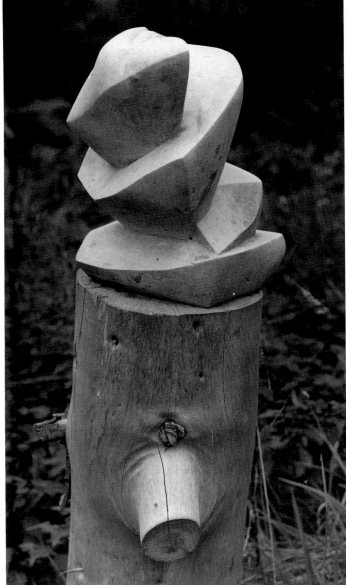

LEFT fig.14 *Green Fuse* Sycamore 1949 (Cat.S43)

ABOVE fig.15 *Savage Growth* Limestone 1949 (Cat.S44)

returns to the medium in which he had worked more than a decade earlier at The Downs School, are an important transitional step in his development. With the terracotta he was able to construct, rather than cut down, and to admit the passage of light and air into and around the forms of the sculpture. This looks forward to the cast concrete and aluminium pieces of the early 1960s, and beyond those works in lead which preoccupied Wright in the 1950s. For the purposes of firing, the thickness of the clay had to be more or less constant throughout each sculpture, and so to a great extent the process dictated the technique.

That Wright was concerned at this time with the opening up of form and the exploration of internal and external spaces is clear from his drawings not only of heads and figures related to his works in terracotta, but also of 'trans-

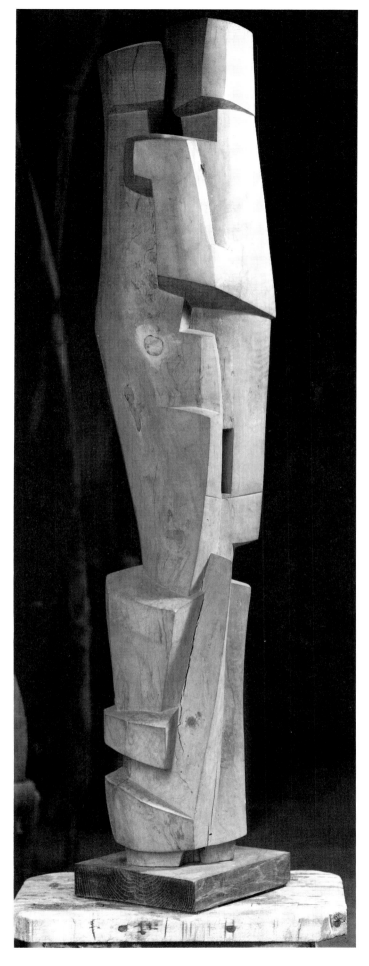

parent buildings' in line, ink and wash that Susan Wright refers to in her diary.[12] They are reminiscent of Giacometti's *The Palace at 4 a.m.* (1932-3) and of certain wire constructions of Picasso. The same diary entry records that Wright was at that time also working in aluminium, having made two angels in bent aluminium sheet. If these are, as they may have been, the aluminium *Experiments in Metal Forms* (Cat.S48) that Wright exhibited at the tail end of his York exhibition, the sculptural and perhaps volumetric properties of this metal were already becoming of interest to the artist.

During this period, Wright's teaching timetable at the Art School had been compressed to enable him to spend three and a half consecutive days each week working at home. Susan gives a crisp description of her husband's daily working pattern in her diary entry for 11 February 1950: 'A. sculpting all day and painting all evenings when not at the Art School.' This constant creative activity brought Wright's name, through the intermediary of Hans Hess, to the ears of Henry Roland, a director of the Cork Street art dealers Roland, Browse and Delbanco. A few weeks before the York exhibition opened, Roland visited Wright and agreed to take 'a few pieces' to try out in London.[13]

A second highly influential gallery director who discovered Wright's work at the 1950 York exhibition was Helen Kapp, the young and dynamic Director of Wakefield Art Gallery. Kapp had been a CEMA lecturer at Wakefield until she was appointed to succeed Frank Atkinson in 1951, and was thus to become the fourth successive director of the gallery who had an active interest in modern art. The gallery at Wakefield had been opened in the former town Vicarage in 1934, under the directorship of Ernest Musgrave, until he moved to Leeds City Art Gallery and Temple Newsam House in 1946. Musgrave's eye and his knowledge of the art world drew important acquisitions to Wakefield, including paintings by Duncan Grant, Charles Ginner, William Roberts and Graham Sutherland. Musgrave also acquired sculpture by Barbara Hepworth and Henry Moore, both artists from the locality, including Moore's seminal *Reclining Figure* in elmwood of 1936. This was the first sculpture by Moore to be acquired by a British provincial public collection. The status of Wakefield Art Gallery during Musgrave's directorship was such that it

fig.16 *Lovers* Holly 1952 (Cat.S49)

attracted gifts from collectors of the eminence of Peggy Guggenheim, Hazel King-Farlow and Lucy Wertheim, and it became practical for exhibitions such as *The London Group* (1937) and *Modern French Art* (1943) to be mounted there. Musgrave was succeeded first by Eric Westbrook (1946-9), who organised Moore's major retrospective exhibition at the gallery (1949), and then by Frank Atkinson (1949-51) who did the same for Barbara Hepworth (1951).[14] For these reasons Hans Hess could justly declare at the opening of the Dudley Holland and Austin Wright exhibition in York in 1950, in the presence of Musgrave, that the battle for modern art had been won in Wakefield for twenty years.

One of Kapp's first innovations at Wakefield was to alternate the established series of West Riding Artists Association exhibitions with the biennial series *Modern Art in Yorkshire*. In these exhibitions, eight or ten artists were given one room each in the gallery, thus effectively creating a group of linked one-man shows. Although Kapp had herself a flair for publicity, it was the gallery's longstanding reputation as a brave out-station, and Kapp's own enterprise at keeping this reputation alive, that brought the national press to her exhibitions. Charles Sewter described Kapp in the *Manchester Guardian* as 'something of a wizard at spotting exceptional talent',[15] while the *News Chronicle* praised Wakefield's endeavours:

The city is lucky to have such an enterprising museum director as Helen Kapp, at the same time as a council that doesn't hold up its hands at her unorthodox schemes. It isn't every town council that would agree to having a permanent collection removed bodily for the sake of local artists.[16]

Helen Kapp herself explained the importance of her *Modern Art in Yorkshire* exhibitions:

It has proved three things — that one man's artistic stature and worth can only be properly estimated when quite a number of his works are shown together; that the best craftsmen today work in the idiom of their times; that a number of excellent artists and craftsmen could be found within the borders of the West Riding.[17]

Austin Wright showed five works in the 1953 *Modern Art in Yorkshire* exhibition, and, two years later, seventeen in a room to himself. These pieces, fifteen of which were standing lead figures of about 10 to 14 inches high, drew the particular attention of Charles Sewter in the *Manchester Guardian* and W. T. Oliver in the *Yorkshire Post*. Sewter, an art historian, teacher and critic who took a considered international view of art, singled Wright out as

the outstanding personality, a sculptor whose small lead figures ... have a highly individual quality of feeling, perfection of craftsmanship, and real monumentality of style. ... It would not be outrageous, far from

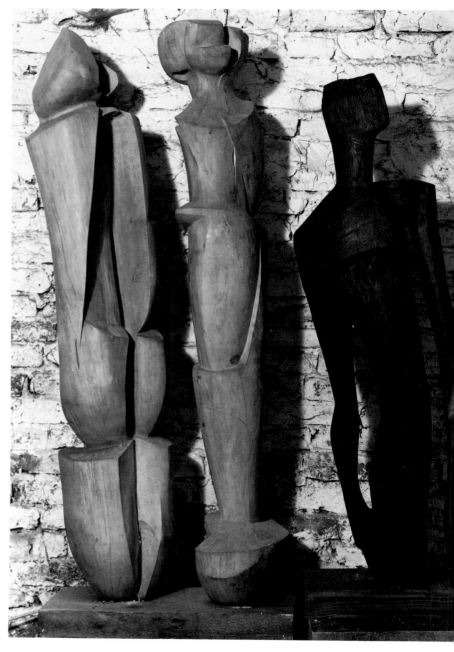

ABOVE fig.17 (left) *Two Forms* Holly 1952 (Cat.S50)
(right) *Thrower* Ash 1954 (Cat.S58)

OPPOSITE LEFT fig.18 *The Whisperers* Beech 1953 (Cat.S53)

OPPOSITE RIGHT fig.19 *Lear* Beech 1954 (Cat.S57)

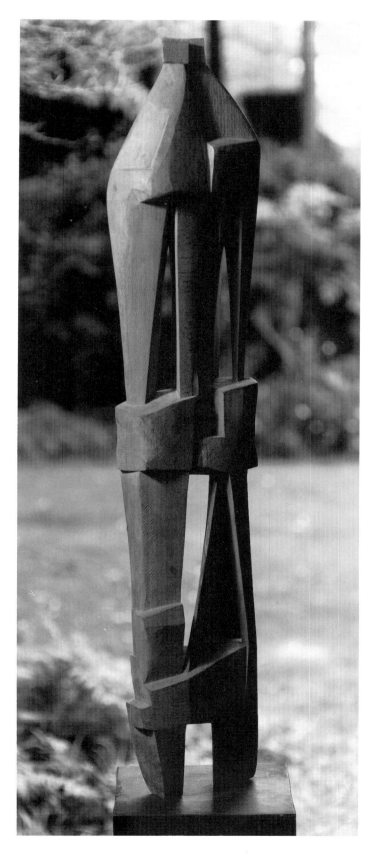

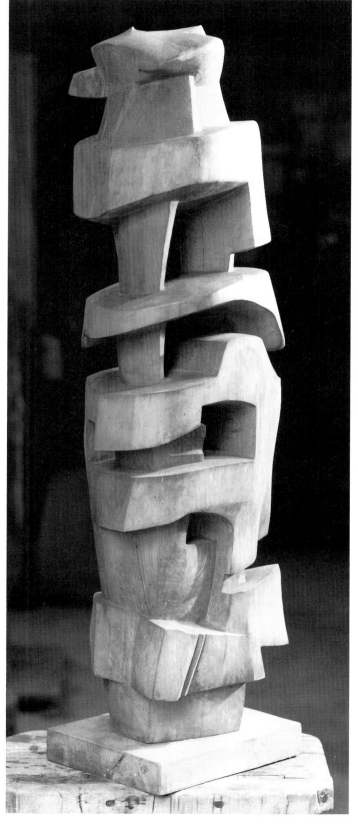

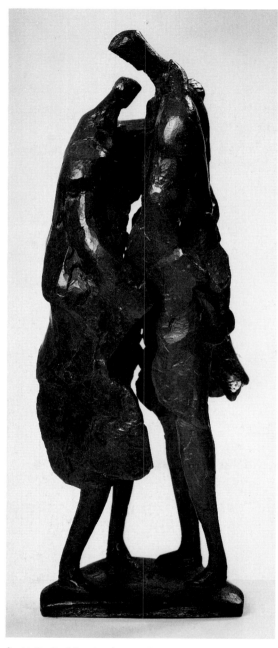

fig.20 *Prodigal Son* Lead 1954 (Cat.S59)

it, to claim that Austin Wright is the most gifted sculptor working in Britain today.[18]

What was it that led Sewter to make such a bold statement? Wright's modernist contemporaries, then exhibiting, included not only Moore and Hepworth, but also Robert Adams (*b*.1917), Kenneth Armitage (*b*.1916), Reg Butler (*b*.1913), Lynn Chadwick (*b*.1914), Geoffrey Clarke (*b*.1924), Hubert Dalwood (*b*.1924), Elisabeth Frink

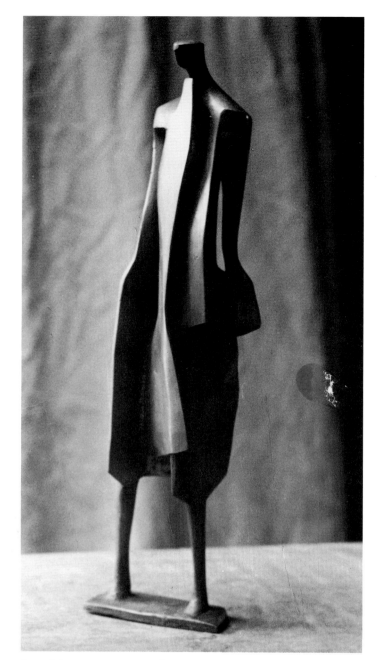

fig.21 *Man in a Long Coat* Lead 1954 (Cat.S60)

(*b*.1930), Kenneth Martin (*b*.1905) and Eduardo Paolozzi (*b*.1924).

Wright's sculpture had, between 1950 and 1955, taken two distinct paths. One is represented by his direct carvings in wood, which follow the development of the 'Tall, Reaching Forms' exhibited in 1950. These, such as *Two Forms* (Cat.S50) and *Lear* (Cat.S57), had become taller with greater physical presence. The second path Wright followed was in the making of smaller lead figures, cast from clay models. Rarely more than 14 inches high, this group included single figures such as *Man in a Long Coat* (Cat.S60); amalgamations of two or three such as *Embracing Figures* (Cat.S62); and groups of individuals, such as *The Argument* (Cat.S63), arranged with narrative intent on a single base.

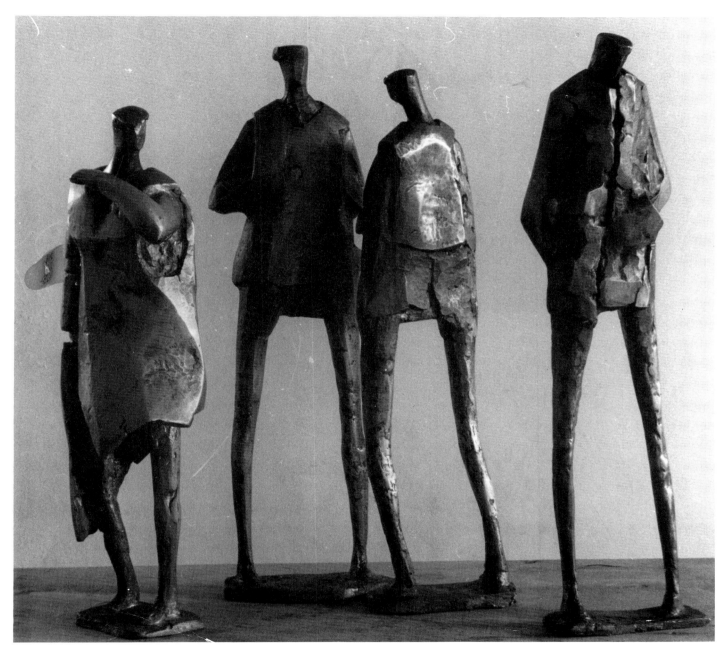

fig.22 *The Argument* Lead 1955 (Cat.S63)

From the earliest of the small lead pieces, Wright moves on over the period 1953-5 to figures with a rougher and creviced surface texture in which the working of the artist's hand is visible in the plaster model. These textures derive ultimately from Wright's memory of the rocky surfaces and shapes that he clung to while climbing in Wales as a young man. Angles, as in *Man in the Wind* (Cat.S67), are pronounced – the head behind the collar, the bulges where the figure's hands are stuffed into his jacket pockets, the sharp edges of the trouser creases. The deep cleft where the jacket opens betrays Wright's interest in the space within, and in forms which divide and erupt. As a formal essay, this piece is alluring and satisfying; as a characterisation of a man standing against a strong wind it is brilliant, having the panache and control of Medardo Rosso or Honoré Daumier. Characterisation – narrative – is a powerful

driving force in Wright's art of this period. *The Argument* (1955), a group of four men, all brothers of *Man in the Wind*, stand apart from each other at the moment of disagreement. There is a simple eloquence in their stances; but the art is also in their placement.

Putting aside the notion that Sewter was then a young critic in search of a discovery, it was perhaps these aspects of narrative and characterisation that led Sewter to claim supremacy for Austin Wright. He wrote of Wright's feeling, craftsmanship and monumentality of style, qualities that are arguably not so richly mixed elsewhere in the sculpture of the mid-1950s. Adams, Butler, Martin and Paolozzi all had more incisively intellectual and theoretical approaches to sculpture than Wright, but none, except perhaps Frink, had the eloquence and passion that in Wright's case comes from his Welsh roots. His literary interests — the strength of his feeling for Hardy's *Jude the Obscure* and for Dylan Thomas's poetry and above all his professional training as a linguist and a teacher of language — all point to the view that Wright's chosen emphasis as a sculptor fell naturally into the literary camp. This concern was quite different to that of his contemporaries, and it was perhaps this trait that Sewter identified in making his view known.

Wright's wood carvings of the period 1950-5 are more directly linked to his earlier work than are the small leads. The bone-like forms that the artist had explored in the 1940s are present, as is the staged vertical growth akin to the growth of a plant stem. This is combined with a new exploration of forms which split down a vertical fissure, to read either as embracing figures (*The Whisperers*, Cat.S53, *Lovers*, Cat.S49) or as two distinct elements (*Two Forms*, (Cat.S50). Characteristic is Wright's use of the meeting of planes cut in contrasting directions, thus creating sharp lines, vibrant light and shade patterns across the works, and encouraging the viewer to move around these multiviewpoint works of art. In *Lear*, the last of his large-scale wood carvings, Wright places emphasis more on the stages of 'growth' in the sculpture, rather than on its verticality. The work has a series of platforms, as a tall building has floors or a cliff caves, into which Wright has carved a variety of interlocking inner spaces.

The wood carvings Wright made at this time were not unique in their day. Rather they are of a form that demonstrates how close in feeling Wright was to the leading movements of contemporary art, even if he was geographically distant from its centre. In their totemic quality there are natural echoes of Brancusi, although the wood carvings of Robert Adams, for example *Divided Pillar* (1950) or

Divided Column (1952), are more immediately comparable.[19] The sculptural idea that Wright seems to be exploring here, of one inner form expanding outwards and sloughing off an outer skin is one that had also preoccupied sculptors such as Richard Bedford, Gordon Herickx and Gertrude Hermes who looked at plant forms for inspiration in the 1930s and 1940s.

Lear also relates to a group of sketchbook drawings of medieval stone walling in York (Cat.Sk19) made by Wright in the summer of 1953. The interlocking shapes of the stones are played on further in the sketchbook and varied into standing and dancing figures made up of separate but integral parts, like interlocking vertebrae or ball and socket joints. Continuing the variations in the same sketchbook, Wright makes standing figures constructed of solid segments sewn loosely but firmly together with flexible vertical rods. The closest contemporary comparison is with Reg Butler's small tin and wire standing figures exhibited in the early 1950s, although Wright's drawings have a firmer architectural quality. We should also consider the parallel with Moore's drawings of the late 1940s and early 1950s. A relevant characteristic of these is the zigzagged line which runs around and defines the form of the sculpture study, be it an abstract figure or a head. The effect given is one of solidity and strength, the zigzags creating the same linear play as the lines of cut and jointed stone in architecture or monumental sculpture. Wright's figure drawing, by comparison, is flexible and light, and akin to the structure of a canvas-covered dirigible. Though Wright is in the same field as that already occupied by Moore, it is a field wide enough to enable many artists to investigate the same features and yet maintain their individuality.

Wright's drawings of the period reveal the close link between his large wood carvings and the small leads, and demonstrate how fully integrated is his art throughout its phases. The sleeker, undercut figure such as *Man in a Long Coat* (1954), is comparable to the recent wood carvings, and the lead *Lovers* (Cat.S71), with its compartments of solid and open form, to the developments of the stone-walling drawings and to *Lear*. The lead standing figure groups, of which there are more than twenty variations, are further explored in Wright's drawings. These take the theme further than the sculptures ever could, arranging figures for example in compartments like cross-sections through buildings. The figures are diminutive, or run the full height of the sheet; and are drawn with the point of the conté crayon, which gives a delicate, feathery line, or with the flat edge. Wash with wax resist creates the setting for the figures.

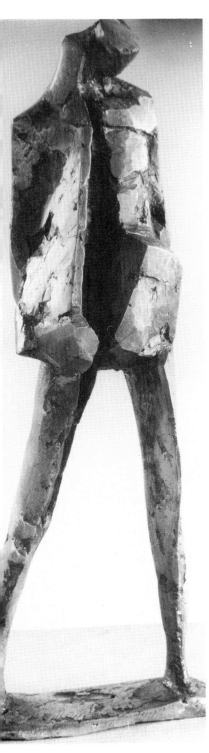

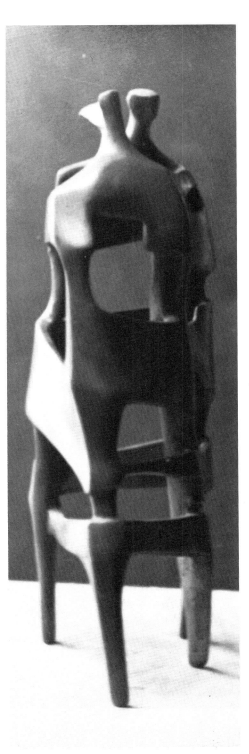

ABOVE LEFT fig.23 *Man in the Wind* Lead 1955 (Cat.S67)

ABOVE RIGHT fig.24 *Lovers* Lead 1955 (Cat.S71)

It is impossible to avoid looking once again to Moore's drawings as a point of reference — though a reference not for Wright, but for the historian. Both artists saw drawing as the first source of expression of their sculptural ideas, and from both drawings came teeming. Both too saw the human figure as a benchmark, an inexhaustible source for shape, form and volume. Where Moore, however, searches for *stasis* and presence, and for the 'new' that has always been, Wright, an artist with more modest ambitions, seeks change, growth, movement, metamorphosis and the quotidian. Thus he is as entranced by the shape of a figure lying in a deckchair on the beach, as by the bursting of an iris bud; and in the making of a landscape out of pepperpots (Cat.Sk29), as by finding figures in the forms of rock faces and landscapes. The staggering quantity and quality of invention in Moore's drawings, and their happy availability in exhibitions and publications, has tended to obscure the achievements of other, different, artists of Moore's generation. Undoubtedly, however, and in this too lies their importance, the availability of Moore's drawings have also given these same contemporaries the confidence to continue and a staunch example to follow.

The explorations of groups and crowds of figures in movement had been a long running source of interest for Wright. Sue Wright's diary of 1951 records: 'A. making lots of exciting groups of figures, bicycles etc. The chief idea being how we overlap and interweave with our fellows — in our relations we become part of a person for a time — part of the same whole anyway.'[20]

The dynamics of massing figures was a preoccupation of many painters and sculptors in the 1950s. The paintings of L.S. Lowry and Robert Medley explore this theme in their very different ways, as do the sculptures of Kenneth Armitage and Lynn Chadwick. Moore and Hepworth were in the 1950s developing the theme further into pairs or trios of integrated vertical forms.

Wright's drawings of figures in movement show also how relevant to his central concerns is the wire and plaster abstract construction *Nucleus* (Cat.S75). Even though it might seem to represent a dead end, this sculpture is a drawing in space closely related not only to Wright's conté drawings of the period, but also to the way in which the rapid pace of scientific discovery in chemistry and physics was being presented to the public in the mid-1950s. Wright's *Nucleus* relates to models of atomic and chemical structures made for teaching and publicity purposes in the 1950s, the decade in which the term 'the Atomic Age' was coined. Perhaps the public apotheosis of the mighty atom came in the still extant structure Atomium, built for the

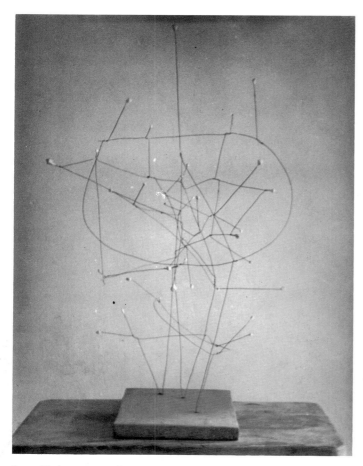

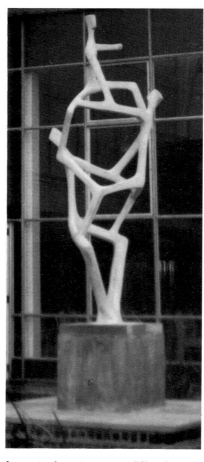

fig.25 *Nucleus* Wire and plaster 1955 (Cat.S75)

fig.26 *Acrobats* Concrete and fibreglass 1952-57 (Cat.S96)

1958 Brussels Expo. Like the atomic particles they represent, the effect of molecular models on art and design travelled fast, from the Festival of Britain to the Brussels Expo; from Lucienne Day fabrics to Ernest Race furniture; from painting by Graham Sutherland and William Gear, to sculpture by Kenneth Martin and Austin Wright.

Wright's entire *œuvre* as a sculptor, from 1945 when he and Susan bought Green View, was produced in the barn across the lawn to the left of the house. This is determinedly not Wright's *studio* – there is no such place – but his workshop. The barn was built as a farm shed, for livestock, produce and equipment, and to this day some of the old bits of rusting ironwork hang undisturbed and cobwebbed as they did in 1945. Although Wright gave the barn a new concrete floor in 1958, and the roof has had to be renewed, it has remained otherwise unchanged. Wright himself slipped into it like a hermit crab into its shell in 1945, as quietly as one day he will slip out of it again. In the barn and on the ground outside Wright car-

ved wood and stone, made his clay and plaster maquettes, cast his lead figures and cut and bent aluminium sheeting for his constructions without the help of any assistant. He has never worked from his sketches or studies – these rarely enter the barn. His practice has been to work on a number of different pieces of differing scale at the same time.

During the period in which he was modelling and casting his lead figures, for example, he was turning also to creating three large-scale sculpture groups, two of which were commissions. In 1952 Wright was invited by Manchester City Council to make a sculpture *Acrobats* (Cat.S96) to be sited at Poundswick School, Wythenshawe, Manchester. This work, a trio of balancing figures in fibreglass-covered concrete, was delayed considerably, and not sited until five years later in 1957. It is now destroyed.

A public commission with a considerably shorter gestation was the Crib (Cat.S81) which, in 1955, Wright was invited to make for Wakefield Cathedral through the

initiative of the Provost Canon Noel Hopkins and the advice of Helen Kapp. The Crib takes Wright's interests in groups of figures and their interaction to the largest scale in which he had yet worked. Although the traditional figures, the Holy Family, the Wise Men and the shepherds were all expected of him, one of the first design decisions he took was the bold one of coalescing the inn and stable, and dividing the resulting structure into self-contained sections. This created divisions for the groups of figures to overcome by their poses and gestures, and in that way generate a dramatic rhythm across the work. The historical source for Wright's Crib is Italian early Renaissance altarpieces, by Duccio, Giotto or Fra Angelico, with their shallow space and attenuated architecture, known to Wright through reproduction. Like his Italian artist fore-

bears, Wright was able to connect the story with contemporary life by the placement of excited groups of singers, pipers and other observers into upper rooms of the three-storey structure in which the Nativity is set. The excitement among the onlookers in Wright's Crib is palpable. Figures rush downstairs, one cranes precariously over the edge to look down on the event below, while a piper and singers serenade the birth. The backdrop to the Crib, which incorporates the Annunciation, exultant angels, starlight and holly, was designed by Wright and woven by the Leeds weaver Theo Moorman.[21] The whole was originally sited in the cathedral's Walsham Howe chapel, where it could be clearly seen, as intended, from the front. Latterly, however, it has been set up annually in the south aisle, where it is first approached from an oblique angle.

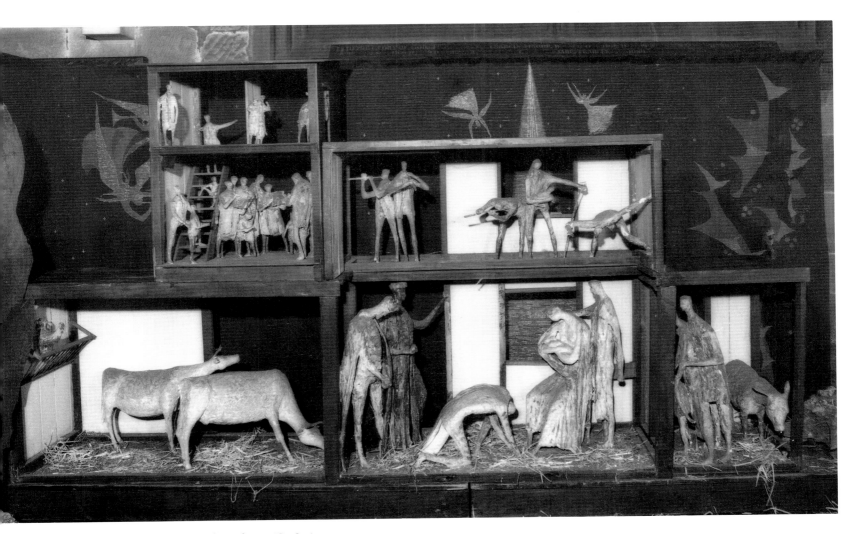

fig.27 Crib Plaster and wood 1955 (Cat.S81)

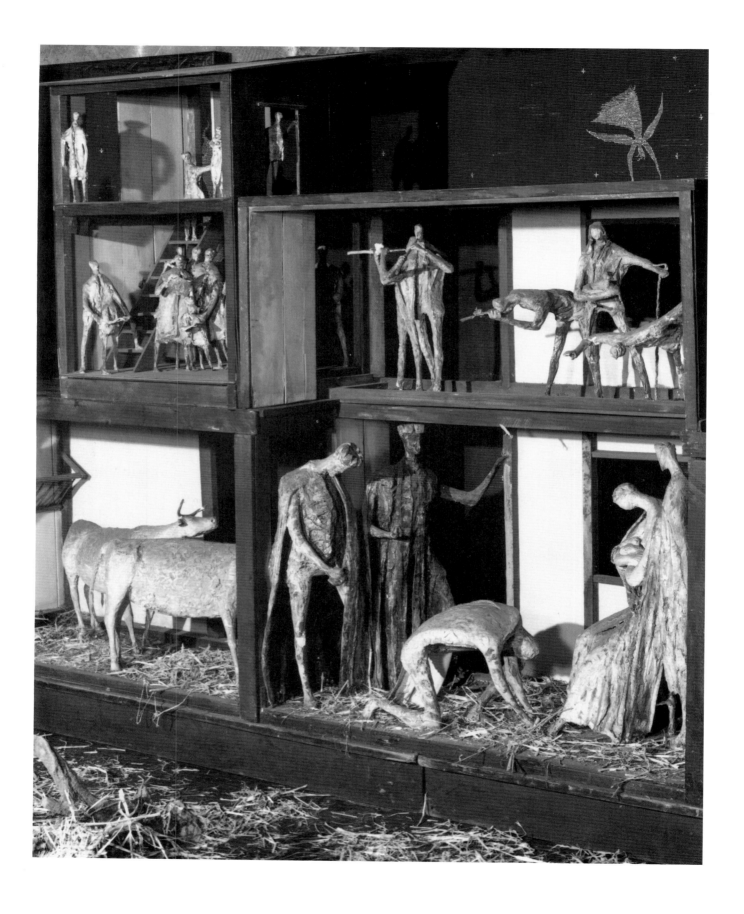

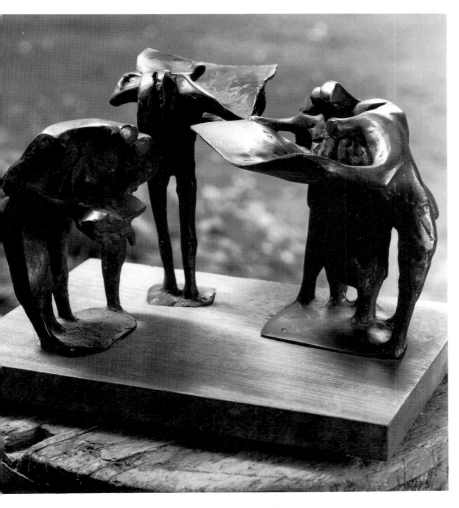

OPPOSITE fig.28 Crib (Cat.S81 – detail)

ABOVE fig.29 *News* Lead 1956 (Cat.S84)

This was the second time that Moorman and Wright had collaborated on church hangings, the first instance being a pulpit hanging for Derby Cathedral (*Angels in the Night Sky*, commissioned 1954). Subsequently, Moorman and Wright collaborated on a pair of tapestries for the Lady Chapel of Manchester Cathedral, one depicting the Visitation and eight other scenes of Biblical meetings, and the other the story of the Nativity (1957) [see also Cats Sk7, 24, 25]. Writing in the *Spectator*, Basil Taylor praised the Wakefield Crib, pointing out that it had 'revitalised what has become a traditional Christmas gesture and in putting modern work into an old building makes a further challenge to the antiquarian timidity which characterises so much of the Church's attitude to the visual arts'.[22]

Taylor's swipe at the Church was ill-informed, particu-larly when one considers that during the mid-1950s one of the greatest collaborations of the century between artist and Church was taking place at Coventry Cathedral (dedicated 1962) under the leadership of Sir Basil Spence. The contribution of Wright and Moorman in Wakefield, Derby and Manchester should be seen in the light not only of the Coventry patronage, but also of the pioneering work of the Revd (later Canon) Walter Hussey in commissioning artists such as Moore, Graham Sutherland and John Piper at Northampton and Chichester.

As the Crib was being installed and dedicated at Wakefield, Wright was preparing to leave York Art School to commit himself to making sculpture full time. This was a brave step to take with a wife and two children to support, and an even braver one in the light of the fact that although Wright was to be given one in 1961, he had just failed to win a Gregory Fellowship at the University of Leeds. Susan Wright's diary entry reveals the background to this: '*Nearly* got the Gregory Fellowship. Mr G. lunched with us and liked the sculpture but the Fellowship went to a more suitable and penniless candidate. Giving Gregory asparagus for lunch (grown by ourselves) made A. seem too opulent!'[23]

Of his break from teaching Wright recalled:

It was then that I really got going here, working solidly on my own. I had a lot to catch up on. Looking back I see how absolutely I became locked and linked to [Green View] – the barn inside and the freedom of the ground outside. The market garden [had become] a wilderness, but has been very gradually transformed into the linked series of spaces and barriers which it now is. It not only provided the starting point for so many sculptures and drawings, but it seems to have become a sculpture in which one is – which is one of my most recent concerns.[24]

Austin Wright's garden became, from the mid-1950s, central to his work, thought and recreation. The presence of the 220 yard long strip of land behind the cottage was one of the factors in the Wrights' decision to buy it in 1945. Over the past fifty years Austin and Susan Wright have transformed it into a series of interlocking spaces, opening and closing, with wild parts alternating with well-ordered spaces, groves of trees with open lawns. Though narrow, it is articulated by bends and turns which make each short walk an adventure; and though long, its sections, like the jointed parts of an insect's body, are complete in themselves. Austin Wright is one of a long line of artists such as Monet and Patrick Heron to whom their garden is not only a source of inspiration and subject-matter but also, in the case of sculptors such as Moore and Frink, the place in which their work can be shown at its best.

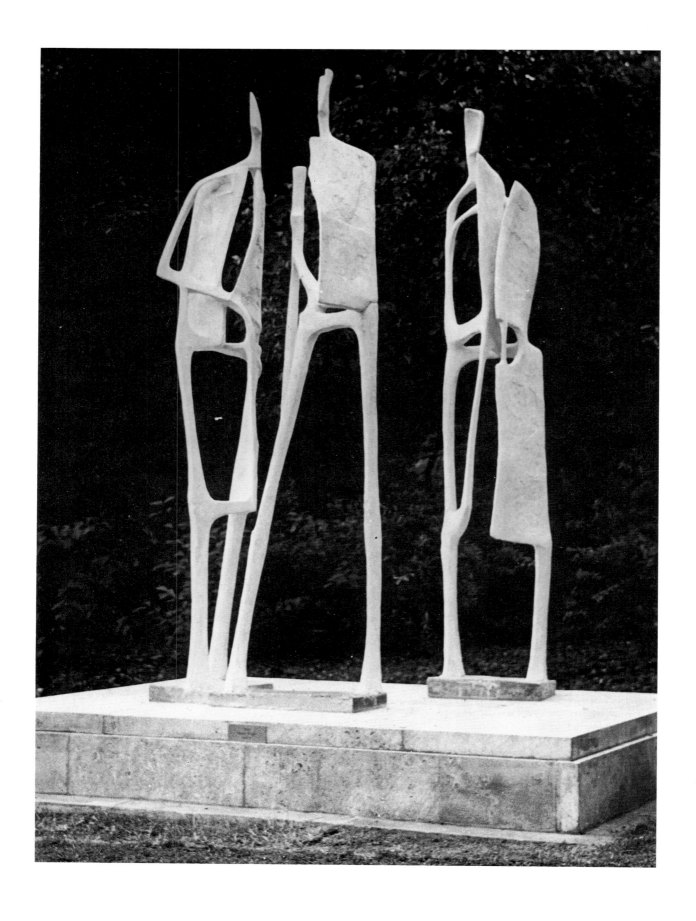

The garden is Wright's nursery for sculptural ideas. It is here that he will draw, by the dozen, studies of the seed pod of a laurel, the bud of a lilac or the swelling growth of an apple – and euphorbia, cow parsley, giant hogweed and hemlock. These are never exact botanical studies, but swiftly rendered conté, ball-point pen or latterly felt-tip pen outline drawings in which the main sense of the plant's shape is reduced to its key structural elements. Wright's sketchbooks are full of such drawings, page after page of them. In addition there are many sheets of royal-size conté drawings made with the flat of the crayon, highlit with a sharp structural line or point.

Of the part that drawing has always played in his work, Wright revealed in 1974:

A batch of drawings occurs spontaneously – there is a sudden exciting find. I am recording ways of travelling across new territory and the result has to look after itself. There is a quirkiness about the actual object which is beyond anything I could invent and I feel there's a potential of great subtlety and riches. Also the experience of seeing for the first time is unique. Some drawings belong to precise times and can't be repeated. No sculpture may result for some time, if at all. In the meantime there is another phase when ideas are turned over, in small line drawings, playing with proportions and structure, hardening the forms. This may go on obsessively, spasmodically, for years.[25]

Rumours of Austin Wright were reaching London by the mid-1950s. That they seemed to take root so quickly in the capital was due to the assiduous support of both Hans Hess, who introduced Wright to Henry Roland, and Helen Kapp. Although Wright himself credits Herbert Read for recommending him to the British Council, it was Kapp who sent to Lilian Somerville, the Director of the British Council Fine Arts Department, a set of photographs of Wright's sculpture.[26] These photographs led the exhibition selection committee, Eric Gregory, Philip Hendy, Philip James, Roland Penrose and Herbert Read, to invite Wright to take part in the exhibition of *Younger British Sculptors* to tour Sweden in 1956 and 1957. This invitation led within three months to a further invitation from the British Council for Wright to contribute to a similar exhibition, *Ten Young British Sculptors*, at the São Paulo Biennale in Brazil. This exhibition toured subsequently to Argentina, Chile, Peru, Uruguay and Venezuela.

The South American adventure took Wright one more step up the ladder of international recognition when he was awarded the Ricardo Xavier da Silveira Acquisition Prize in São Paulo. At the same ceremony the Painting Prize was awarded to Ben Nicholson. Wright's award was an honour more in name than in substance, for the 50,000 cruzieros (£250) prize money was reduced by a 10 per cent slice taken by the Biennale authorities, and a further 10 per cent taken by the British Council – though this was later waived in recognition of the fact that soon after the award was announced the value of the Brazilian cruziero fell against the pound.[27] As Wright was obliged to pay £80 for a new cast of *The Argument* to replace that acquired by São Paulo, the net benefit to him was £111 6s 11d.

By the time Wright won his first international recognition in Sweden and South America he was in his mid-forties, and not strictly a 'young' British artist any more. His work was gaining in recognition in Britain, with *Trio* (Cat.S100), a three-figure group made in plaster for bronze, being included in the 1957 Holland Park Open Air Sculpture exhibition, one of the revelatory series of open air sculpture exhibitions organised in the 1950s by the London County Council. These skeletal figures, standing 9 feet high, were stylistically a bold marriage between the manner of the wood carvings Wright had exhibited in 1950, and the more recent leads. The attenuation of the wood carvings is echoed in the structure of the trio of figures, their limbs and bodies being reduced beyond the shapes of bone to the forms of scaffolding. The flanges which articulate the figures are, on the other hand, a development of the undercut areas of clothing on some of Wright's lead figures, and of the treatment of his terracotta heads. Growing critical support for his work was now encouraging Wright to weave his sculptural ideas into one another, and to explore their application to a large scale.

The consistent merit in Wright's work encouraged the British Council to award him in 1957 a travel scholarship to Italy. This he took up in the late summer of that year, directly after spending a family holiday in Anglesey. 'The change of light from Wales to Italy was staggering', Wright recalled.

One day I was at Bull Bay, and the next – whoosh – in Venice! Art books at that time were small and in black and white. The real *size* of the paintings stopped me in my tracks. Those artists were *fearless*. All sorts of colours arrived together in these things. I sat in front of Piero's *Finding of the True Cross* in Arezzo all day, and watched the sun coming across the fresco and illuminating it piece by piece. And then the wonderful Byzantine mosaics at Ravenna. The size! I had to make drawings with my whole arm.

While Wright was in Italy, the news of his São Paulo award came through. Such thrilling news in so exciting a place made him feel that at last he had broken through the critical barrier, and that now he need never look back. He arti-

OPPOSITE fig.30 *Trio* Plaster 1957 (Cat.S100)

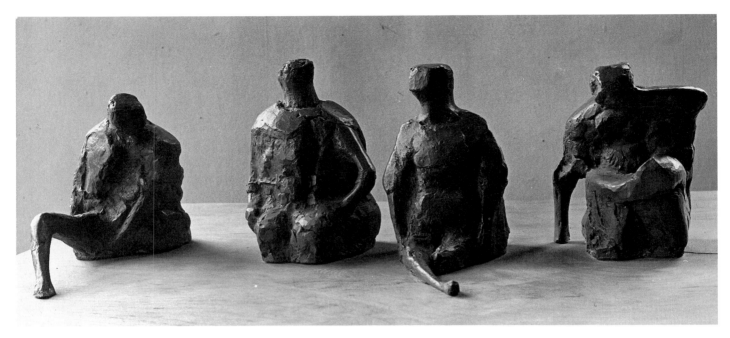

ABOVE fig.31 *Four on a Beach* Lead 1957 (Cat.S115)

RIGHT fig.32 *Table Man* Lead 1958 (Cat.S123)

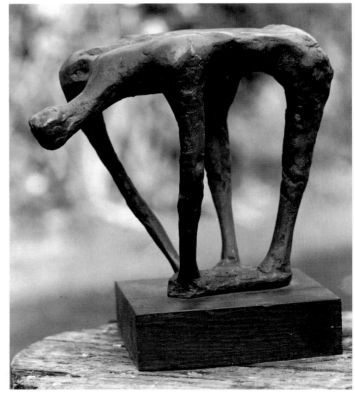

culated what he now wanted to achieve in sculpture, and
more particularly how he hoped his audience would
respond, in some words published in the catalogue of the
exhibition he shared at York City Art Gallery in 1956 with
the painters Norman Adams and Russell Platt:

Sculpture is to be explored – like a building, a ruin, a landscape, a town.
Think how you would cross it, climb it; where you would rest and
where you want to get in the end. Two contrasted kinds of structure,
eg the carcase and the landscape – two kinds of 'order' – 'order' and
'disorder'. The one fixed in form, balanced, 'ordered', the other changing,
strewn, haphazard, weathered.
The hand as the measurer of sculpture – joining the structural elements,
grasping mass, balance, tension, textures. Pick up a man by the ankles,
so that he remains standing, catch him by the left leg or wrist and throw
him down the stairs.
The strength and frailty of human beings.

Wright's work, now with a mature span of ten to fifteen
years, had by the mid-1950s settled down in its priorities.
As the paragraphs above reveal, Wright saw these as the
exploration of structure, and the reconciliation of order and
disorder, active and passive, in dynamic sculptural terms.
In his small figure sculpture, Wright explores groupings,
meetings, partings and conversations between individuals.
Robert Melville, in his introduction to the catalogue of the
British Council *Younger British Sculptors* exhibition in
Sweden, made it clear that this was also the concern of

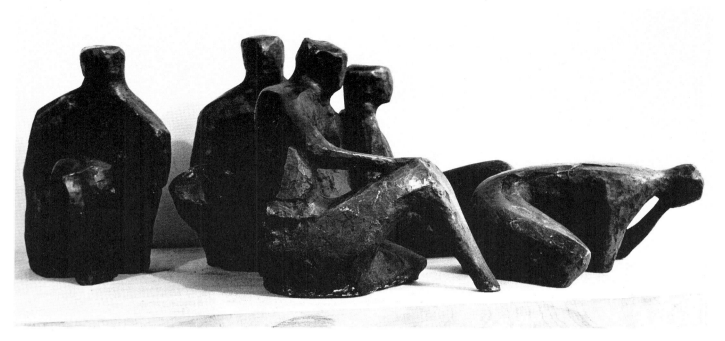

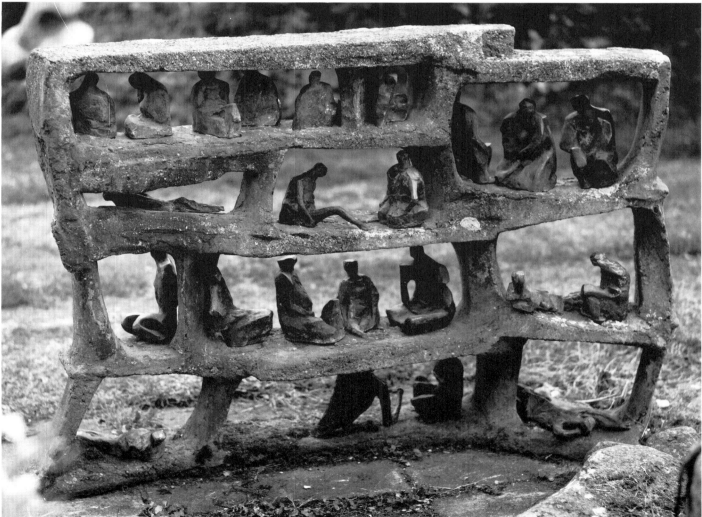

TOP fig.33 *Silent Five* Lead 1958 (Cat.S126)

ABOVE fig.34 *Limbo* Lead & concrete (CatsS128 & S129) [Photograph taken in 1993, with three figures missing]

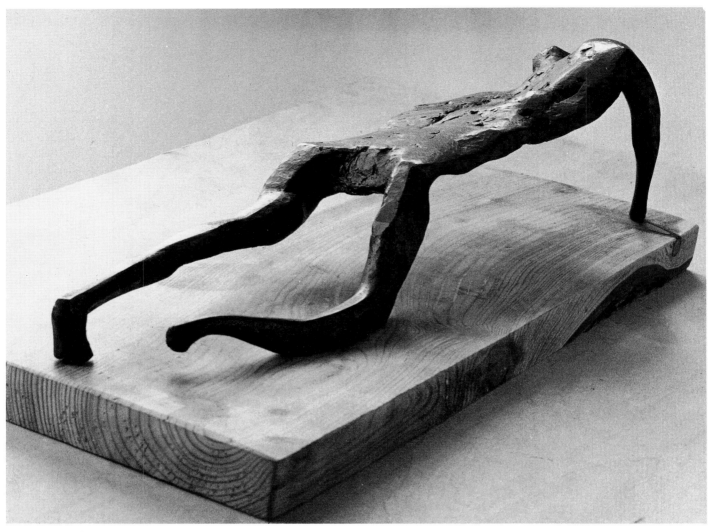

fig.35 *Crawling Man* Lead 1960 (Cat.S158)

many of Wright's contemporaries, and that the anxieties of the immediate post-war period as expressed in sculpture were passing:

Our sculptors' most recent work is . . . no longer deeply engaged in solemnly depicting these difficult times. The carefully thought-out constructions defending themselves tooth and nail have given way to friendlier figures which are less on their guard and more inclined to greet you spontaneously and in a friendly fashion than to poke and pinch invisible enemies. The feeling of human solidarity, I think, comes wonderfully alive in Kenneth Armitage's groups of figures, where the figures are sometimes so intimate with one another that they can share common parts of the body, and in Austin Wright's study of two people sharing an improvised rain shelter and in Lynn Chadwick's tender loving couple.[28]

In 1957 Wright's lead figures became squatter and heavier, seated rather than standing, and rock-like, rather than akin

to lighter bone or wood formations. The culmination of this new trend is *Limbo* (Cats S128 and S129), a concrete structure of the kind prefigured in drawings such as fig.112, inhabited by twenty-six lead seated and reclining figures. The figures, squat and lumpy, themselves derive from the many drawings Wright made on Welsh beaches in Anglesey and the Gower Coast on family summer holidays. Stephen Bone spotted the 'calm universality' of the *Limbo* figures and their many variations such as *Four on a Beach* (1957) and *The Silent Five* (1958), drawing a comparison with the same quality that Moore had achieved in some of his maquettes.[29] A further, and perhaps more relevant, comparison should be drawn between these figures and Cézanne's approaches to the same subject in his paintings of *Bathers*.

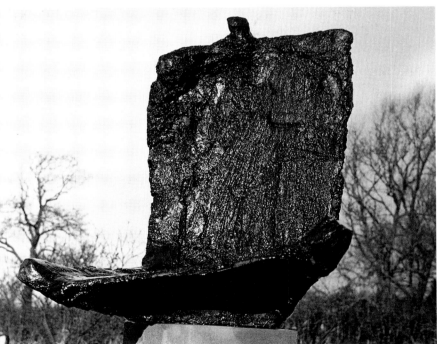

TOP fig.36 *Shore Figure* Concrete 1960 (Cat.S165)

ABOVE fig.37 *Scribe* Concrete 1960 (Cat.S166)

Wright was reaching the end of his work in lead with these seated figures. He found himself becoming very limited in terms of scale by the medium, instead finding himself interested in making larger-scale sculpture. Transitional lead figures, in which the form becomes flatter and thinner in section, as if beaten out from a lump, are *Crawling Man* (Cat.S158) and *Table Man* (Cat.S123). Alongside this trend to flatter forms is the gradual elimination by Wright of the head in his figures. As a result, the concentration is upon the torso and body structure, and the consequent shapes and spaces that are thereby unlocked.

To enable him to work economically at a greater scale, yet retain the mass and solidity of his lead figures, Wright turned to concrete. Dalwood and Paolozzi were already using this medium, as had artists of an older generation such as Moore and Frank Dobson. Wright's concrete pieces, which include *Shore Figure* (Cat.S165, exhibited in 1960 as *Slab Figure*), and *Scribe* (Cat.S166) are made on a steel and chicken-wire armature. To hold the concrete in place while it set, Wright used wood and metal shuttering, newspaper and even old telephone directories — anything that came to hand in the barn as Wright worked at speed.

Where the smaller lead figures displayed arrested movement, the concrete figures, some of which were up to 6 feet long, have a majestic, static quality. The majority were painted black, though some, such as *Squatter* (Cat.S141), are recorded as having been coloured, their rough texture reflecting the light and creating vibrant patterns of shadow and highlights. The heads in all these works are reduced to a mere knob, if the head is present at all. Wright's main concern is in the relationship between the torso and the legs, which may be systematically draped to provide a single form, or undraped to make two further forms linked to the torso. A languid left arm may stretch from one section of the form to another (*Signature*, Cat.S137), or may support the falling line of the torso of a reclining figure (*Man Leaning Back*, Cat.S161). In each case the rib cage of the figure is flattened. Made over the years 1959 and 1960, these twenty-nine recorded works in concrete represent an impressive and physically extremely demanding output. Wright referred later to 1960 as 'the Concrete Year'.[30] Compared for example with Frank Dobson's large classic concrete figures of the early 1950s, with their heavy limbs and strapping torsos, Wright's have a swooping grace and delicacy that defies the natural weight of the material.

The increase in scale of the concrete pieces was a consequence of Wright's growing interest in making sculpture to be shown out of doors. *Trio* was an early instance of this development, being followed by *Limbo* and the plaster

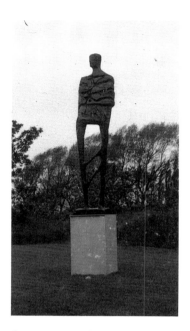

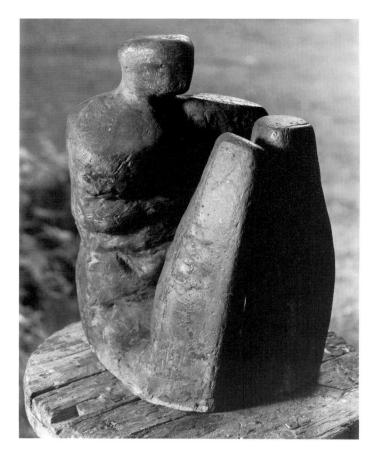

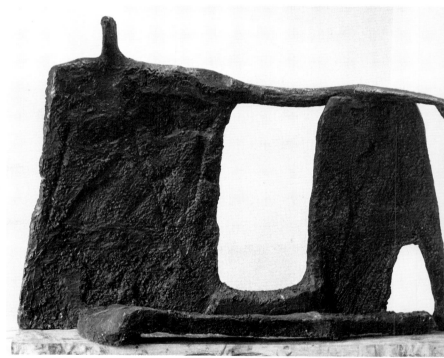

figure *Icarus* (Cat.S132), at over 8 feet high. The concrete sculptures, and *Icarus*, were first shown at Wakefield Art Gallery in the retrospective exhibition that Helen Kapp gave to Austin Wright in 1960. The new works were seen as an adventurous new direction for the artist, and excited the art critics of both *The Times* and *The Guardian*. The *Times* critic, David Thompson, suggested that Wright's sculpture needed to be seen in relation to the work of Moore and Armitage.

For like Moore and Armitage, Mr Wright is a humanist sculptor, but one more concerned with an anecdotal interest in people ... than with the more concentrated theme of the human body as a sculptural object. That is, until recently. For the inclusion in this exhibition of his latest work, which has yet to be seen in London, marks a development which is itself a parallel to Armitage's gradual abandonment of groups for single figures.[31]

David Thompson further hailed the concrete figures as

undoubtedly [Wright's] best work. ... He is excellent at imbuing the inorganic with a sense of life, animating his material with a gesture like the turn of a tiny knob-like head, or the arching away from the body of an arm or leg. ... These figures should much enhance his reputation when they have been more widely seen.

Curiously, and indeed sadly, the concrete figures were hardly ever seen again, and certainly not in London. Two, *Neptune* (Cat.S144) and *Shore Figure*, reached public collections, but most of the rest have disappeared or are destroyed. What played against them was their considerable weight, volume and fragility. Their presence at Wakefield, however, and the acclaim that they and the exhibition received, was undoubtedly a factor in encourag-

TOP LEFT fig.38 *Icarus* Plaster 1959 (Cat.S132)

TOP fig.39 *Squatter* Concrete, coloured (Cat.S141)

ABOVE fig.40 *Signature* Concrete 1959 (Cat.S137)

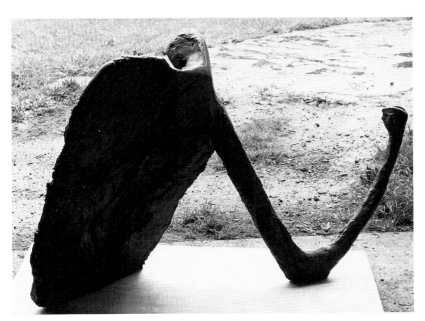

ing Quentin Bell, then Head of the Department of Fine Art at the University of Leeds, to invite Wright onto the short-list for the next round of the Gregory Fellowships in Sculpture while the Wakefield exhibition was still running.[32] The Gregory Fellowships had been founded in 1950 by the printer and publisher Eric Gregory, with the aim of enlarging the experience of students by bringing them into contact with practising artists. The artists — poets and musicians as well as painters and sculptors — won a generous stipend and the freedom to work in university surroundings for up to three years. The first three Gregory Fellows in Sculpture were Reg Butler (1950-3), Kenneth Armitage (1953-5) and Hubert Dalwood (1955-8). Eric Gregory had died in 1959, but his Fellowships were maintained by the University until 1970. Wright was appointed in February 1961 at a stipend of £700 p.a.

The Gregory Fellowship in Sculpture was the hinge of Austin Wright's career. It provided him not only, as was

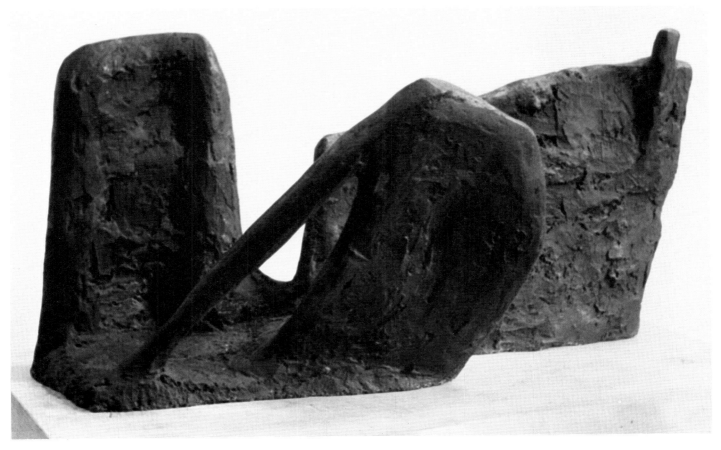

TOP fig.41 *Man Leaning Back* Concrete 1960 (Cat.S161)

ABOVE fig.42 *Neptune* Concrete 1959 (Cat.S144)

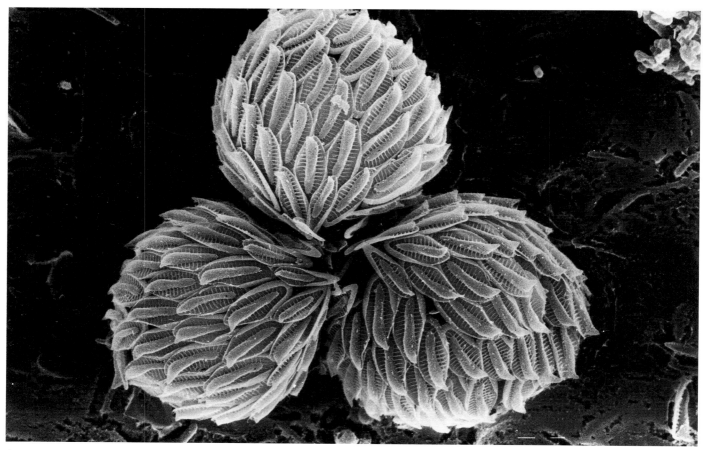

fig.43 *Synura petersenii*. A colonial golden brown alga. Scanning electron micro-photograph by Professor Irene Manton, University of Leeds, c.1967-8

intended, with the time and money he required to devote himself to making sculpture, but in addition it introduced him to staff and students of the University whom he would not normally have met, and to academic practices in an intellectual atmosphere that he did not have access to in his everyday life. The crucial change that took place in Wright's art during his Gregory Fellowship was one of material. The regular income that the Fellowship brought him enabled Wright to move from working in concrete and lead to casting in aluminium. This had at least six practical advantages. First, it allowed him to return to the making of maquettes in plaster on wire and metal armatures, rather than to the direct handling of heavy and messy concrete. Secondly, the extreme ductility of aluminium allowed him to create thinner, more apparently fragile forms, in which two larger sections might come together at a narrow joint. The ductility of the metal also enabled Wright to pick up the slightest nuance of the surface detail of the plaster. Having no surface texture of its own, unlike concrete, aluminium did not get in the way of the artist's intention. And finally, it was light to use and carry, and relatively cheap. Being released from the earthbound materials of lead and concrete was for Wright like being sprung into the air.

Wright had used aluminium at least once in the past, in 1950 when he made the pair of angels, *Experiments in Metal Forms*. Of the material, Wright recalled in 1993:

It egged me on. It was just *there*. I had no urge to do bronze – no real need like others. Aluminium has great lightness – incredible shadows and lightness. It projects its lightness. It speaks out to any form of light in the sky. Come out into the garden in any form of light, sunlight, moonlight, and it chirps out in a startling way.

The particular attraction of the material is perhaps enhanced for Wright himself by his partial colour blindness.

Aluminium has a very short history as a material for sculpture. It was first isolated by Hans Christian Ørsted in 1825, and introduced to the public at the 1855 Paris Exposition. One of the first sculptors to use it was Alfred Gilbert (1854-1934), in order to obtain the dramatic effect of polychromy in his Shaftesbury Memorial (1893) in Piccadilly Circus. The basin of the memorial, in bronze and copper, was topped by the figure of *Eros*, the first large sculpture to be cast in aluminium. Gilbert was later to use aluminium again in parts of the tomb of the Duke of Clarence in the Albert Memorial Chapel, Windsor Castle (1892-1928). Artists born in Britain in the twentieth century who have also used aluminium include Geoffrey Clarke, Hubert Dalwood, Peter Lanyon and Eduardo Paolozzi.

Early in his period as Gregory Fellow, Wright was invited to the University's Department of Botany where he met the Professor, Irene Manton. This meeting and the subsequent friendship, was to prove crucial to Wright's

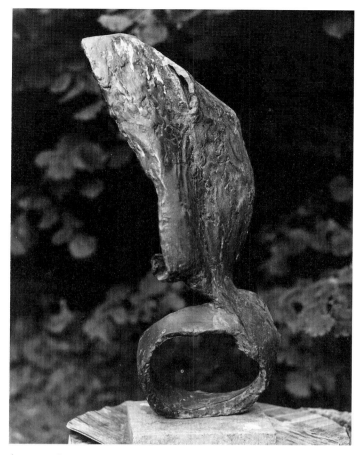

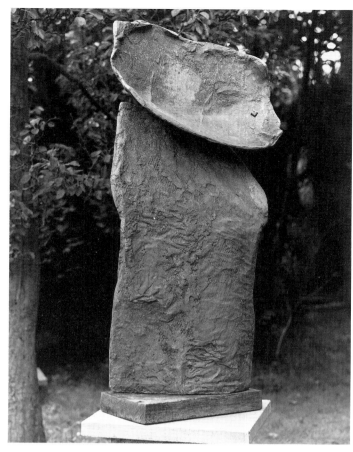

fig.44 *Bowling Torso* Bronze 1961 (Cat.S191)

fig.45 *Atlas* Aluminium 1961 (Cat.S193)

work. 'Meeting her was a piece of good fortune', Wright recalled. On the walls, corridors and stairwell of Botany House he found Manton's outstanding collection of paintings and prints by Chinese, European and British artists, including Picasso, Miró, Klee, Mondrian, Moore, and Terry Frost. Alongside the pictures, Manton had hung examples of electron micrographs of plant forms and their textures – the sperm of algae, mosses and ferns, or the molecular structure of part of a leaf – that she and her colleagues had taken in the course of their work. The importance of this meeting for Wright lay not only in his making friends with a woman of extraordinary intellect, breadth of vision and understanding, but also in the fact that through Manton's work the *interior* of plants were revealed to him. He was now able to see through and into a surface that to the innocent eye was opaque and a barrier to vision. The scale and verticality that Wright's new sculpture adopted came as a direct result of his seeing Manton's photographs, which magnified their subjects up to 300,000 times. Through them he was able to peer into the enormous depths of the body of a plant. Manton's influence on Wright was comparable to the influence that the greatly enlarged plant photographs of Karl Blossfeldt had had on the earlier generation of sculptors, Richard Bedford, Gertrude Hermes and Henry Moore.

The Gregory Fellows exhibition at Leeds City Art Gallery in 1962 gave Wright the opportunity to show thirty-four of the sculptures that he had made as a Fellow. Eighteen of these were large aluminium pieces, including *Atlas* (Cat.S193), *Observer* (Cat.S206), and *Moon* (Cat.S214). The exhibition was the first to be held in the newly created ground-floor gallery which, during the directorship of Robert Rowe, was isolated from the rest of the City Art Gallery and given over specifically to sculpture, with an anteroom for drawings.[33] The exhibition revealed a number of points about the development of Wright's sculpture. The presence of the group of eleven lead pieces, all made in 1961, demonstrated how Wright's movement away from a specifically descriptive interest in the human figure had begun in the artist's customary medium of lead. The titles of some of these pieces, for example *Twisting Torso* (Cat.S179) and *Threaded Spine* (Cat.S186), reveal their human root, and reveal too Wright's need to return to the security of an accustomed medium in order to develop new sources in his art.

Wright's concerns were moving away from living figures and towards an exploration of the process of decay, and the breaking down of human forms after death to the point at which they only just retain their initial strength as structures. Some studies in a sketchbook of 1961 (Cat.Sk41) are inscribed 'Body as a wall' and 'Bodies in the ground'. This reflects the development in Wright's thought

from his considering the human body as a person, to the body as a thing. The humanity and the interest in the neat anecdotal moment, as captured in *The Argument*, had given way by the early 1960s to a detachment that, over the succeeding years, became total. Wright's statement in the 1956 York exhibition catalogue, quoted above, in which violence abstracted from a nursery rhyme is explicit, is a sign of his professional concern for the strength of materials beginning to replace his feeling for the person.

Wright's interest in the strengths of structures is manifest also in his current preoccupation in his drawings with ancient ruins, such as those near York at Fountains and Rievaulx, where time has worn away the skin and returned the ribs and columns to a state comparable to the buildings' appearance during construction. The change also showed itself in the way that objects that had originally meant little to him, recurrent natural forms, suddenly

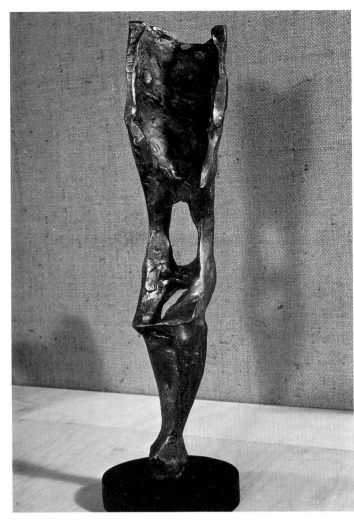

RIGHT fig.46 *Twisting Torso* Lead 1961 (Cat.S179)

BELOW fig.47 *Threaded Spine* Lead 1961 (Cat.S186)

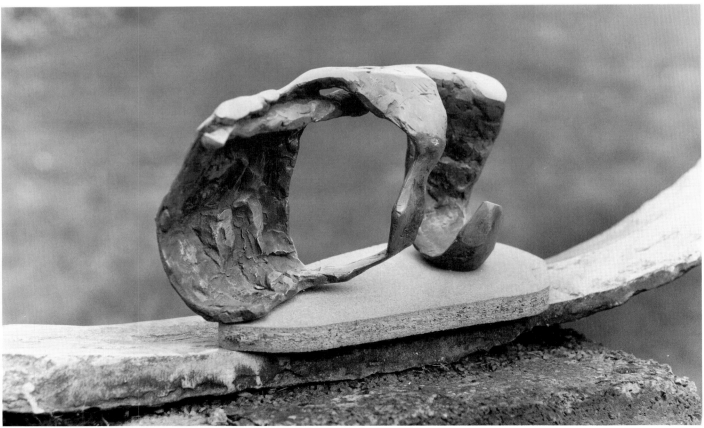

attained a significance. Speaking to *Yorkshire Life* in 1964, Wright described how his barn was bedecked with dead things – tree roots, pieces of bark, animal skins and dried rhubarb leaves: 'These things I have been seeing for years. Suddenly they began to have a relevance. Now I cannot go out without bringing something home.'[34] In an illuminating photograph in the *Yorkshire Life* article, Wright is seen holding a withered rhubarb leaf and a piece of wood shaped like an animal's skull against the textured surface of one of his aluminium sculptures. This work had been cast with tree-bark and aerial photographs in mind.

Aluminium allowed the scale of Wright's work to take a quantum leap. *Moon* is 10 feet high; *Tower 1* (Cat.S213) nearly 8 feet. They reflect not only growth in nature, but also, more specifically, Wright's interest in the variety and grandeur of cliff and rock formations. Family summer holidays in the late 1950s were spent in Cornwall and in the early 1960s at Angle, on the Pembrokeshire coast, where rocky outcrops jut directly out of the sand around a closely curving bay. Wright made many conté drawings inspired not only by coastal rock shapes and textures, but also by continually evolving cloudscapes over the sea. Wright first developed these natural inexhaustible forms in terms of his sculpture in the concrete slab figures and later in the aluminium works. *Split Back* (Cat.S232) for example was inspired by Huntsman's Leap, a crevice of rock on the South Wales coast across which a huntsman tried to jump and, according to local legend, fell to his death on the rocks below. Wright, who remembers hanging out over the edge of the precipice to experience the extent of the cleft of rock, has turned the Leap through 90 degrees to make a vertical sculpture. Yorkshire landscapes also gave Wright the springboards he needed for his art. *Atlas*, a massive lower form supporting a scoop-like upper, was prompted by one particular moment on the North Yorkshire Moors when Wright witnessed a cloud climbing upwards over a hillside. 'Cloud and hill sucked at each other', he recalled, 'and each drained a bit from the other.'

The common thread running through these sculptures is that they consist, predominantly, of two sections meeting at a pelvis-like joint. One section may be a solid rectangular, though characteristically flat, element, and the other a ring or arch. Wright's sketchbook drawings illustrate the genesis of his ideas for sculpture. In the sketches he quickly runs through variations on themes in which landscape forms are played off against the forms of bones, plants or clouds. The rough surface textures, enlivened by the marks left in the aluminium by the expanded metal armature, are juxtaposed with highly polished areas which

Wright has abraided with an electric buffer. These are tough, masculine, even disturbing works, which give the appearance of having been Wright's opponents in the wrestling out of a form, rather than companions in a smoothly inevitable creative process. They are also, as Anthony Tucker observed in his *Guardian* review of Wright's 1962 Leeds exhibition, seemingly aware of the viewer.[35]

The quality of animus in Wright's sculpture, its living spirit, is a product of its inescapable relationship with the human figure in its primeval, rotting state; the ghost of a dryad watching from behind a tree or the menacing satyr lurking in the undergrowth. The watchfulness – it is a quality strongest in the vertical sculptures – is compounded by Wright's development of a characteristic flourish to the upper section, whether it be the leafhead or eponymous crescent moon in *Moon*, or the cleft claw-like section at the upper tip of *Tower 1*. This is a development from the vestigial heads of some of Wright's sculpture of the 1950s, and has parallels both in medieval crests on knights' helms, and in the design of watch-towers or radar masts where the 'eye' is at the highest point. In later sculptures, such as *Corona* (Cat.S231), which was inspired by a press photograph of a solar flare, the upper flourish has a more literal, decorative function.

Another common feature in Wright's sculpture of his Gregory Fellowship period is that however large a piece may be it is generally relatively flat, even two-dimensional. Wright's sculptures of this period have area, not volume. This drew criticism from Eric Newton, reviewing Wright's exhibition at the Rowan Gallery in London in 1964. Wright, he believed,

has a weakness. It is his obsession with what sculptors call 'frontality'. However inventive he may be, he has never asked the spectator to walk round his sculptures. There is always one point of view from which they could be more easily read. Move round them to one side or another; still worse, look at them from the back (they all have a back) and they lose their impact.[36]

Newton's criticism presupposes that sculpture must necessarily have an assertive bulk and occupy space. Though Wright's 'flat' sculpture does have a dominant viewpoint, other aspects have fascinations of their own. *Armour* (Cat.S207) is, from the side, a threatening wall of beaten metal, a castle curtain wall, a rocky emplacement. From the edge, however, it becomes vulnerable, violable, like the entrance to a sea-cave or to the petals of a flower that will admit a pollenating insect. *Atlas*, too, has a powerful, dominating presence like a fortification or a soldier-in-arms when seen from the front. From the side, on the other hand,

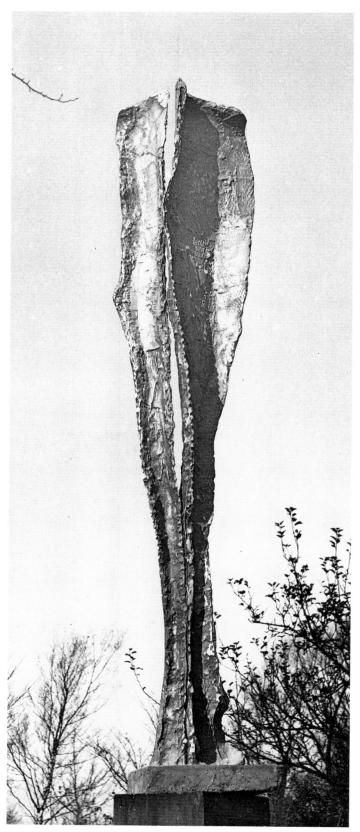

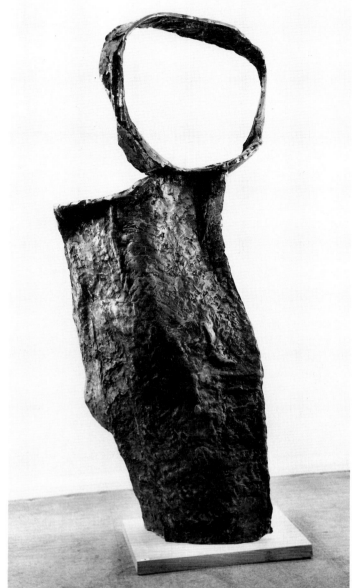

LEFT fig.48 *Split Back* Aluminium 1964 (Cat.S232)

fig.49 *Observer* Aluminium 1962 (Cat.S206)

it too becomes fragile, stalk-like and ephemeral like a poppy. Both of these works suggest parallels with human-kind: as Wright's sculpture suggests, we are all an amalgam of the strong and the weak. Being concerned with surface and area rather than volume, Wright's sculpture is akin to relief, a quality that was noted in a number of architectural schemes that Wright was involved in during the 1960s and 1970s in Hull, Leeds and Newcastle (see Cats S121-S122, S258-S259, S322).

There was an urgency in the work in Wright's Gregory Fellowship exhibition that, in retrospect, marked his passage from the beginnings of his career to his period of mature flowering. The creak that might have been audible after dark in the silent Leeds City Art Gallery would have been 'the force that through the green fuse drives the

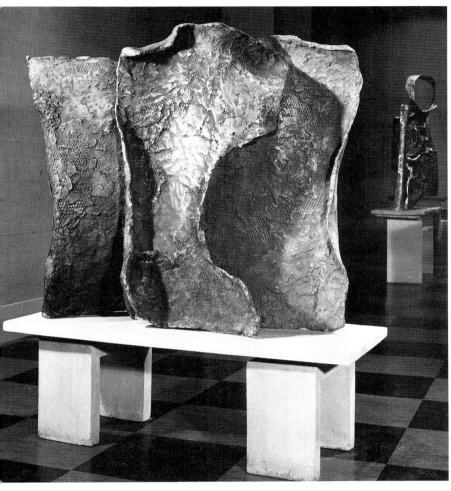

fig.50 *Armour* Aluminium 1962 (Cat.S207)

flower'. The exhibition demonstrated the renewal of the energy that was abundant in Wright's early wood carvings, but which had directed itself in a different way in his lead and concrete figures of the 1950s. This return to the urge for growth and verticality is evidence of the integration of Wright's work as he progresses through his career, and approaches at different periods in his life the universal themes in nature that have had such an abundance for him.

By now Wright was in his early fifties, the age at which Moore had been honoured with a European touring exhibition by the British Council, and Hepworth by a major retrospective exhibition at the Whitechapel Art Gallery. Indeed, he was in his fiftieth year when Quentin Bell, inviting Wright onto the short-list for the Gregory Fellowship, outlined the main object of the Fellowship being to 'allow

young [*sic*] artists to develop their talent ...'.[37] He was, however, now attracting a committed following of collectors. One in particular, the economist Philip Andrews, Fellow of Nuffield College, Oxford, discovered Wright's work at the Zwemmer Gallery in the 1950s, where he bought a group of lead figures. Subsequently, Andrews regularly sought out Wright's exhibitions, and from the Gregory Fellows exhibition he bought *Rolling Torso* (Cat.S188) and *Hook Torso* (Cat.S199). Of the latter, Andrews wrote revealingly:

It is an impressive figure. I like the detail of its surfacing enormously. There is a wonderful mountain pass high up between the two blades. I did not really appreciate before that the hook had so many echoes of a rib cage in its lower surface. ... Hook Torso really is a big figure in both senses of the word.[38]

The subtle duality that Andrews identifies is a constant theme in Wright's sculpture, its point and its counterpoint. It is echoed in the artist's exploration of the two-part subjects based on the human body which have characteristically been head and shoulders, and pelvis-ring and torso. The head shrank in importance in Wright's sculpture of the 1950s, and likewise in the 1960s the presence of the pelvis modulated to the point where it became synonymous in *Habitat* (Cat.S239) or *Greeting* (Cat.S256) with an eye or the central seed pod of a flower. The formal relationship between the ring and the torso in, for example, *Bowling Torso* (Cat.S191) and *Ring and Wall* (Cat.S229) is varied by Wright to an extreme in *Big Leaves* (Cat.S211) and *Husk* (Cat.S236) where the ring is reduced to nothing, or to a vestigial state only. This movement and change, which ripples through Wright's *œuvre*, has itself an organic quality that ensures the constant vitality of Wright's sculpture. The development also has a root in changes in Wright's technique. *Habitat* was the first sculpture he made using argon arc welding, a method in which temperatures in excess of 6000°C allow two pieces of aluminium to be joined together at 'an absolute minimal point, like a sewing tack', as Wright himself put it. In using this method in later sculptures such as *Main Road* (Cat.S275) and *Neigwl* (Cat.S295), Wright was able to achieve a combination of great height and extreme delicacy of form.

A shift of emphasis from the human body to plant forms as a primary source for Wright occurs at this time. The pelvis-ring becomes a flower head in *Ring Flower* (Cat.S200); an uncurling plant form in *Frond* (Cat.S225; amended by artist in the 1980s); and a bulb or tuber in *Flowering Torso* (Cat.S195). Where in the 1950s the titles of Wright's sculpture involved words like 'Swimmer', 'Figure', 'Bather' and 'Reader', all indicating their human

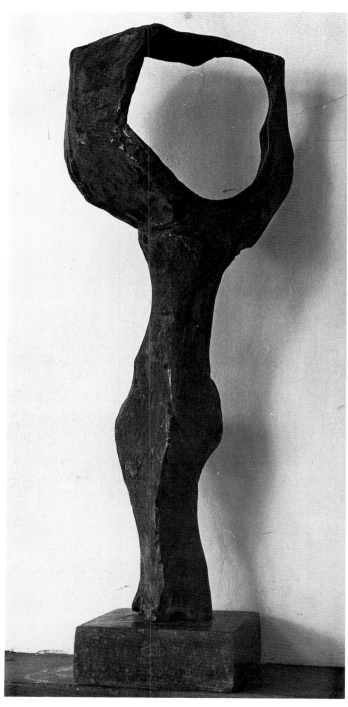

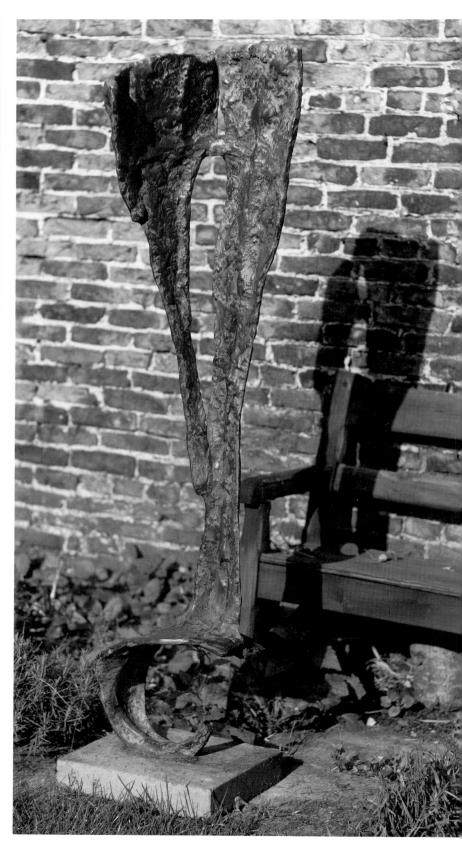

fig.51 *Ring Flower* Bronze 1962 (Cat.S200)

ABOVE RIGHT fig.52 *Hook Torso* Bronze 1962 (Cat.S199)

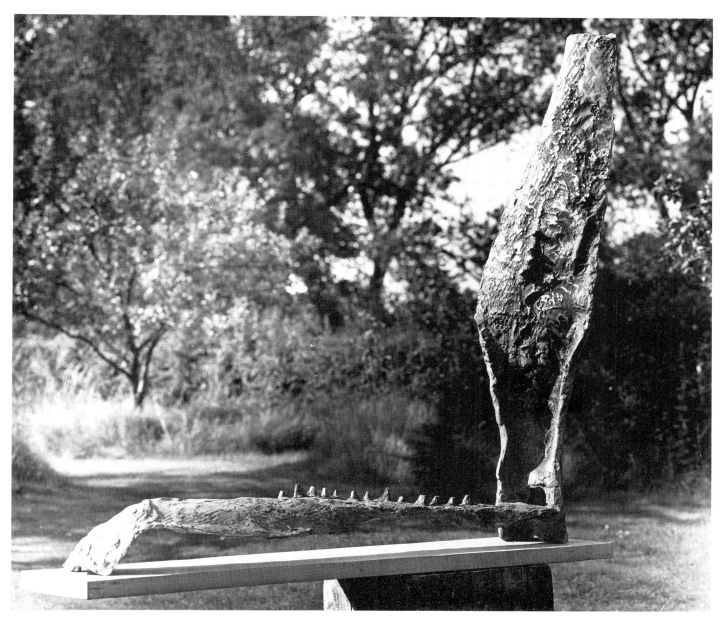

fig.53 *Entrance* Aluminium 1962 (Cat.S203)

connections, by the mid-1960s the dominance had shifted to plant words, such as 'Leaves', 'Stalk', 'Frond' and 'Flower'. With this change came a move to staccato, single-word titles, lacking a definite or indefinite article, as opposed to the descriptive or anecdotal titles of the 1950s: *Torque, Graft, Relic, Bow, Stalk, Frond, Project* follow each other in sequence through the catalogue raisonné in 1963 like children in a skipping game. If this is a sign of Wright making sculpture in which each piece is a self-contained, complex and nameable *thing*, it is also a general trend among sculptors of the day. The catalogue of the 1963 LCC Battersea Park Sculpture in the Open Air exhibition lists *Monitor* (Armitage), *Mid-day* (Caro) *Boltedflat* (Hoskin) and *Crucifix* (Kneale).

The titles Wright gives to his sculpture, and indeed their form, may also refer to external influences. The piece that came to be called *Wound* (Cat.S227), with its armour-plate walls and ragged gaping hole, was being made by Wright when news of the assassination of President Kennedy came through. *Bow* (Cat.S223), a majestic curved piece in five

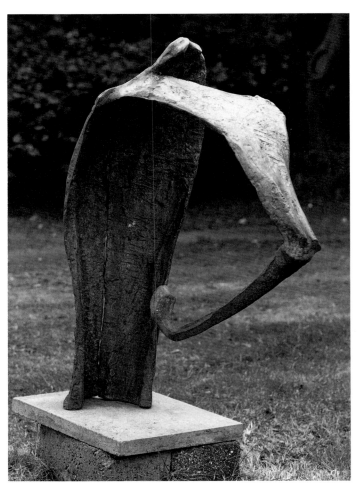

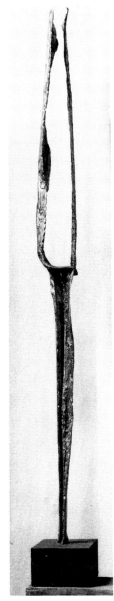

fig.54 *Frond* Aluminium 1963 (Cat.S225)

ABOVE fig.55 *Husk* Aluminium 1964 (Cat.S236)

OPPOSITE fig.56 *Big Leaves* Aluminium 1962 (Cat.S211)

sections was made as a sculptural analogy of a Bartok string quartet in 5:8 time. To Wright music has been a constant source of relaxation, pleasure and inspiration:

A day never passes without his picking up and playing his viola. If it can be arranged, string quartet playing is perhaps his greatest love, but taking part annually in the Palm Sunday Bach passions in York Minster has meant a tremendous lot to him for over 25 years. He has got to know many of the great orchestral works through playing them in amateur orchestras, never having been a listener to records or tapes.[39]

As the 1960s progressed, surface texture in Wright's sculpture began increasingly to become marginalised. The tactile quality of the plaster model reproduced and honed in the aluminium sculptures exhibited in the Gregory Fellows exhibition, gave way to a sleeker finish, and to the artist's more subtle variation of surface planes. He remarked later: 'I only regard texture as frankly the stuff of making.'[40] This

process was gradual, and developed with Wright's growing interest in the sculptural possibilities of commercial aluminium section and treadplate, and of the assemblage of forms in place of modelling. In part this was an inevitable process. Wright's cast aluminium slabs were becoming thinner and thinner in the early years of the decade – *Armour* (Cat.S207) and *Guillotine* (Cat.S228) – so it was a natural step when area, as opposed to volume, became suggested by cut and shaped aluminium sheet in *Phase* (Cat.S252) and *Newton Wonder* (Cat.S254).

This trend towards thinness of form is paralleled at this time by Wright's tendency increasingly to make sculpture which has only a very slight physical existence. The introduction of argon arc welding became one of the enabling factors in this development. *Juggler* (Cat.S244) and particularly *Ring* (Cat.S243) derive their power from the space that they articulate and surround, rather than the space that

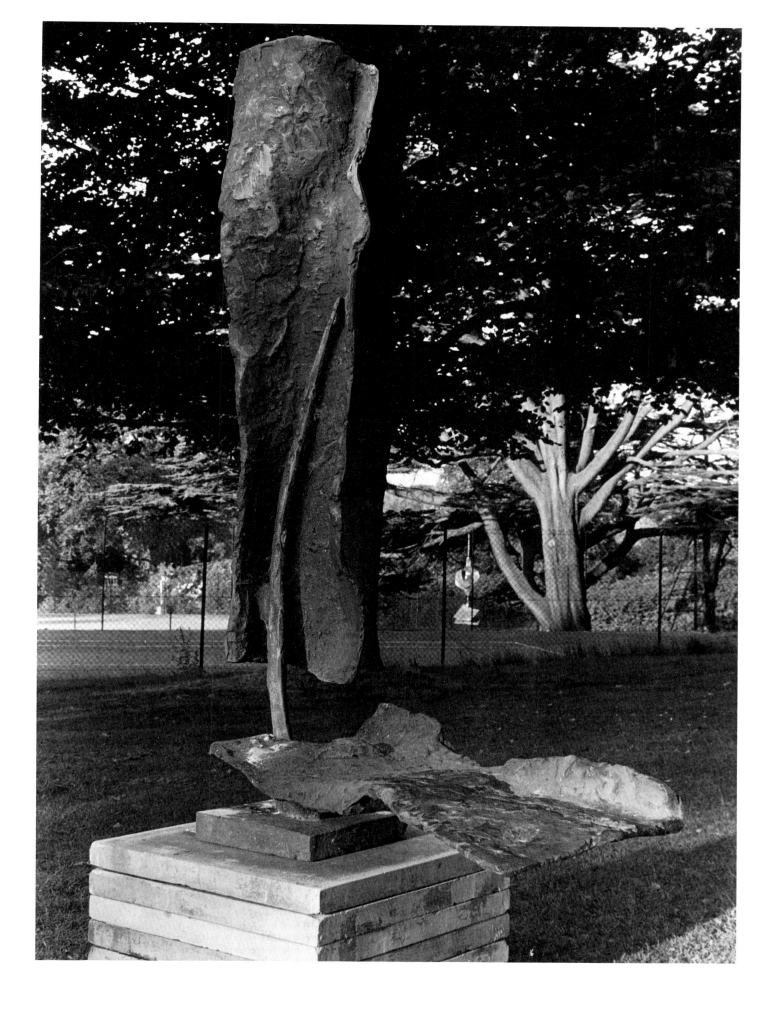

BELOW fig.57 *Bow* Aluminium 1963 (Cat.S223)

RIGHT fig.58 *Scoop* Aluminium 1962 (Cat.S215)

OPPOSITE TOP LEFT fig.59 *Wound* Aluminium 1963 (Cat.S227)

OPPOSITE TOP RIGHT fig.60 *Guillotine* Aluminium 1963 (Cat.S228)

OPPOSITE BOTTOM fig.61 *Ring and Wall* Aluminium 1964 (Cat.S229)

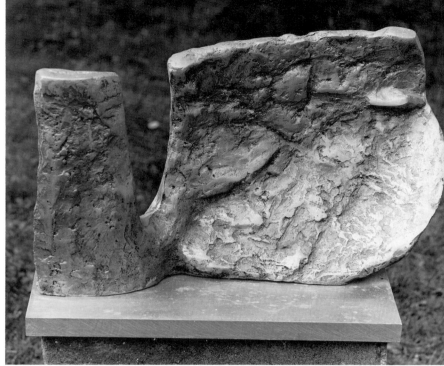

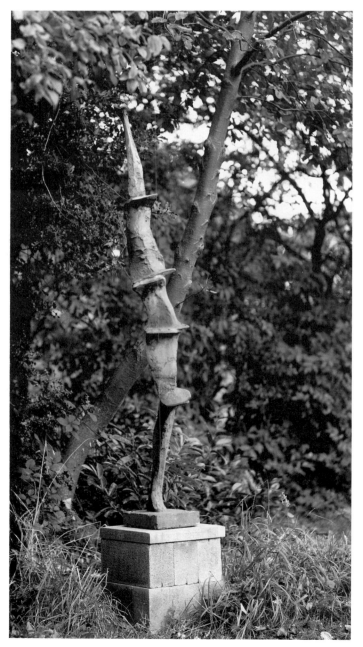

they themselves occupy. *Ring*, indeed, is a sculpture of a gesture, the windmilling of his arms and the whoop of joy which Wright emitted when he heard the news that a New York collector had just bought *Observer* (Cat.S206) from the Contemporary Art Society exhibition *British Sculpture in the Sixties* held at the Tate Gallery. So delicate, so fleeting is *Ring*, that, like a soap-bubble or the gesture that Wright spontaneously flung out, it almost is not there. *Ring* is one of a considered group of sculptures of the 1960s and 1970s in which Wright created what can accurately be described as the apotheosis of the pelvis. In *Four Rings* (Cat.S246), *Overture* (Cat.S286) and *Two Rings* (Cat.S312, originally sited on Roppa Moor, above Helmsley, North Yorkshire; now vandalised), the circle has completely digested the slab form that had accompanied it in earlier sculpture.

The creation of *Two Rings*, discussed further below, was prompted during a walk Wright took in the mid-1970s above Roppa Plantation, on land owned by Lord Feversham. Landscape, particularly the landscape of North and West Yorkshire and Wales, and the clouds floating above them, has had a deep and engrained importance for Austin Wright from the early days in which he painted on Welsh coastal hills. He has always carried a sketchbook wherever he walks, and fills these with rapid, open line landscape studies. These help him to resolve the light and airy sculp-

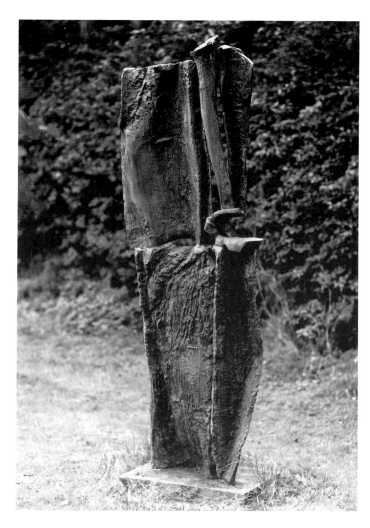

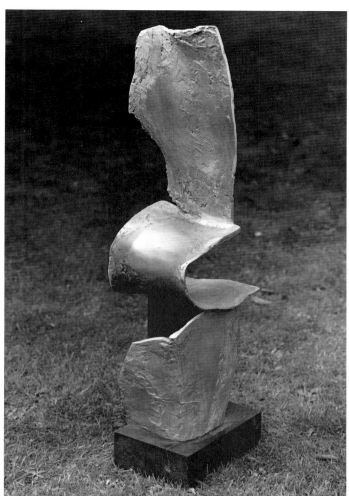

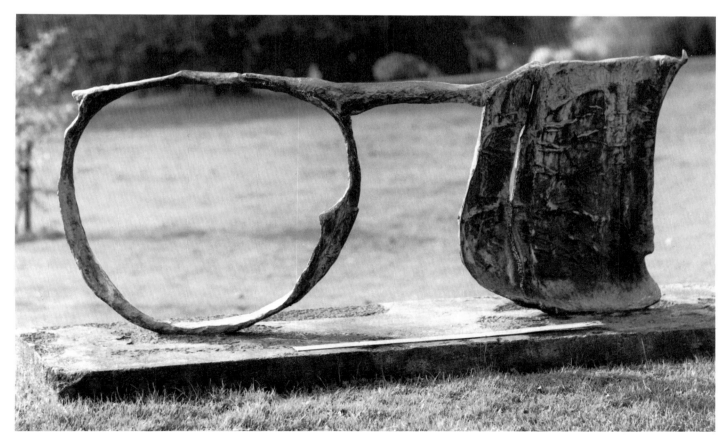

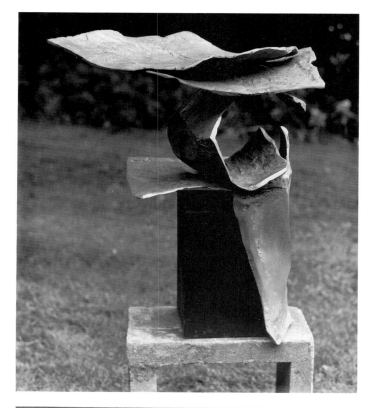

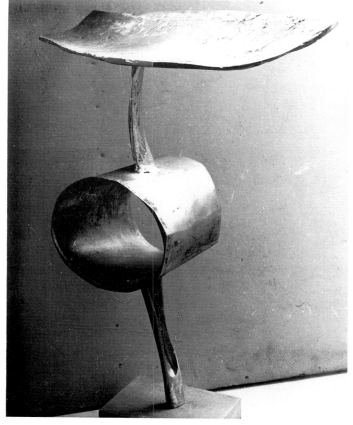

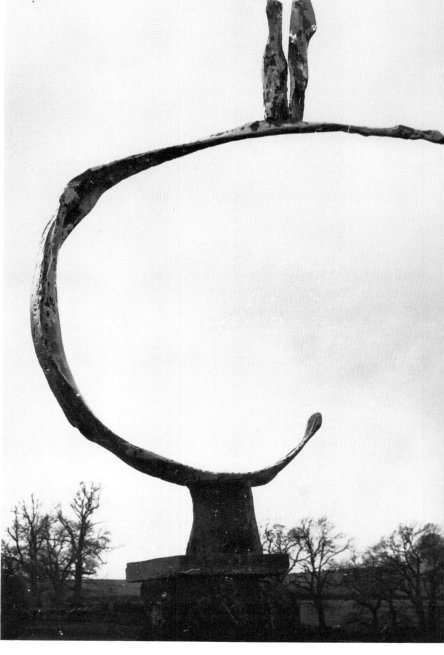

ABOVE LEFT fig.62 *Habitat* Aluminium 1964 (Cat.S239)

LEFT fig.63 *Sign* Aluminium 1965 (Cat.S241)

ABOVE fig.64 *Corona* Aluminium 1964 (Cat.S231)

ture which takes the extended lines of landscape as its sub-
ject. *Main Road*, with its graphic representation of road and
roundabouts, is one of the earlier and purer pieces of
Wright's landscape sculpture, and refers as much to a road
map as to an actual landscape. *Neigwl* is, like *Split Back*
referred to earlier, a landscape turned sideways, specifically
a rendering of the land above Porth Neigwl (Hell's Mouth)
at the tip of the Lleyn Peninsular in North Wales. Another
related work is *Sarn* (Cat.S290), a hanging construction of
aluminium section and piano wire inspired by a landscape

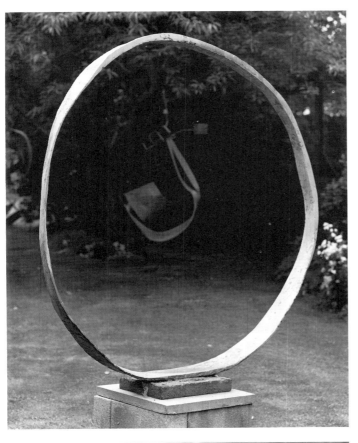

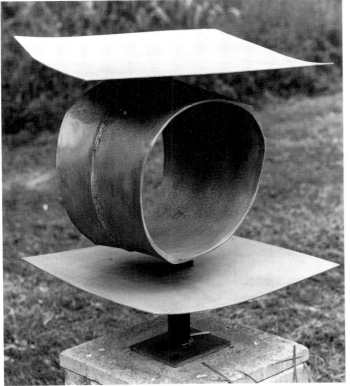

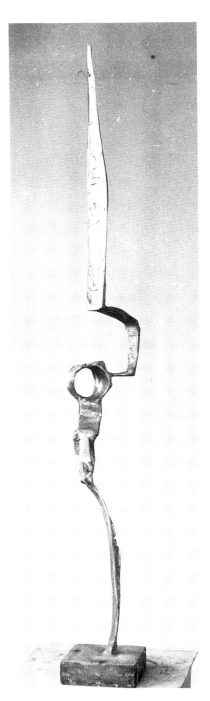

ABOVE LEFT fig.65 *Ring* Aluminium 1965 - 69 (Cat.S243)

LEFT fig.66 *Phase* Aluminium 1967 (Cat.S252)

ABOVE fig.67 *Juggler* Aluminium 1965 (one element of *Juggler and Trick*, Cat.S244)

near Neigwl. The piano wire has a specific narrative as well as structural intent, being a suggestion of the electrical and telephone wires that string the landscape together. The iconographic roots of Wright's landscape sculptures, made after holidays in North Wales with his family and old friends, lie in a fruitful combination of the art of the eighteenth- and early nineteenth-century map-maker and the drawings of Miró and Klee. The map-maker's representation of the long journey between, for example, London and York might take the form of the extended string of

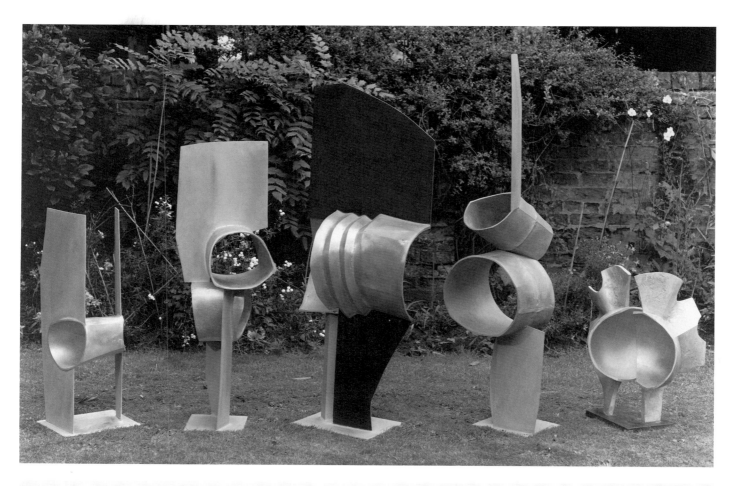

TOP fig.68 left to right: *Conoid* 1968 (Cat.S270); *Spondee* 1968 (Cat.S269); *Newton Wonder* 1967 (Cat.S254); *Eclipse* 1967 (Cat.S253); *Pair Impair* 1968 (Cat.S265) Aluminium

ABOVE fig.69 *Relief model of Leeds City Art Gallery Façade, incorporating idea for relief sculpture* Wood and aluminium 1967 - 68 (Cat.S259)

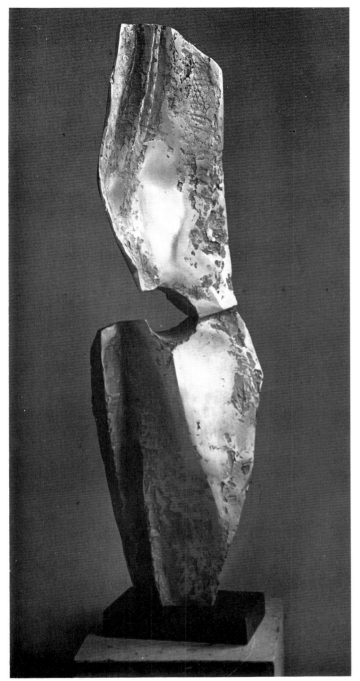

fig.70 *Greeting* Aluminium 1967 (Cat.S256)

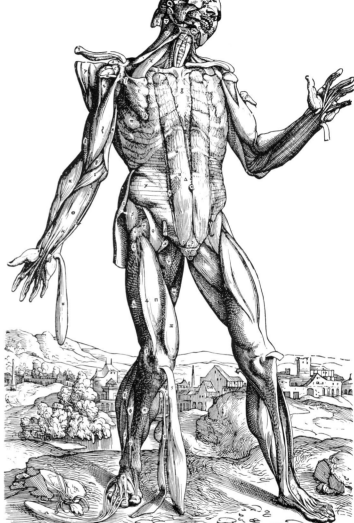

fig.71 Plate V from *De Humani Corporis Fabrica* (1543) by Andreas Vesalius

the Great North Road interrupted at intervals by towns and turnpikes; while the drawings of Miró and of Klee, who wrote of 'taking a line for a walk', reflect the animated body language that Wright adopts as he speaks.

During the first few years of the 1970s, Wright explored the wide potential of hanging sculpture. On the wall of his workshop groups of redundant farming implements had hung rusting for years. The determined shapes of these objects had already given him ideas for sculpture, such as *Balancer* (Cat.S187) and *Scoop* (Cat.S215). These ideas were quickened when Wright found a reprinted copy of *De Humani Corporis Fabrica* (1543), the illustrated treatise by

the sixteenth-century anatomist Andreas Vesalius. He was prompted to interpret the engravings of flayed corpses in Vesalius in sculptural terms, in *Ikones* (Cat.S281), *Butcher* (Cat.S300) and *Anatomists* (Cat.S293). See also Cat.Sk50.

The most ambitious of Wright's hanging sculptures are *Obst* (Cat.S299; German for 'Fruit') and *Aquarius* (Cat.S298) which have, since they were made in 1973, hung from the branches of the cherry tree in Wright's garden. *Aquarius* carries, cut into one of its flanges, a 'drawing' which at one level is a piece of Miró-like surface decoration, but which at another is a graphic instruction as to how the piece should be assembled when Wright himself is no longer

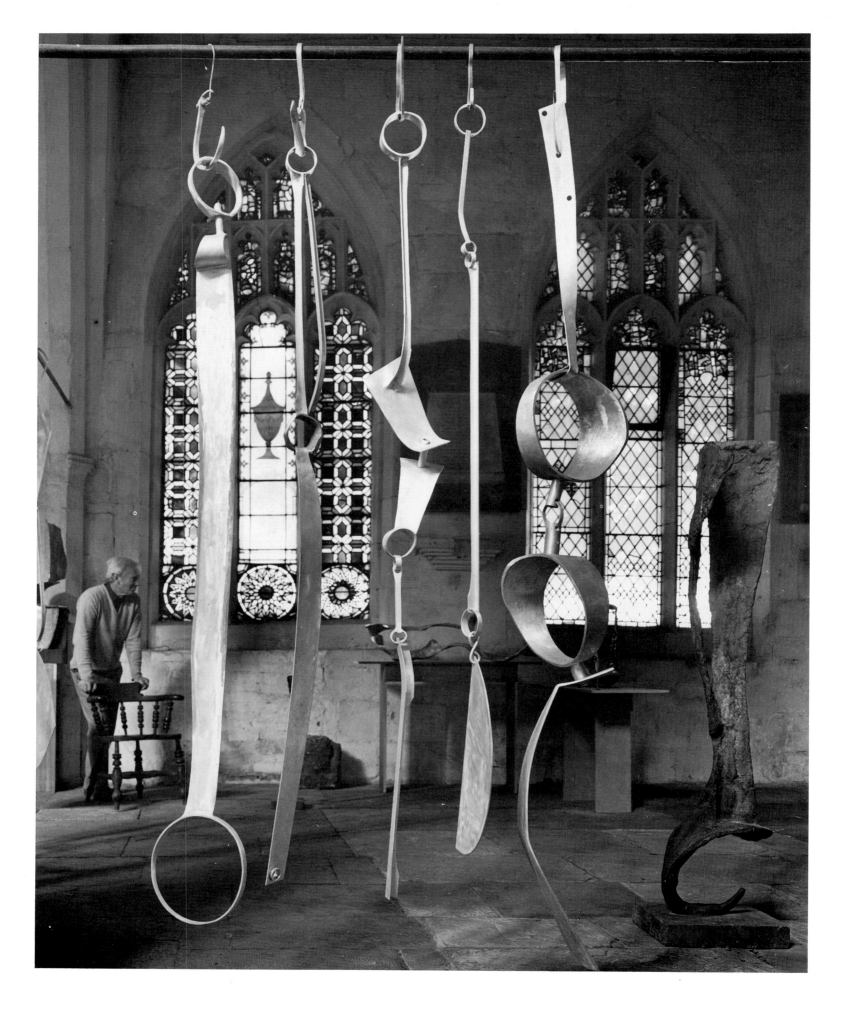

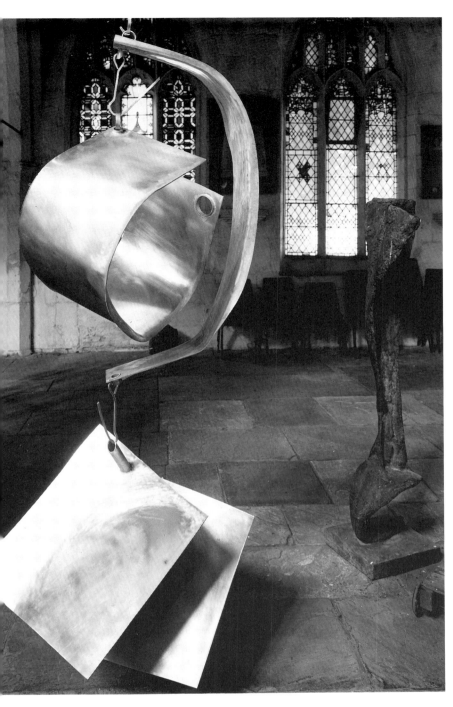

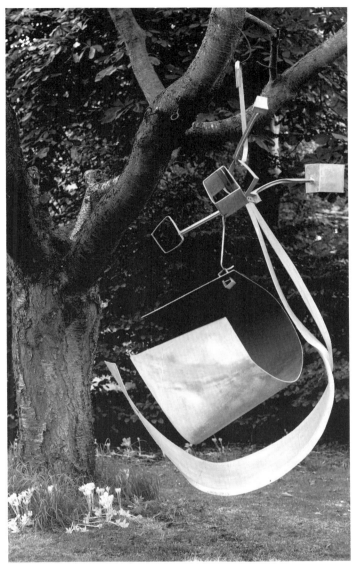

OPPOSITE fig.72 *Ikones* Aluminium 1970 (Cat.S281)
The artist is standing to the left

ABOVE LEFT fig.73 *Obst* Aluminium 1973 (Cat.S299)

ABOVE fig.74 *Aquarius* Aluminium 1973 (Cat.S298)

around to do it. This pair of voluminous objects, which hang at human level, shoulder to shoulder with the viewer, articulate and enlarge the space consumed by the tree, and together tree and sculpture create an environment being truly, 'sculpture in which one is'. When his *Cherry Tree* suite of lithographs and related drawings were exhibited at the Park Square Gallery in Leeds in 1976, Wright described what, to him, a tree is:

A tree is a prime sculptural form – developing freely in space, air from an approximate centre – a volume of air held aloft. ... Within there is a continuous circulation – each bit of structure feels for its own space

– as between horizontal and vertical, keeping the relaxed balance. Air is created in the structure. It must breathe.

During the course of the 1970s, Wright received two commissions to make major pieces of sculpture for outdoor sites in Yorkshire. The scale of the proposed works, their status and high public profile, reflected not only the esteem in which Wright's art was held, but in addition they reflected their commissioners' confidence in Wright as a sculptor who could work in large forms, in exposed sites, and to time and budget. Although it is perhaps to be regretted that these works were both enclosed within Yorkshire, and

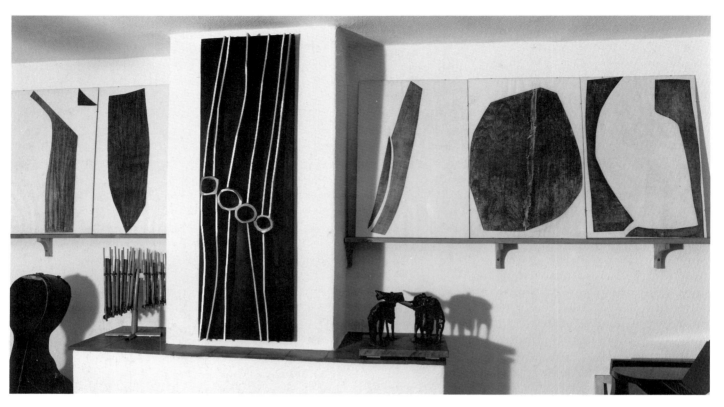

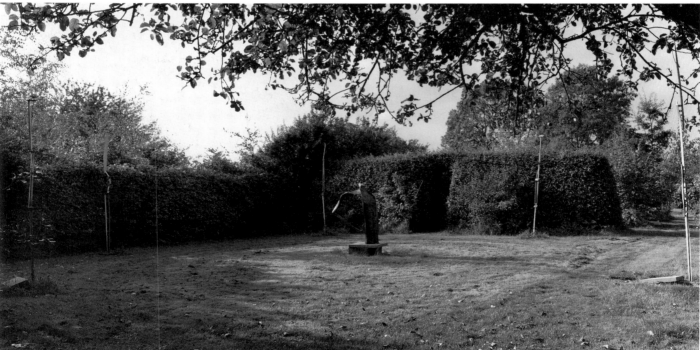

TOP fig.75 *Wallscape* Aluminium on painted wood 1968 (Cat.S272). The work is shown hanging in Wright's Music Room at Upper Poppleton. Proofs of the wood rubbing series *Forest* (CatsP1-9) hang alongside

ABOVE fig.76 *Botanical Garden* Aluminium 1973 (Cat.S294) sited in Wright's garden, 1993

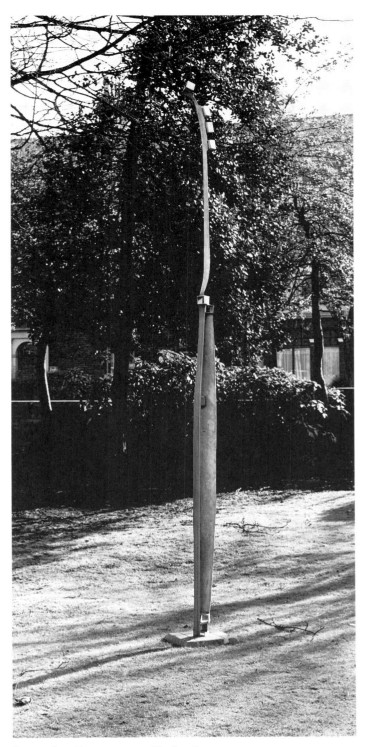

fig.77 *Cilan* Aluminium 1973 (Cat.S296)

fig.78 *Riffli* Aluminium 1974 (Cat.S309)

so did not immediately take Wright's reputation far out into the wider world, it is certain that this minor obstacle to recognition would have been overcome in time. What is to be more deeply mourned, however, is the tragedy that both of these works have now been destroyed.

Wright's *Two Rings* was installed on Roppa Moor above Helmsley in 1977 after victory had been won in a bitterly fought campaign for the planning permission sought by Yorkshire Arts Association. The proposal, which was prominently debated in the *Yorkshire Post* in 1975 and 1977,

came forward after Lord Feversham had given his unyielding support to Wright's desire to place two 8 feet high adjacent circular forms in the landscape. The sculpture is a direct development of Wright's work with the basic organic structures of the human body – the pelvis, the eye socket, the open mouth – and in this remote spot its further parallels with the forms of boulders and ring-stones became clear and appropriate. Before it was mutilated in 1989, Wright's sculpture was a subtle and courteous response to a grand landscape, a frame and an articulation to the

panoramic view in which it had alighted. Its reticence, and indeed its kinship with the forms of gesturing hands was underlined by Margaret Read, the widow of Sir Herbert Read, in a letter to the *Yorkshire Post* published shortly after the work had been installed:

The problem of placing a man-made object on a spectacular site is that it must not compete. A Henry Moore Woman Mountain or a Barbara Hepworth Walkthrough Monument would be too much. This work is a commentary in rough aluminium, the gesture that a painter or photographer makes when he frames with his hands the limit of the selected vision. If it is not too fanciful I would say that it reminds me of the Dürer *Praying Hands*. It is man's affirmation of Nature.[41]

The joyful echoing forms in *Two Rings* have their roots in two related strands of Wright's art. One is that represented by his equally joyous and gestural *Ring* of 1965-9, while the other lies in his exploration of Japanese calligraphic shapes in a series of pen and brush drawings first exhibited

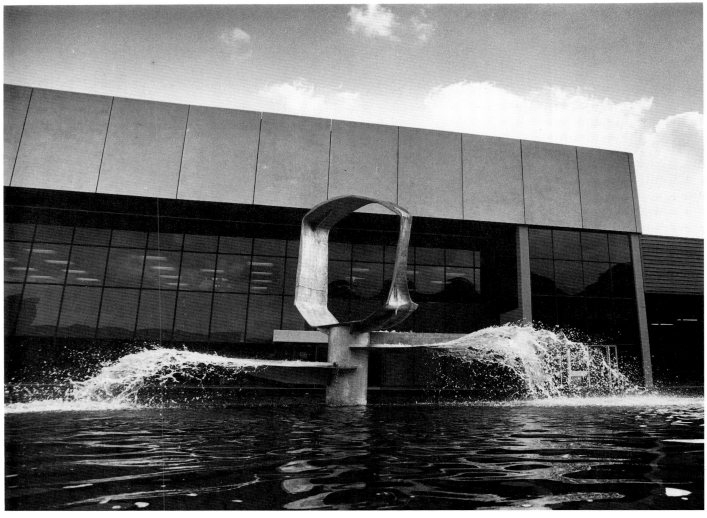

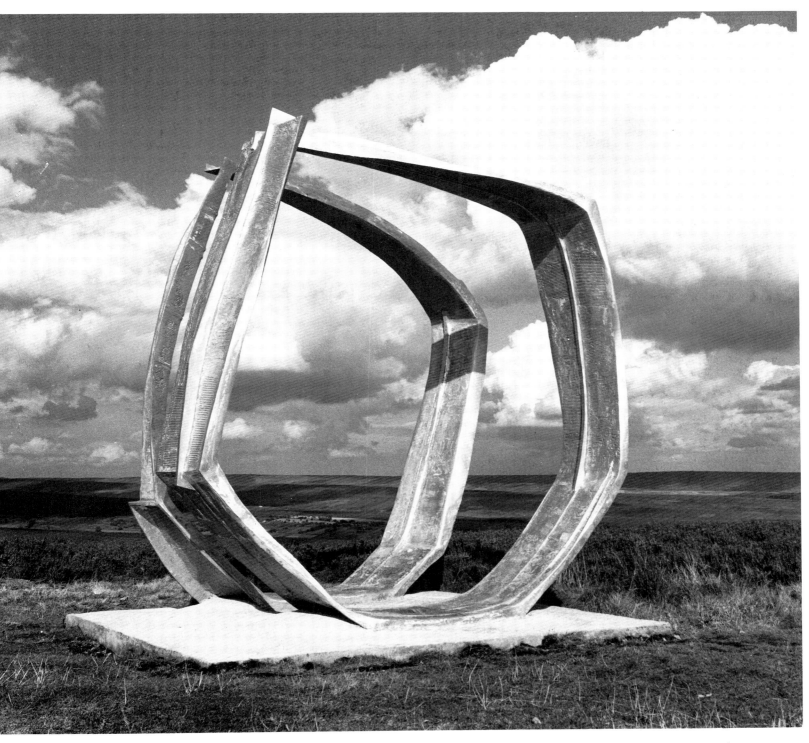

OPPOSITE TOP fig.79 *Maquette for North Yorkshire Moors Sculpture* Aluminium 1975 (Cat.S311)

OPPOSITE BOTTOM fig.80 *Fountain* Aluminium, at E. J. Arnold, Hunslet, Leeds 1978-9 (Cat.S315). Destroyed

ABOVE fig.81 *Two Rings – Sculpture on the Moors*, Roppa Bank, Helmsley. Destroyed (Cat.S312)

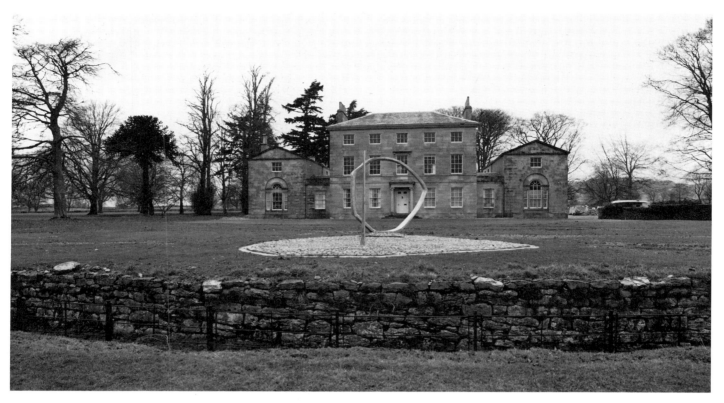

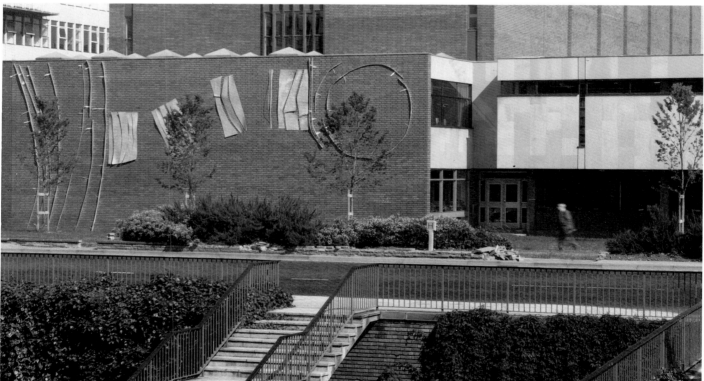

TOP fig.82 *Sundial* Aluminium on gravel, at Broughton Hall, nr Cartmel 1976-9 (Cat.S313). Destroyed

ABOVE fig.83 *Wall Relief at the University of Northumbria* Aluminium and steel 1981 (Cat.S322)

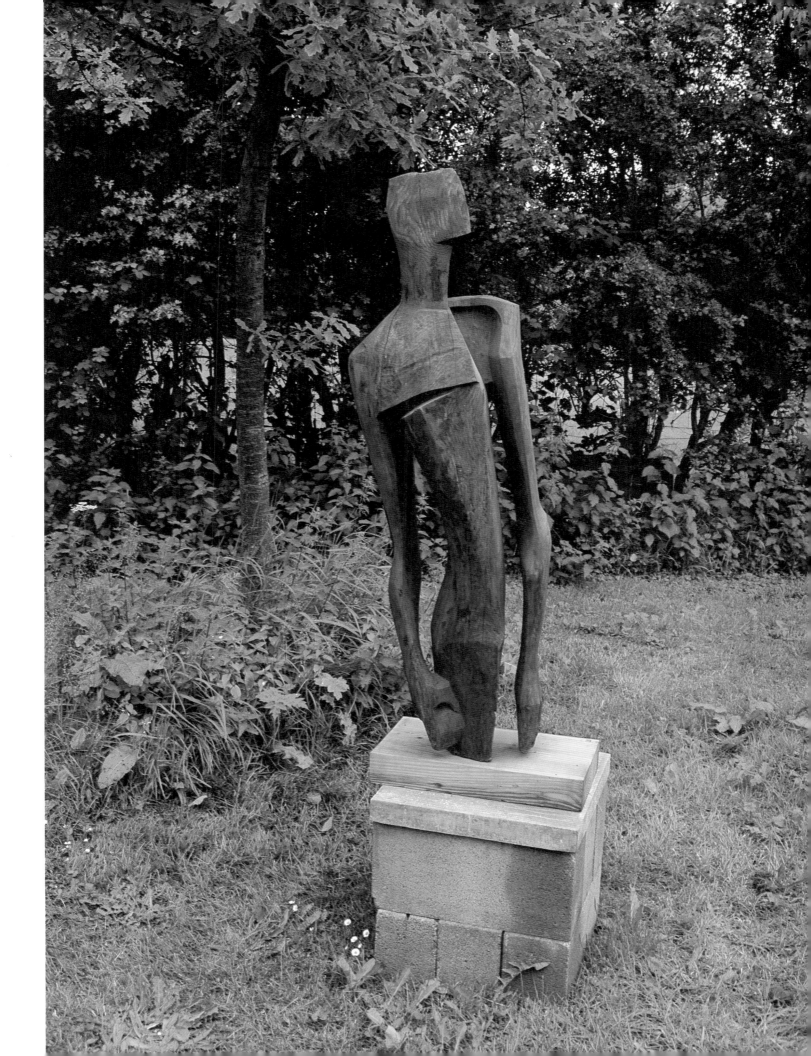

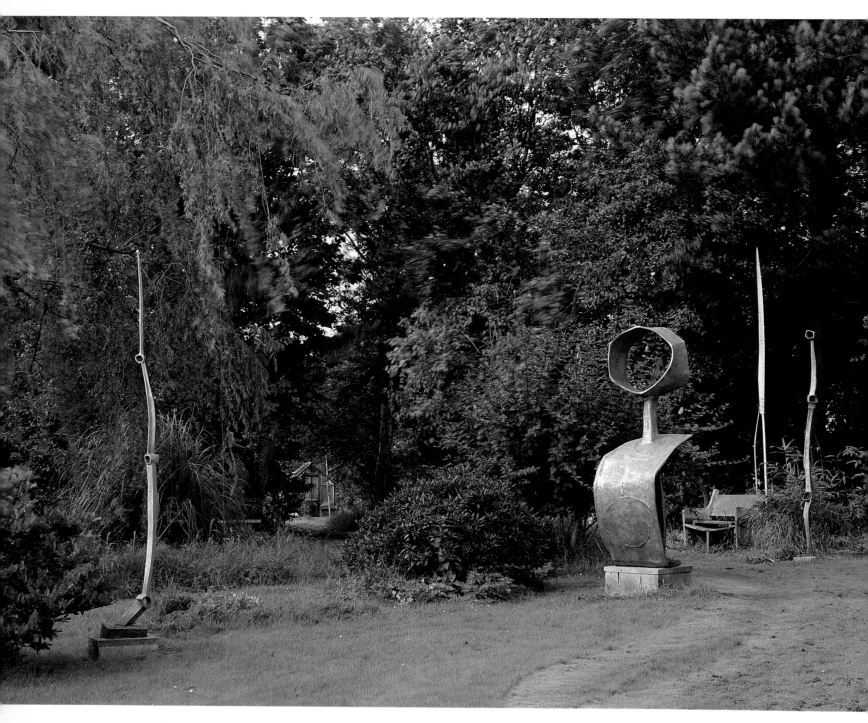

I ON PREVIOUS PAGE *Thrower*. ?1954. 128.6 × 38.5 × 22 cm (Cat.S58)

II ABOVE View in Austin Wright's garden, Upper Poppleton, photographed in Summer 1993

III OPPOSITE *The Norns*. 1990-1. Each *c*.250 cm high (Cat.S354)

IV OVERLEAF LEFT Detail of *Split Back*. 1964. 197 × 44 × 30.5 cm (Cat.S232)

V OVERLEAF RIGHT View in Austin Wright's garden, Upper Poppleton, photographed in Summer 1991. The sculptures are:
front: *Frond* (Cat.S225)
back: *Riffli* (Cat.S309)

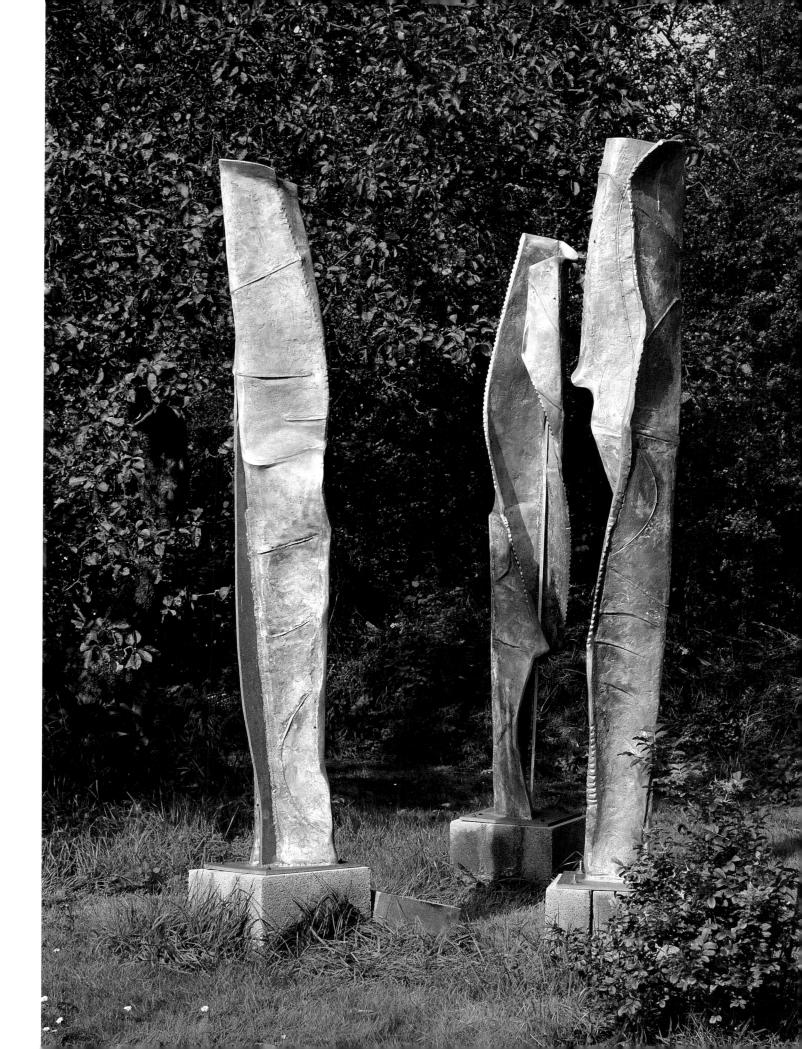

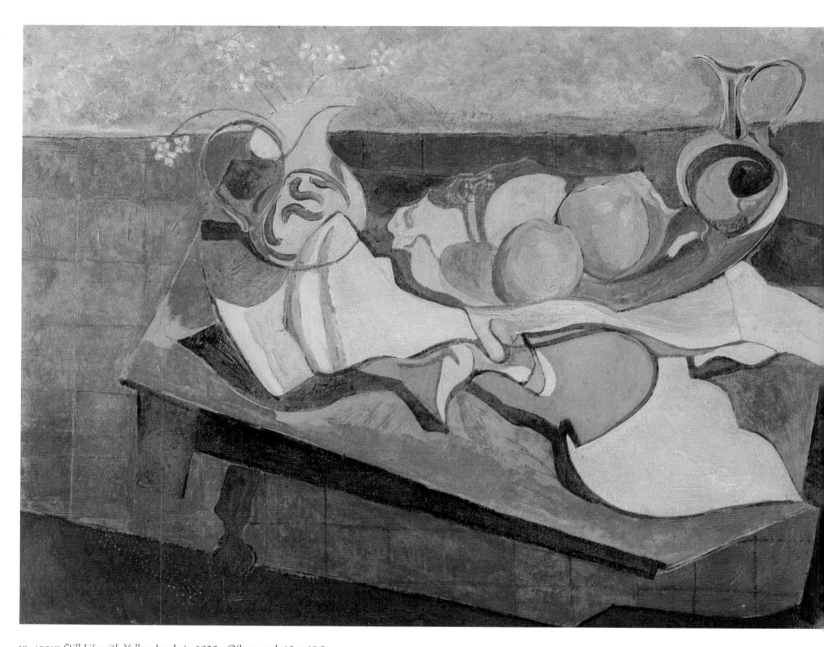

VI ABOVE *Still Life with Yellow Jug*. Late 1920s. Oil on card, 49 × 63.5 cm

VII OPPOSITE *Portrait of W.H. Auden*. c.1935. Oil on board, 41 × 32 cm

VIII OVERLEAF Austin Wright's barn workshop, Upper Poppleton, photographed in Summer 1993. The tall sculpture in progress on the right is the untitled piece no.S352, begun in 1990

at Newcastle Polytechnic Gallery in 1974. Although super-ficially these fluid images resemble Japanese letterforms, they are lightly borne and inventive variations on the plant-inspired ring, line and slab motifs that had appeared with such fertility in Wright's sculpture. 'Well why not', Wright remarked in 1992, 'They're so sculptural.' Other small-scale sculpture, such as *Sign* (Cat.S241) and *Phase* (Cat.S252) explore this gestural, calligraphic sculptural manner.

The second of Wright's major public sculptures of the 1970s was the fountain (Cat.S315) commissioned in 1978 by the Leeds firm E.J. Arnold Ltd for their new factory and warehouse. The fountain, which was destroyed after the buildings changed hands in the early 1980s, had a dual role. It both circulated the water in the round pond that supplied the factory's sprinkler system, and acted as a welcome sculptural feature in the bleak urban landscape of Hunslet, south Leeds. In an extended series of notes and studies (Cat.Sk62), Wright develops the three sources of inspiration for the fountain. These are the forms of the Norber Stones, a group of large boulders near Settle; the Baroque fountains of Rome, which Wright visited with Olaf Arnold in 1977, and where the idea for this commission grew; and his vision of the action of flowing water. 'The idea of spreading water over curved plates came to me from watching large waves shed their water over slabs of rock.'[42] Wright's notes reveal his assessment of the options that were available to him:

Either (1) strong jet for each section A 360 cm or A 420 cms, or (2) to obtain varied flow, strong jet to lower curve and gentler force for upper curve, on both leaves. The gentler force being operable indefinitely in windy conditions. If (2) not feasible, use equal strong jets, 4 in all, on both leaves.

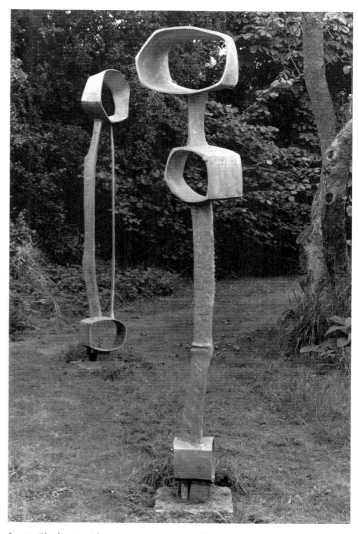

fig.84 *Checkmate* Aluminium 1981 Two of four elements (Cat.S320)

These now lost public commissions, and a further large-scale commission of the 1970s, also lost (*Sundial*, Cat.S313; installed 1979 at Broughton Hall, Cumbria; destroyed 1980s), reflects the rare fertility of Wright's production as a public sculptor continuing unabated into his late sixties and seventies. His 60 feet long wall piece for Newcastle Polytechnic, now the University of Northumbria (Cat.S322), is still happily extant. The artist's passion for landscape that is so vividly reflected in the forms and siting of his work, was articulated by Wright in the remarkable extempore address he gave to the invited audience at a Degree Congregation at the University of York in July 1977. This was on the occasion of the conferment on him of an Honorary Doctorate, in front of the Chancellor of the University, Lord Clark of Saltwood, the same man who

over forty years earlier had introduced the young Austin Wright to the treasures of the Ashmolean Museum in Oxford. In his address, which is reprinted in full on pp.139-41, Wright carried his audience over the hills and plains, towns and villages of Yorkshire, shaping and moulding in words the forms of the landscape that he loved and has lived in since the 1930s:

… it is particularly the land that flows out from York that has held me … and if I went anywhere else – if I had to go anywhere else – it would only be to carry it in my head. It's the one place that I needed to return to to work. I could take all the journeys to fabled Shiraz and Samarkand without meaning. I am no tourist. It is here. I have always believed that, artistically, the real thing is under your feet.

The University of York conferred more than an Honorary

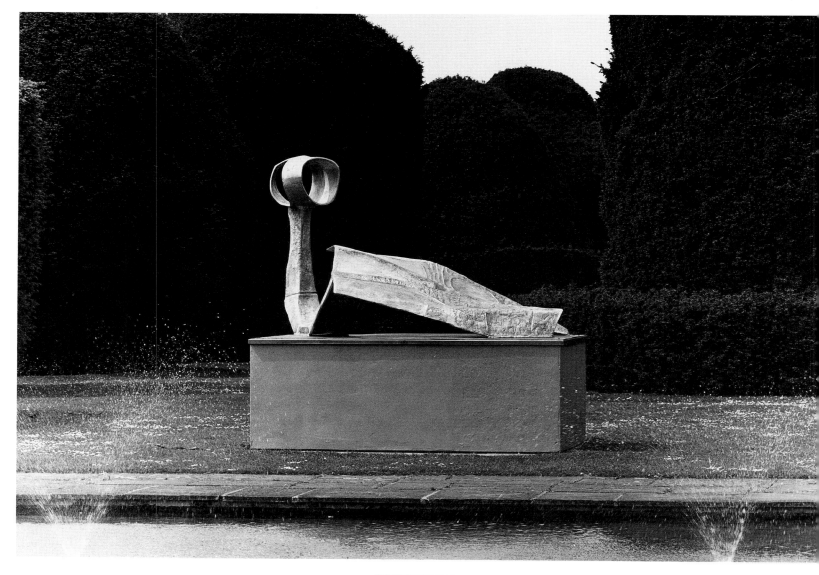

Degree on Wright; they gave him, in the early 1980s, the opportunity to make a large-scale reclining figure in aluminium, to be sited on a plinth that had been vacated by the recalled loan of a sculpture by Henry Moore. Wright's *Dryad* (Cat.S335), installed in 1984 beside a pool, and against a long line of tall topiaried yews, is an alert leaf form, a shining, featherlight, magical presence whose double ring head rises proudly above an arching horizontal form. *Dryad*, both plant and person, seed pod and spirit, is an eloquent climax to the artist's production of public sculpture, a series of important works that had in previous years been so dogged by ill-luck. *Dryad*, and indeed other works commissioned by the University of York (Cats S251 and S360-361) have infiltrated the fabric of the University, to the extent that some of them formed the inspiration for the music for chamber orchestra and viola *Three Sculptures of Austin Wright* (1991) composed by John Paynter, Professor of Music at York.

Dryad was just one of more than thirty sculptures Wright made during his seventies. The decade began with the large retrospective exhibition marking his 70th birthday at the Yorkshire Sculpture Park in 1981, followed a

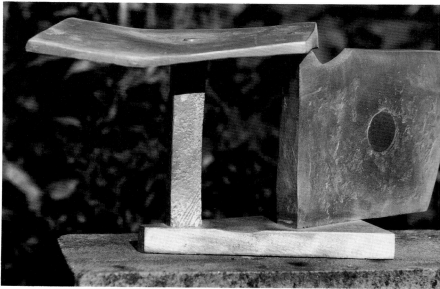

TOP fig.85 *Dryad* Aluminium 1984 (Cat.S335)

ABOVE fig.86 *Japanese Garden* Aluminium 1981 (Cat.S321)

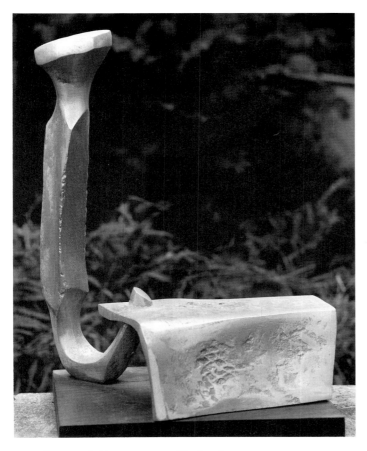

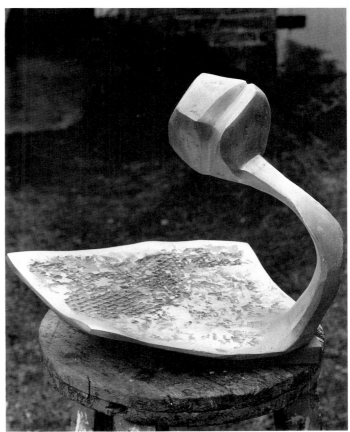

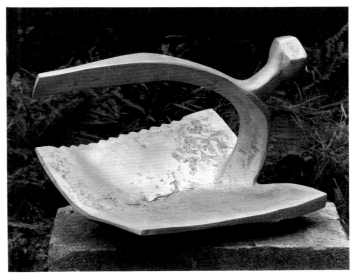

ABOVE fig.87 *Nail* Aluminium 1982 (Cat.S324)

ABOVE RIGHT fig.88 *Knob* Aluminium 1982 (Cat.S328)

RIGHT fig.89 *Spike* Aluminium 1982 (Cat.S325)

year later by an exhibition of new small-scale work at the
Arcade Gallery in Harrogate. A quality common to
Wright's late, small sculpture is their kinship with utensils.
Spike (Cat.S325), *Knob* (Cat.S328), *Nail* (Cat.S324) each
have an apparent purpose which is transcended by their
power as sculptures. They are complete in themselves, and
have the firm sleekness of silent objects newly minted. In
Yockenthwaite Five (Cat.S330), *Marske Field* (Cat.S353) and
Seed Heads (Cat.S340), the artist continues exploring his
intense and fertile pleasure in groups of simple things.
Yockenthwaite Five is a sculptural reflection of a group of
five tall, straight trees that Wright discovered and recorded
in a sketchbook at Yockenthwaite, north-east of Settle,
while *Marske Field*, an assemblage of re-used waste alumin-
ium plate and casting plugs, was prompted by the sight of
another group of trees skirting the edge of a field near
Markse, west of Richmond.

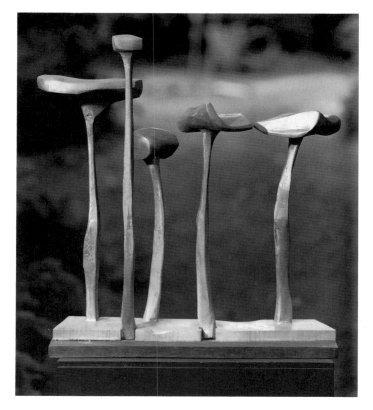

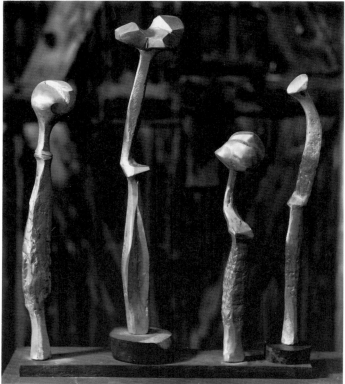

Wright is continuing to make sculpture in his eighties. *The Norns* (Cat.S354) is a group of three evocative curling vertical leaf-based forms inspired by the three Fates of Norse legend, Urg, Verdandye and Skuld. The most recent work, completed when this essay was being written in 1993, is the pair of 16 feet high masts, *Stalk* and *Stem* (Cats S355 and S356) made of lengths of cast and section aluminium welded into place with the surety that only an artist totally at one with his material could achieve. The sculptures are as elegant and resonant as radio masts, but the flourish of waste aluminium treadplate at their topmost point gives them a sudden acid twist, a sting in the tail that comes from the knowledge that we may be looking at a transmitter, a surveillance camera, a coxcomb or a severed head on a tall pole.

Austin Wright's career is approaching its conclusion just as the careers of Richard Deacon (*b.*1949), Tony Cragg (*b.*1949), Peter Randall-Page (*b.*1954) and Andy Goldsworthy (*b.*1956) have reached their first maturity and international recognition. These sculptors have all found fresh inspiration in the growth of plants and the utensils of science, sources which, since the 1960s, have been fertile for Wright also. Apart from a brief skirmish in the 1950s, Wright's art was never seriously taken up by critics and opinion-formers as being representative of the mood of his

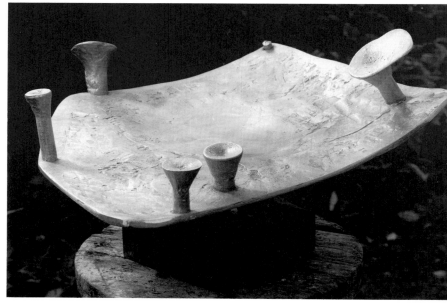

TOP LEFT fig.90 *Yockenthwaite Five* Aluminium 1982 (Cat.S330)

TOP RIGHT fig.91 *Seed Heads* Aluminium 1986 (four elements from Cat.S340)

ABOVE fig.92 *Marske Field* Aluminium 1990 (Cat.S353)

OPPOSITE fig.93 *Wall and Tower* Aluminium: 3 elements on a wooden base 1988 (Cat.S348)

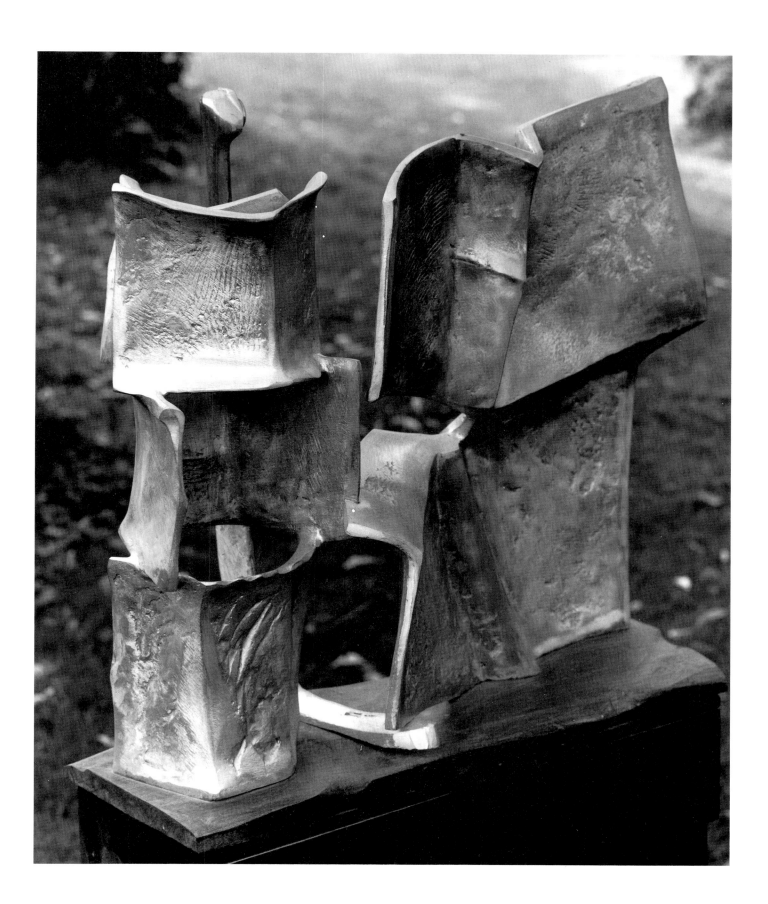

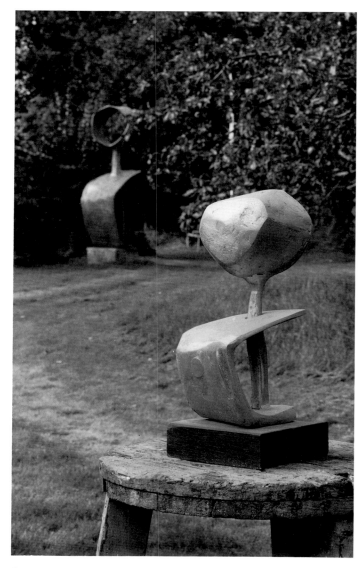 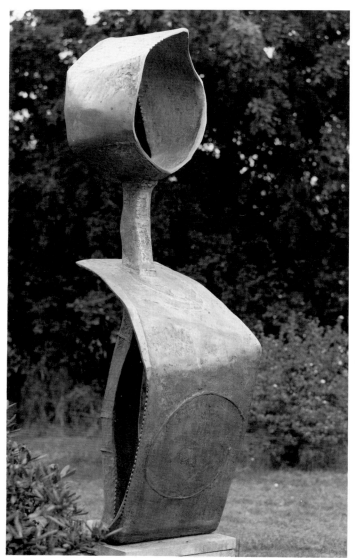

fig.94 *Pommel 1* Aluminium 1982 (Cat.S332)
(*Pommel 2*, Cat.S334, is in the background)

fig.95 *Pommel 2* Aluminium 1983 (Cat.S334)

generation, simply because it was not. Wright had no inter-
est in *This Is Tomorrow*, the New Generation, Young Con-
temporaries or Pop, or any of the artist groupings that
ebbed and flowed through the post-war years. He has also
been indifferent to the Royal Academy, which has shown
his work in its Summer Exhibitions, but has never elected
him an Associate.

As a 'self-taught' artist – and all that that signifies is that
he did not go to an orthodox art college – and one who
was detached by age both from the generation of Moore
above him and that of Paolozzi below, Wright existed in
a different sphere. Able thus to follow his own interests

with no peer-group pressure or professional rivalry, he
developed in his own way like a scarce plant in a shaded
habitat. That younger artists found sculptural excitements
in plant forms and utensils in the 1980s gives no particular
credit to Wright; but what it does indicate is that Austin
Wright has been lightly treading these same long paths for
quite some time already.

Notes

1 Thus described by AW in a letter to JH, 10.7.93. Further quotes from AW come, when unreferenced, from conversations held between him and JH in 1981 and during 1992 and 1993

2 Michael Yates, then age thirteen, quoted Humphrey Carpenter: *W.H. Auden: A Biography*; Allen and Unwin, 1981, p.143

3 Francis Hoyland: *Alive to Paint*; Oxford University Press, 1967

4 Letter Patrick George to JH, 22.8.93

5 For Wright's account of this, see Humphrey Carpenter: *op.cit.*, pp.176–7

6 His portrait of W.H. Auden is painted on a board manufactured by H. Schmincke & Co, Düsseldorf

7 Conversation between JH and AW, 1981

8 Austin Wright submitted a proposal for the Unknown Political Prisoner competition, organised by the ICA in 1952 and 1953. His maquette is lost

9 'In recent years, Mr Musgrave said, York Gallery's contribution to the field of art had been remarkable. It was now regarded as one of the most important galleries in the provinces.' *Yorshire Evening Press*, 17.6.50

10 York Art Gallery: *Preview*, vol.xxviii (April 1975), p.978

11 'Show Epitomises Modern Art'; [Yorkshire newspaper unknown, possibly *Yorkshire Evening Press*] 17.6.50

12 16.1.50

13 SW diary, 29.4.50

14 I am grateful to Gillian Spencer, Director of Wakefield Art Gallery and Museums (1974–90) and Nino Vella, currently Keeper of Art, for providing me with this information

15 10.10.55

16 Wilma Moy-Thomas: 'They Really Love their Yorkshire'; *News Chronicle*, 21.10.55

17 Margaret Roberts: '18 Young Artists get their chance'; *News Chronicle*, 8.10.55

18 A.C.S. [A.C. Sewter]: 'Modern Art in Yorkshire'; *Manchester Guardian*, 10.10.55. Other artists in the exhibition included Kenneth Piggott, Terry Frost, Colin Saxton, Erik Forrest, Thea Downing, Geoffrey Plant, Trevor Stubley, Tom Whitehead, Russell Platt, Audrey Fowler, Kathleen Mills, Irwin Hoyland, Francis Cooper, H.R. Stone and Barbara Cass

19 See Alastair Grieve: *The Sculpture of Robert Adams*; London, The Henry Moore Foundation and Lund Humphries, 1992, nos 110 and 142

20 SW diary, 1951

21 For further details of AW's collaboration with Moorman, see Mary Sara's *Appreciation* of Theo Moorman in Hilary Diaper (ed.): *Theo Moorman 1907-1990*; University Gallery, Leeds, 1992, pp.75ff, and passim

22 Basil Taylor: 'Church Patronage'; *Spectator*, 6.1.56, p.20

23 SW diary, 1955. The successful 'penniless' candidate this time was Hubert Dalwood

24 Letter AW to JH, 4.5.81

25 From: *British Sculptors – Attitudes to Drawing*; Sunderland Arts Centre, 1974

26 Letter Lilian Somerville to AW, 26.6.56

27 Letter Lilian Somerville to AW, 20.12.57

28 Robert Melville: Introduction to *Yngre Brittiska Skulptorer*; Riksforbundet for Bildande Konst and the British Council, Sweden, 1956-7. I am grateful to Edwina Simpson of the Embassy of Sweden, London, for translating this passage from the Swedish

29 Stephen Bone, *Manchester Guardian*, 11.3.58, in a review of AW's exhibition at Roland, Browse and Delbanco

30 Letter to JH, 10.5.81

31 'Distinctively Personal Sculpture of Mr Austin Wright'; *The Times*, 26.9.60

32 Letter Quentin Bell to AW, 20.10.60

33 The work of the concurrent Gregory Fellow in Painting, Trevor Bell, occupied an upstairs room in Leeds City Art Gallery at the same time. Although catalogued as one, Wright's and Bell's exhibitions were physically quite separate

34 Ian E.F. Morton: 'The Moderns – Austin Wright'; *Yorkshire Life*, May 1964, pp.58-9

35 Anthony Tucker: 'Gregory Fellows'; *The Guardian*, 29.10.62

36 Eric Newton: 'Sculpture by … Wright in London'; *The Guardian*, 8.5.64

37 Letter Quentin Bell to AW, 20.10.60

38 Letter Philip Andrews to AW, 26.11.62

39 Letter Susan Wright to JH, 10.5.81

40 AW annotation to typescript by JH, May 1981

41 *Yorkshire Post*, 28.9.77

42 AW, quoted in W.J. Strachan: *Open Air Sculpture in Britain*; Zwemmer/Tate Gallery, 1984, p.194

Catalogue of Sculpture

1939-1993

Key to exhibitions referred to in Catalogue

WRA [followed by date]	*West Riding Artists*; Wakefield City Art Gallery
York, 1950	*Dudley Holland & Austin Wright: Two Modern Artists*; York City Art Gallery
Wakefield, 1953	*Modern Art in Yorkshire*; Wakefield City Art Gallery
Wakefield, 1955	*Modern Art in Yorkshire*; Wakefield City Art Gallery
Arts Council, 1956	*Some Contemporary British Sculpture*; Arts Council
York, 1956	*Norman Adams, Russell Platt & Austin Wright: Three Modern Artists*; York City Art Gallery
RBD, 1956	*Philip Sutton & Austin Wright*; Roland, Browse & Delbanco, Cork St, London
Arts Council, 1957	*Contemporary British Sculpture*; Arts Council
Holland Park, 1957	*Sculpture 1850 and 1950*; Holland Park, London
RBD, 1958	*Norman Adams & Austin Wright*; Roland, Browse & Delbanco, Cork St, London
Middelheim, 1959	*V Biennale of International Sculpture*; Middelheim, Belgium
Wakefield, 1960	*Austin Wright Retrospective*; Wakefield City Art Gallery
Leeds, 1962	*Gregory Fellows: Trevor Bell & Austin Wright*; Leeds City Art Gallery
Bradford, 1963	*Austin Wright*; Lane Gallery, Bradford
Rowan, 1964	*Austin Wright*; Rowan Gallery, Lowndes St, London
Tate, CAS, 1965	*British Sculpture in the Sixties*; Organised by the Contemporary Art Society, Tate Gallery
Whitechapel, 1967/68	*British Sculpture and Painting from the Collection of Leicestershire Education Authority*; Whitechapel Art Gallery, Dec 1967–Feb 1968
Menston, 1968	*Austin Wright*; Goosewell Gallery, Menston, Ilkley
Aldbourne, 1969	*Sculpture in a Landscape*; Sorbus, Aldbourne, Wiltshire
Manchester, 1971	*Austin Wright*; Peterloo Gallery, Manchester
Menston, 1971	*Austin Wright*; Goosewell Gallery, Menston, Ilkley
York, 1973	*Austin Wright*; York Festival exhibition at St Martin-cum-Gregory
Menston, 1973	*Austin Wright*; Goosewell Gallery, Menston, Ilkley
Newcastle, 1974	*Austin Wright Retrospective*; Polytechnic Gallery, Newcastle upon Tyne
Menston, 1975	*Austin Wright*; Goosewell Gallery, Menston, Ilkley
Manchester, 1975	*Theo Moorman and Austin Wright*; Royal Northern College of Music, Oxford Rd, Manchester
YSP, 1981	*Austin Wright 70th Birthday Retrospective*; Yorkshire Sculpture Park
Harrogate, 1982	*Austin Wright, New Work*; Arcade Gallery, Lowther Arcade, Harrogate
Margam, 1983	*Sculpture in a Country Park*; Margam Sculpture Park, South Wales
Hull, 1988	*Austin Wright Retrospective*; Ferens Art Gallery, Hull
Kirkby Lonsdale, 1989	*Austin Wright*; Gallery North, Kirkby Lonsdale, Cumbria
Grape Lane Gallery, 1989	*Austin Wright*; Grape Lane Gallery, York

Note to the Catalogue

It is the ambition of this catalogue to list all the sculptures made by Austin Wright from his earliest known piece, made in 1939, to work completed up to the time of going to press. Without doubt, a number of works will have escaped its trawl, but it claims at least to be as complete as time and knowledge allow.

Its foundations were laid by Sarah Davenport, a post-graduate student on the Sculpture Studies Course at the University of Leeds, who took dimensions and gathered further essential catalogue information for almost all of Wright's known sculptures, recording this on inventory sheets that are now kept at the Henry Moore Institute in Leeds.

The catalogue gives the title and date of each work, in chronological order, the date being followed by Sarah Davenport's inventory number, where one was allocated. Medium, dimensions where known and the place and date of each work's first exhibition are also given, as is its catalogue number at that exhibition. If the present whereabouts of a work is known, it is listed as 'The Artist', 'Private Collection' or by the name of a public collection. If a work is known to have been destroyed, this is stated. Within each year grouping, I have organised sculptures according to medium, thus: Wood, Stone, Terracotta, Plaster, Lead, Bronze, Concrete, Aluminium.

It was Wright's practice to make small editions of a number of his works. Some, in particular pieces from the 1950s which were originally cast in lead,

were later recast by Wright in lead or in other materials such as bronze or aluminium. The catalogue records the existence of these other versions where they are known, but the number of works in each edition is not given, as no accurate record of this survives.

Where I have not found documentary evidence of dating in the artist's papers, I have used evidence from contemporary exhibition catalogues. Thus the given date may be that on which a work was first exhibited, rather than the year in which it was made. JH

Dimensions are given in centimetres before inches, and height before width before depth.

Catalogue numbers are prefixed by S for Sculpture, P for Prints and Sk for Sketchbooks.

1939

S1 Dancing Figure
1939 (1)
Pinewood
32 × 11 × 9 cm (12½ × 4¼ × 3½ in)
First Exh: York, 1950 (62)
Susan Wright
see fig.1

1940

S2 Female Figure
1940
Limewood
40.5 × 11.5 × 10 cm (16 × 4½ × 4 in)
First Exh: York, 1950 (63)
Private Collection, York
not illustrated

S3 Angular Dancer
1940 (3)
Limewood
35 × 18.6 × 15 cm (13¼ × 7¼ × 6 in)
First Exh: York, 1950 (64)
The Artist
see fig.2

S4 Bollard
1940 (4)
Limestone
44.5 × 36 × 36 cm (17½ × 14 × 14 in)
First Exh: York, 1950 (65)
The Artist
see fig.3

S5 Figure
1940 (35)
Limewood
30.5 cm (12 in) high
First Exh: York, 1950 (66)
Private Collection, Wales

S6 Leaning Figure
1940 (2)
Alabaster
16.8 × 24 × 15 cm (6½ × 9½ × 6 in)
The Artist
Carved from alabaster found on Penarth Beach, Cardiff
not illustrated

1941

S7 Compact Form
1941 (5)
Elmwood
31 × 32 × 41 cm (12¼ × 12½ × 16 in)
First Exh: York, 1950 (67)
The Artist
see fig.4

S8 Horse
1941 (6)
Mahogany on wooden base
24.8 × 21 × 8.2 cm ($9\frac{3}{4} × 8\frac{1}{4} × 3\frac{1}{4}$ in)
First Exh: York, 1950 (68)
The Artist
see also Cat.Sk1

S9 Figure
1941 (15)
Beech
44 × 15.8 × 14.8 cm ($17\frac{1}{4} × 6\frac{1}{4} × 5\frac{3}{4}$ in)
First Exh: WRA, 1941 (158)
The Artist

S10 Figure
1941
Satinwood
First Exh: WRA, 1941 (159)
not illustrated

S11 Construction
1941
Wire and cotton
First Exh: WRA, 1941 (228)
not illustrated

1942

S12 Female Figure
?1942 (16)
Hornton Stone
47 × 39 × 33 cm ($18\frac{1}{2} × 15\frac{1}{4} × 13$ in)
The Artist

S13 Emerging Form
1942 (7)
Yew
45.7 × 19 × 15.9 cm ($18 × 7\frac{1}{2} × 6\frac{1}{4}$ in)
First Exh: York, 1950 (69)
Leeds City Art Galleries [Given by
Frank Lambert in memory of his wife,
1958]
not illustrated

S14 Figure
1942 (8)
Holly
41 × 15.2 × 15 cm (16 × 6 × 6 in)
First Exh: WRA, 1942 (129)
Susan Wright
see fig.5

S15 Fragment
1942 (9)
Gypsum
28 cm (11 in) high
First Exh: York, 1950 (71)
not illustrated

S16 Construction
1942
Wire and cotton
First Exh: WRA, 1942 (128)
not illustrated

1943

S17 Figure
1943 (18)
Yew
69.2 × 34.5 × 9.0 cm ($27\frac{1}{4} × 13\frac{1}{2} × 3\frac{1}{2}$ in)
First Exh: WRA, 1943 (283)
Private Collection, Oxford

S18 Evolving Figure
1943
Elm
71 cm (28 in) high
First Exh: York, 1950 (74)
not illustrated

S19 Figure
1943 (10)
Hoptonwood Stone
69.5 × 45 × 26 cm ($27\frac{1}{4} × 17\frac{3}{4} × 10\frac{1}{4}$ in)
First Exh: York, 1950 (73)
The Artist

S20 Figure
1943
Limestone
First Exh: WRA, 1943 (284)
not illustrated

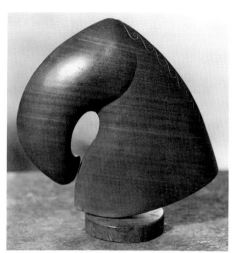

S8

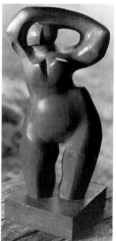

S9

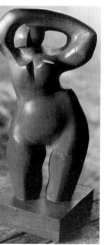

S19 S12

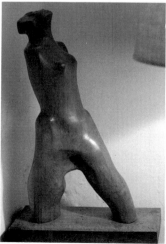

S17

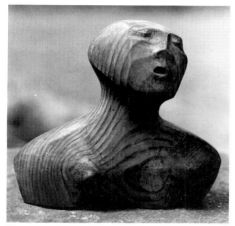

S24

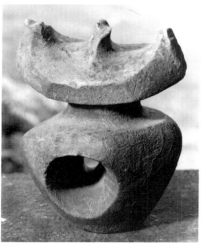

S27

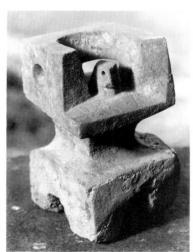

S28

1944

S21 Female Figure
1944 (11)
Elmwood
67.5 × 34 × 34 cm (26½ × 13¼ × 13¼ in)
First Exh: York, 1950 (75)
Leeds City Art Galleries [Purchased 1950]
Nicknamed 'Mrs Bosomworth' by the artist and his wife
not illustrated

S22 Growth
1944
Ash
66 cm (26 in) high
First Exh: York, 1950 (76)
not illustrated

S23 Figure
1944
Limewood
First Exh: WRA, 1944 (193)
not illustrated

1945

S24 Head [previously part of a destroyed torso]
1945 (12)
Pinewood
24 × 26 × 7.5 cm (9½ × 10¼ × 3 in)
First Exh: Hull, 1988 (1)
The Artist
'Direct carving, image and form prompted by the piece of wood itself.' AW

S25 Emerging Form
1945 (13)
Hornton Stone
31 × 30 × 24.5 cm (12¼ × 11¾ × 9¾ in)
First Exh: York, 1950 (77)
The Artist
see fig.6

S26 Advancing Figure
1945 (14)
Hornton Stone
31 × 16 × 16.5 cm (12¼ × 6¼ × 6½ in)
First Exh: York, 1950 (78)
The Artist
Damaged – a section is missing from the top and rear. 'I asked Moore about Hornton Stone. Very expensive stone, including transport and everything. Very nice, tight grained and beautifully coloured, very uniform stone.' AW
see fig.7

1946

S27 Rising Form
1946 (20)
Hornton Stone
29.5 × 24.5 × 19 cm (11½ × 9½ × 7½ in)
First Exh: York, 1950 (79)
The Artist

S28 Strong Point
1946 (21)
Hornton Stone
25.7 × 16 × 17 cm (10 × 6¼ × 6¾ in)
First Exh: York, 1950 (80)
The Artist

S29 Alert Form
1946 (19)
Ancaster Stone
44 × 34 × 28 cm (17¼ × 13¼ × 11 in)
First Exh: York, 1950 (81)
The Artist
see fig.8

1947

S30 Tall Figure
1947 (28)
Sycamore
78.5 × 17.7 × 17.5 cm (31 × 7 × 7 in)
First Exh: York, 1950 (82)
The Artist
see fig.9

S31 Swimmer 1
1947 (22)
Sycamore
13 × 91.5 × 23 cm (5 × 36 × 9 in)
First Exh: York, 1950 (83)
The Artist

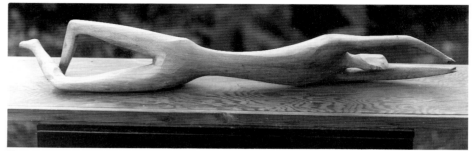

S31

S32 Swimmer 2
1947 (36)
Wood
81.3 cm (32 in) high
Private Collection, Wales

S33 Shriek
1947 (29)
Sycamore
76 × 16.4 × 16 cm (30 × 6½ × 6¼ in)
First Exh: York, 1950 (84)
The Artist
'The wood was given to me by a North
Yorkshire Moors wheelwright.' AW
see fig.10

1948

S34 Angel
1948 (30)
Sycamore
83.5 × 14.9 × 15.2 cm (32¾ × 5¾ × 6 in)
First Exh: York, 1950 (85)
The Artist
see fig.11

S35 Reaching Form
1948
Ash
94 cm (37 in) high
First Exh: York, 1950 (86)
not illustrated

S36 Figure
1948
Yew
First Exh: WRA, 1948 (94)
not illustrated

S37 Head
1948-50 (24)
Terracotta
43 × 31 × 21.4 cm (17 × 12¼ × 8½ in)
First Exh: Hull, 1988 (10)
The Artist

S38 Head
1948-50 (26)
Terracotta
36.3 × 19 × 24.7 cm (14¼ × 7½ × 9¾ in)
First Exh: Hull, 1988 (11)
The Artist
see fig.12

S39 Trio
1948-50 (27)
Terracotta
11.5 × 10.8 × 7.7 cm (4½ × 4¼ × 3 in)
First Exh: Hull, 1988 (12)
The Artist
not illustrated

S40 Figure
1948-50 (23)
Terracotta
24.7 × 10 × 8 cm (9¾ × 4 × 3¼ in)
The Artist

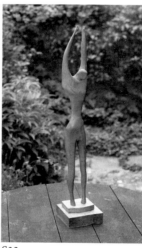

S32

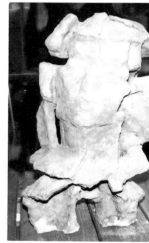

S37

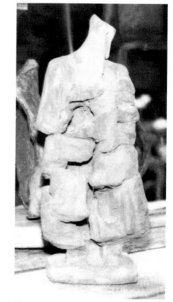

S40

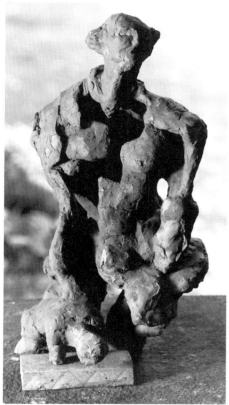

S41

S45

S41 Mother and Child
1948-50 (25)
Terracotta
43.5 × 21.3 × 21.5 cm (17 × $8\frac{1}{4}$ × $8\frac{1}{2}$ in)
The Artist
Damaged – child's arm missing from
base at the front

S42 Three Figures
1948-50
Terracotta
Destroyed
see fig.13

1949

S43 Green Fuse
1949 (33)
Sycamore
71 × 15.7 × 19 cm (28 × $6\frac{1}{4}$ × $7\frac{1}{2}$ in)
First Exh: York, 1950 (88)
The Artist
The title refers to Dylan Thomas's poem
'The force that through the green fuse
drives the flower'
see fig.14

S44 Savage Growth
1949 (32)
Limestone
37 × 30 × 28 cm ($14\frac{1}{2}$ × $11\frac{3}{4}$ × 11 in)
First Exh: York, 1950 (87)
The Artist
see also Cat.Sk3
see fig.15

S45 Figure
1949 (31)
Marble
18.5 × 37 × 24.5 cm ($7\frac{1}{4}$ × $14\frac{1}{2}$ × $9\frac{3}{4}$ in)
The Artist
Carved from a bust of Shakespeare
which had fallen from one of the build-
ings of Bootham School during the Blitz
on York in 1940

1950

S46 Annunciation
1950 (40)
Yew
122 cm (48 in) high
First Exh: York, 1950 (89)
Repr: *Yorkshire Evening Press*, 17.6.50.
not illustrated

S47 Sharp Growth
1950 (41)
Ash
213.4 cm (84 in) high
First Exh: York, 1950 (90)
not illustrated

S48 Experiments in Metal Forms
1950 (39)
Aluminium
First Exh: York, 1950 (91)
Possibly the 'two gleaming angels' in
bent aluminium sheet that Susan Wright
mentions in her diary, 16.6.50
not illustrated

1952

S49 Lovers
1952 (37)
Holly
138.5 × 26.7 × 23.1 cm
($54\frac{1}{2}$ × $10\frac{1}{2}$ × 9 in)
First Exh: Wakefield, 1953 [as *Locking
Forms*. Then RBD, 1956 (2) & Wakefield,
1960 (62) as *Lovers*]
The Artist
'Getting the gaps pierced in the wood
was the important thing.' AW
see fig.16

S50 Two Forms
[aka *Growing Forms*]
1952 (42)
Holly
152.7 × 30 × 25.5 cm (60 × 11¾ × 10 in)
First Exh: Wakefield, 1953 [as *Growing Forms*]
The Artist
AW found the wood in a hedge at Castle Howard, and brought it home in two sections on his motorbike after a workman had chopped it with his hatchet. The workman's chop is retained at the top of one form and the bottom of the other. The Forms are always kept together, and are mounted on rods so that they can be swivelled. 'for the title, I prefer plain "Two Forms"': AW annotation to typescript of JH, 5.5.81
see fig.17

S51 Maquette for Monument to the Unknown Political Prisoner
1952
Destroyed
not illustrated

S52 Bathers in Moonlight
1952
Wire and plaster
First Exh: WRA, 1952 (102)
not illustrated

1953

S53 The Whisperers
1953 (43)
Beech
100 × 21 × 11 cm (39¼ × 8¼ × 4¼ in)
First Exh: Wakefield, 1953 [possibly exhibited as *Lovers*, Wakefield, 1960 (63)]
The Artist
Incomplete. The piece has lost its tiny heads
see fig.18

S54 Watching Figure [aka *Watcher*]
1953 (44)
Pear
87.1 × 30.6 × 25.1 cm (34¼ × 12 × 9¾ in)
First Exh: Wakefield, 1953
The Artist
The wood was given to the artist by a North Yorkshire Moors wheelwright

S55 Prisoner
1953
Sycamore
76 cm (30 in) high
First Exh: York, 1956 (80)
Possibly related to Cat.S51
not illustrated

S56 Seated Figure
1953 (45)
Plaster
63.5 cm (25 in) high
First Exh: Wakefield, 1953

1954

S57 Lear
1954 (48)
Beech
114 × 32 × 30 cm (44¾ × 12½ × 11¼ in)
First Exh: Wakefield, 1955 (114)
The Artist
'However much a man is battered by circumstances, the elements, his own misfortunes and faults, he still stands.' AW
see fig.19

S58 Thrower
?1954 (38)
Ash [?]
128.6 × 38.5 × 22 cm (50½ × 15¼ × 8¾ in)
First Exh: RBD, 1956 (1) [as *Figure*]
The Artist
'A hefty trunk that I had around, waiting to be treated. I most remember the excitement of breaking through between arm and body and finding it in the right place on the other side – such a discovery!' AW
see col.pl.I and fig.17

S59 Prodigal Son
1954 (47)
Lead
26 cm (10¼ in) high
Inscr: AAW [on underside of base]
First Exh: York, 1956 (86)
Prov: Mrs M. Brownlow, by whom bequeathed to The Fitzwilliam Museum, Cambridge, 1972
see fig.20

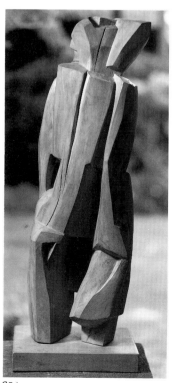

S54

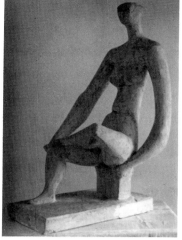

S56

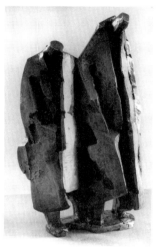

S65

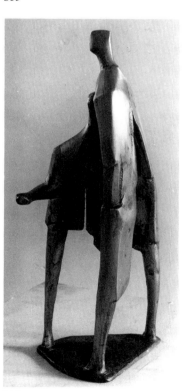

S66

S60 Man in a Long Coat
[aka *Man in a Coat*]
1954 (70)
Lead
30.5 cm (12 in) high
First Exh: Wakefield, 1955 (100)
Private Collection, Devon
see fig.21

S61 Male Trio
1954 (54)
Lead
26.6 cm (10½ in) high
First Exh: WRA, 1954 (91)
Private Collection, Sussex
not illustrated

1955

S62 Embracing Figures
1955 (46)
Lead
22.9 cm (9 in) high
First Exh: Wakefield, 1955 (99)
not illustrated

S63 The Argument
1955 (49)
Lead
28 × 38 × 29.7 cm (11 × 15 × 11¾ in)
[4 elements, set on a wooden base]
First Exh: Wakefield, 1955 (101)
[A bronze cast was subsequently shown
through the British Council in South
America where, *inter alia*, it won the
Ricardo Xavier da Silveira Acquisition
Prize of 50,000 cruzieros at the São
Paulo Biennale.]
Wakefield City Art Gallery; a bronze
cast coll. Museu de Arte Moderna, São
Paulo, Brazil
An unrecorded number of lead and
bronze casts have been made of indi-
vidual figures, and of the whole group
see fig.22

S64 Embryo
1955 (56)
Lead
17.8 cm (7 in) high
First Exh: Wakefield, 1955 (102)
not illustrated

S65 Two Men in Greatcoats
1955 (52)
Lead
25.4 cm (10 in) high
First Exh: Wakefield, 1955 (103)
Private Collection
'Made after I had been doing some
mountaineering – hence the deep crevi-
ced forms.' AW

S66 Father and Son
1955 (68)
Lead
23 cm (9 in) high
First Exh: Wakefield, 1955 (104)

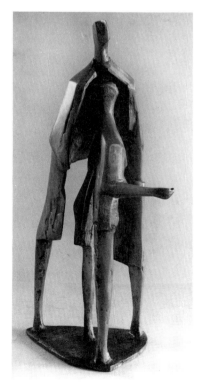

S66

S67 Man in the Wind
1955 (58)
Lead
30.5 × 14 × 10.2 cm (12 × 5½ × 4 in)
First Exh: Wakefield, 1955 (105)
Private Collection, Yorkshire
Editioned in bronze
see fig.23

S68 Three Spectators
1955 (73)
Lead
25.5 cm (10 in) high
First Exh: Wakefield, 1955 (106)
[As *Spectators*. Also shown RBD, 1956
(9) as *Spectators*]
Vassar College Art Gallery, Poughkeep-
sie, New York

S68a Two Spectators
1955
Lead
26 cm (10¼ in) high

S69 Female Trio
1955 (51)
Lead
21 cm (8¼ in) high
First Exh: Wakefield, 1955 (108)
[Subsequently British Council, Sweden,
1956-7]
Hammargyunnasiet, Sandviken,
Sweden: Sandviken Community Art
Collection
not illustrated

S70 Shelterers in Sacks
1955 (57)
Lead
26.4 × 11 × 9 cm (10½ × 4¼ × 3½ in)
Inscr: L5 [circled] in ink
First Exh: Wakefield, 1955 (109)
Private Collection, Devon
not illustrated

S71 Lovers
1955 (67)
Lead
28.6 × 10.4 × 7.5 cm (11¼ × 4 × 3 in)
First Exh: Wakefield, 1955 (110)
The Artist
Editioned in lead
see fig.24

S72 Standing Spectator
1955
Lead
26 cm (11 in) high
First Exh: Wakefield, 1955 (111)
not illustrated

S73 Standing Man
1955 (72)
Lead
First Exh: Wakefield, 1955 (112)
not illustrated

S74 Human Handgrenade
[aka *Weathered Man*]
1955 (50)
Lead
First Exh: Wakefield, 1955 (113)

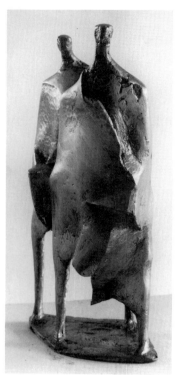

S68a

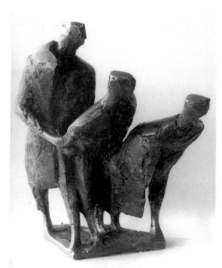

S68

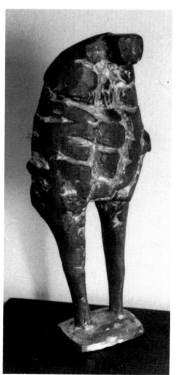

S74

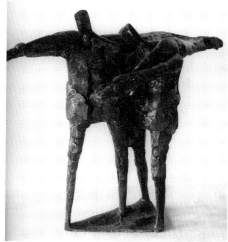

S76

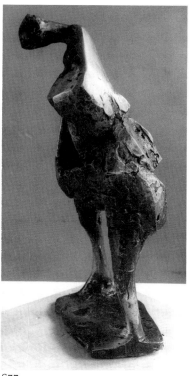

S77

S79

S75 Nucleus
1955 (69)
Wire and plaster
First Exh: Wakefield, 1955 (115)
see fig.25

S76 Two Men with a Load
1955 (103)
Lead
25.4 cm (10 in) high
First Exh: RBD, 1956 (10)

S77 Labourer
1955 (71)
Lead
19 cm (7½ in) high
First Exh: RBD, 1956 (11)

S78 Strider
1955 (55)
Lead
29.2 cm (11½ in) high
First Exh: RBD, 1956 (13)
not illustrated

S79 Huddle
1955 (64)
Lead
15.5 × 13.2 × 12.6 cm (6 × 5¼ × 5 in)
First Exh: York, 1956 (90)
The Artist
Editioned in lead and bronze

S80 Pair
1955 (65)
Lead
25.8 × 13.2 × 9 cm (10 × 5¼ × 13½ in)
First Exh: Wakefield, 1960 (2)
The Artist
Editioned in lead and bronze
not illustrated

S81 Crib
1955
Wood and plaster: 21 sculptural elements of 40 figures and animals, set in a six-part wooden framework on a wood base, before a tapestry designed by Wright, and woven by Theo Moorman
178 × 300 × 52 cm (70 × 118 × 20½ in)
Dedicated at Wakefield Cathedral, December 1955
Cathedral Church of All Saints, Wakefield
The Crib was originally designed to be sited in the Walsham Howe Chapel at the Cathedral, where the hooks for the Moorman tapestry remain *in situ*
see figs 27, 28

S82 Lovers
1956 (97)
Beech
109 × 25.2 × 33.5 cm (43 × 9¾ × 13 in)
First Exh: York, 1956 (79)
The Artist

S82

S83 Father and Son
1956 (102)
Plaster
91.5 cm (36 in) high
First Exh: Arts Council, 1956
not illustrated

S84 News
1956 (88)
Lead. Three elements set on wooden
base
24 × 34.4 × 29.4 cm (9½ × 13½ × 11½ in)
First Exh: York, 1956 (84)
Welsh Arts Council Collection
Editioned in lead and bronze as a group;
individual figures have also been cast.
One bronze group was cast under the
artist's direction by Forgebronze,
Seascale, Cumbria, in 1979]
see fig.29

S84a Man Reading
1956
Lead
30.5 cm (12 in) high

S85 Disrupting Trio
[aka *Departing Trio, Trio Departing*]
1956 (93)
Lead
25.6 × 22.5 × 20 cm (10 × 8¾ × 7¾ in)
First Exh: York, 1956 (87)
The Artist
Editioned in bronze

S86 Two Bathers
1956 (84)
Lead
33.8 × 16 × 15.2 cm (13¼ × 6¼ × 6 in)
First Exh: York, 1956 (91)
A bronze edition of four was cast by
Chris Boulton, Fine Art Bronze Foundry,
Sheffield, in the 1980s. This edition was
subscribed to by the Schools Museums
Services of Wakefield, Sheffield and
Huddersfield, each of whom acquired a
cast. The fourth cast entered the artist's
collection

S84a

S86a

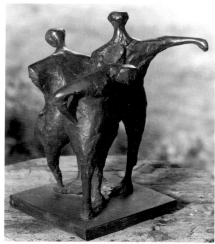

S85

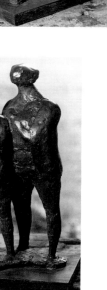

S86

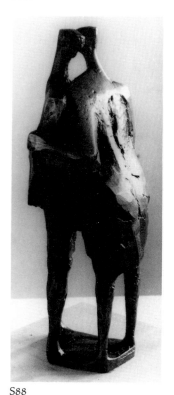

S88

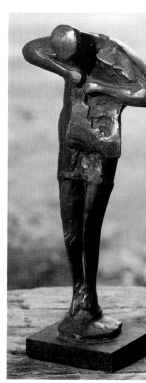

S89

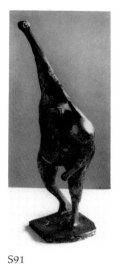
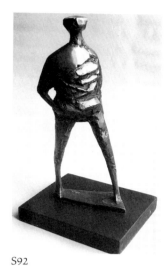

S91 S92

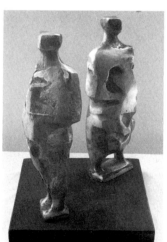

S93

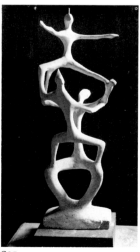

S95

S86a Two Women
1956
Lead
36.7 × 17.5 × 14 cm (14½ × 7 × 5½ in)
First Exh: RBD, 1956 (5)
Art Museum, Worcester, Mass, USA

S87 On the Precipice
1956 (99)
Lead
36.8 cm (14½ in) high
First Exh: RBD, 1956 (7)
not illustrated

S88 Conversation
1956 (100)
Lead
24.1 cm (9½ in) high
First Exh: RBD, 1956 (8)

S89 Hammerhead
1956 (94)
Lead
31.9 × 15.2 × 14.9 cm (12½ × 6 × 5¾ in)
First Exh: RBD, 1956 (12)
Lead casts in Arts Council Collection;
Leeds City Art Galleries (bequeathed
Professor Robert Holmes); National
Museum of Wales (pres. CAS of Wales)
Editioned in bronze

S90 Sandwich Man
1956 (101)
Lead
22.9 cm (9 in) high
First Exh: RBD, 1956 (14)
not illustrated

S91 Hurler
1956 (105)
Lead
29.8 × 10.8 × 9 cm (11¾ × 4¼ × 3½ in)
First Exh: RBD, 1956 (16)
Editioned in bronze

S92 Strider
1956 (98)
Lead
29.2 cm (11½ in) high
First Exh: RBD, 1958 (13)

S93 Standing Workmen
1956 (85)
Lead
30.5 cm (12 in) high
First Exh: RBD, 1958 (37)

1957

S94 Preliminary study for Acrobats
1952-7 (76)
Wire and plaster
27 × 15 × 11.8 cm (10¾ × 6 × 4¾ in)
The Artist
not illustrated

S95 Maquette for Acrobats
1952-7
Wire and plaster
c.40 cm (15¾ in) high
Repr. *Manchester Evening News*,
6.2.57.

S96 Acrobats
1952-7 [installed 1957] (107)
Concrete with a fibreglass skin
300 cm (118 in) high
Commissioned for Poundswick Gram-
mar School, Wythenshawe, Manchester.
Removed after prolonged vandalism,
and destroyed, late 1970s
see also Cat.Sk19
see fig.26

S97 Maquette for Standing Figure
1956/57 (79)
Plaster
23.5 × 8 × 6.3 cm (9¼ × 3¼ × 2½ in)
The Artist
not illustrated

S98 Standing Figure
1956/57 (80)
Aluminium
23 × 8.4 × 6 cm (9 × 3¼ × 2¼ in)
The Artist
Cast of Cat.S97 made in 1979. Editioned
in bronze at the same time
not illustrated

S99 Preliminary study for Trio
1952-7 (78)
Wire and plaster
22 × 8 × 9 cm (8¾ × 3¼ × 3½ in)
The Artist
not illustrated

S100 Trio
1957 (108)
Plaster
219 cm (86¼ in) high
First Exh: Holland Park, 1957 (28).
Illus. in cat.
Contemporary photographs of *Trio*
were used, without the artist's know-
ledge, as an integral part of the sleeve
design for the LP record, CD and cas-
sette of 'Choke' by The Beautiful South,
1990 (Go! Discs Ltd/Polygram Ltd).
Sleeve design by Ryan Art. The same
design was also used on a T-shirt, spot-
ted by the author in Warwick town
centre, 1992, and Birmingham Bull Ring,
1993
see fig.30

S101 Maquette for Two Figure
group [unexecuted]
Mid-1950s (77)
Wire and plaster
28 × 7 × 9 cm (11 × 2¾ × 3½ in)
The Artist
not illustrated

S102 Full Fathom Five
1957 (122)
Plaster
68.5 cm high × 188 cm wide (27 × 74 in)
First Exh: Arts Council, 1957

S103 Startled Pair
1957 (127)
Lead
33 cm (13 in) high
First Exh: RBD, 1958 (35)
not illustrated

S104 Friends
1957 (128)
Lead
22.9 cm (9 in) high
First Exh: RBD, 1958 (36)
not illustrated

S105 Cubic Five
1957 (118)
Lead: 5 elements
14.4 × 11 × 11.4 cm (5¾ × 4¼ × 4½ in)
First Exh: RBD, 1958 (40). Has also been
displayed with the elements in line
under the title *Quebique Queue*.
Inscr: Numbers I to V marked on the
base of each element
The Artist
Editioned in bronze

S106 Critics
1957 (110)
Lead
30.5 cm (12 in) high
First Exh: RBD, 1958 (41)
Private Collection, Yorkshire
see fig.121

S107 Gossip Game
1957
Lead
12.5 cm (5 in) high
First Exh: RBD, 1958 (43)
not illustrated

S108 Mother and Child
1957 (112)
Lead
32 × 9 × 7.5 cm (12½ × 3½ × 3 in)
First Exh: RBD, 1958 (44)
Private Collection, Yorkshire
not illustrated

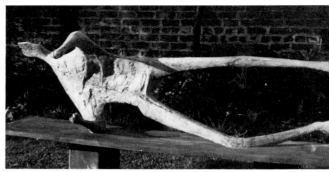

S102

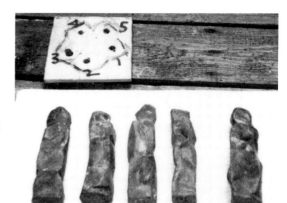

S105

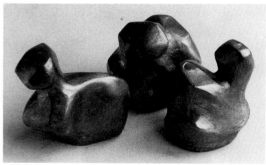

S110

S109 Dumb Man
1957 (126)
Lead
30.5 cm (12 in) high
First Exh: RBD, 1958 (45)
not illustrated

S110 Missiles
1957 (109)
Lead: 3 elements
10.2 cm (4 in) high
First Exh: RBD, 1958 (46)

S111 Weathered Man
1957 (125)
Lead
33 cm (13 in) high
First Exh: RBD, 1958 (47)
not illustrated

S112 Five Women
1957 (114)
Lead: 5 elements on wood base
31.8 × 30.8 × 29.7 cm
($12\frac{1}{2}$ × 12 × $11\frac{3}{4}$ in)
First Exh: RBD, 1958 (49)
York City Art Gallery
Acquired in 1961 in exchange for *Four on a Beach* [Cat.S115] Cat.S112 was originally mounted on a square board, which was exchanged for a rectangular one when the work was acquired by York. The original square base was reunited with the figures in 1991

S113 Skeleton Man
1957 (124)
Lead
28 cm (11 in) high
First Exh: RBD, 1958 (50)
not illustrated

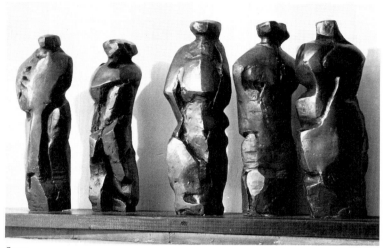

S112

S114 Man and Wife
1957 (111)
Lead
25.4 cm (10 in) high
First Exh: RBD, 1958 (51)
not illustrated

S115 Four on a Beach
1957 (120)
Lead: 4 elements on wood base
24 × 97.8 × 66 cm ($9\frac{1}{2}$ × $38\frac{1}{2}$ × 26 in)
Individual dims:
a: 17 × 13 × 10.8 cm ($6\frac{3}{4}$ × 5 × $4\frac{1}{4}$ in)
b: 15.1 × 11.5 × 21.5 cm (6 × $4\frac{1}{2}$ × $8\frac{1}{2}$ in)
c: 16.8 × 11.3 × 19.3 cm ($6\frac{1}{2}$ × $4\frac{1}{2}$ × $7\frac{1}{2}$ in)
d: 16 × 12 × 15.4 cm ($6\frac{1}{4}$ × $4\frac{3}{4}$ × 6 in)
First Exh: RBD, 1958 (52)
The Artist
Purchased by the Friends of York City Art Gallery in 1958, and exchanged for Cat.S112 in 1961.
Editioned in bronze
see fig.31

S116 Hinged Pair
1957 (113)
Lead
25.4 × 15.2 × 7.6 cm (10 × 6 × 3 in)
First Exh: RBD, 1958 (53)
[as *Flexible Pair*]
Private Collection, Kidderminster

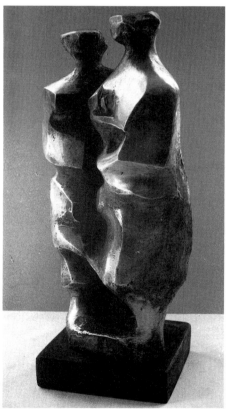

S116

S117 Crumbling Crowd
1957 (119)
Lead
9.4 × 19 × 15.3 cm (3¾ × 7½ × 6 in)
First Exh: RBD, 1958 (54)
The Artist

S118 Tower Woman
1957 (123)
Lead
33 cm (13 in) high
First Exh: RBD, 1958 (55)
not illustrated

S119 Break Up
Lead
1957
11.5 cm (4½ in) high
First Exh: RBD, 1958 (56)
not illustrated

S120 Lazarus
1957 (115)
Lead
33.5 × 9.5 × 7.5 cm (13¼ × 3¾ × 3 in)
First Exh: Wakefield, 1960 (17)
Private Collection, Yorkshire

1958

S121 Swimmers
1958 (131)
Plaster
94 cm (37 in) long
First Exh: Hull, 1988 (48)
Ferens Art Gallery, Hull
Maquette for unexecuted wall relief
proposed for Queens Gardens, Hull.
The final commission was awarded to
Robert Adams. See: Alastair Grieve:
The Sculpture of Robert Adams; London,
Henry Moore Foundation/Lund
Humphries, 1992, pp.73-4
not illustrated

S122 Untitled
1958 (132)
Plaster
94 cm (37 in) long
First Exh: Hull, 1988 (49)
Ferens Art Gallery, Hull
Maquette for unexecuted wall relief pro-
posed for Queens Gardens, Hull
not illustrated

S123 Table Man
1958 (137)
Lead
29.5 × 21.3 × 28 cm (11¾ × 8½ × 11 in)
First Exh: RBD, 1958 (38) [as *Bending
Man*. Also exhibited Wakefield, 1960
(10) as *Bending Man*]
The Artist
'I was making the head play a smaller
role here.' AW
see fig.32

S124 Six by the Sea
1958 (138)
Lead
91.5 cm (36 in) long
First Exh: Wakefield, 1960 (21)

S125 Man and Woman
1958 (133)
Lead: 2 individual elements
a: 38 × 20 × 23.5 cm (15 × 7¾ × 9¼ in)
b: 37.2 × 41 × 17 cm (14¾ × 16 × 6¾ in)
First Exh: Wakefield, 1960 (23)
Cartwright Hall, Bradford City Art
Galleries

S126 Silent Five
1958 (130)
Lead on elmwood base
25 × 79.8 × 46.9 cm (9¾ × 31½ × 18½ in)
First Exh: Wakefield, 1960 (24)
Glynn Vivian Art Gallery, Swansea, pur-
chased 1961 with the aid of The
Gulbenkian Foundation
Editioned in lead
see fig.33

S117

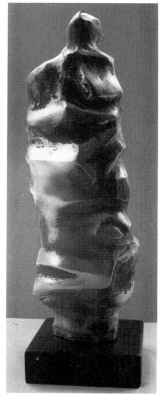
S120

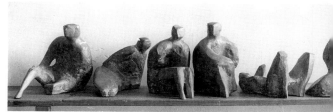
S124

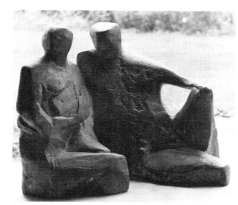

S125

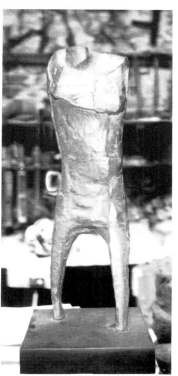

S127

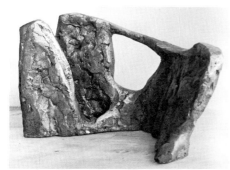

S133

S127 Tower Torso
1958 (136)
Lead
41.5 × 16.3 × 17.2 cm ($16\frac{1}{4}$ × $6\frac{1}{2}$ × $6\frac{3}{4}$ in)
The Artist

S128 Limbo Figures
1958 (135b-zz)
Lead: 26 elements within concrete structure, Cat.S129
a: 14.6 × 21 × 8 cm ($5\frac{3}{4}$ × $8\frac{1}{4}$ × $3\frac{1}{4}$ in)
b: 13.6 × 15 × 8.4 cm ($5\frac{1}{4}$ × 6 × $3\frac{1}{4}$ in)
c: 20.5 × 15.2 × 18.5 cm (8 × 6 × $7\frac{1}{4}$ in)
d: 26.8 × 16.7 × 17.2 cm
($10\frac{1}{2}$ × $6\frac{1}{2}$ × $6\frac{3}{4}$ in)
e: 24 × 19.3 × 18.1 cm ($9\frac{1}{2}$ × $7\frac{1}{2}$ × 7 in)
f: 19.3 × 18.5 × 13.5 cm ($7\frac{1}{2}$ × $7\frac{1}{4}$ × $5\frac{1}{4}$ in)
g: 27 × 20.2 × 18 cm ($10\frac{3}{4}$ × 8 × 7 in)
h: 22.5 × 16 × 12.2 cm ($8\frac{3}{4}$ × $6\frac{1}{4}$ × $4\frac{3}{4}$ in)
i: 20.3 × 11.6 × 14 cm (8 × $4\frac{1}{2}$ × $5\frac{1}{2}$ in)
j: 24.5 × 22.2 × 16.5 cm ($9\frac{3}{4}$ × $8\frac{3}{4}$ × $6\frac{1}{2}$ in)
k: 22.5 × 12 × 14.5 cm ($8\frac{3}{4}$ × $4\frac{3}{4}$ × $5\frac{3}{4}$ in)
l: 26.5 × 16 × 15.5 cm ($10\frac{1}{2}$ × $6\frac{1}{4}$ × 6 in)
m: 20 × 15.5 × 14.5 cm ($7\frac{3}{4}$ × 6 × $5\frac{3}{4}$ in)
n: 24.8 × 17.3 × 15 cm ($9\frac{3}{4}$ × $6\frac{3}{4}$ × 6 in)
o: 21.7 × 17 × 13 cm ($8\frac{1}{2}$ × $6\frac{3}{4}$ × 5 in)
p: 22 × 14 × 17 cm ($8\frac{3}{4}$ × $5\frac{1}{2}$ × $6\frac{3}{4}$ in)
q: 23.4 × 14 × 14 cm ($9\frac{1}{4}$ × $5\frac{1}{2}$ × $5\frac{1}{2}$ in)
r: 9.9 × 38.5 × 10.5 cm ($3\frac{3}{4}$ × 15 × 4 in)
s: 6.3 × 10.7 × 34 cm ($2\frac{1}{2}$ × $4\frac{1}{4}$ × $13\frac{1}{2}$ in)
t: 5 × 9.5 × 30 cm (2 × $3\frac{3}{4}$ × $11\frac{3}{4}$ in)
u: 4.6 × 8.5 × 29.5 cm ($1\frac{3}{4}$ × $3\frac{1}{4}$ × $11\frac{1}{2}$ in)
v: 9.2 × 9 × 30 cm ($3\frac{1}{2}$ × $3\frac{1}{2}$ × $11\frac{3}{4}$ in)
w: 15.5 × 13 × 10 cm (6 × 5 × 4 in)
x: 16.2 × 12.4 × 9.5 cm ($6\frac{1}{4}$ × $4\frac{3}{4}$ × $3\frac{3}{4}$ in)
y: 15 × 12.4 × 11 cm (6 × $4\frac{3}{4}$ × $4\frac{1}{4}$ in)
z: 14.8 × 11 × 11.5 cm ($4\frac{3}{4}$ × $4\frac{1}{4}$ × $4\frac{1}{2}$ in)
First Exh: Middelheim, 1959 (150)
see also Cat.Sk33
see fig.34
The Artist

S129 Limbo Structure
1958 (135a)
Concrete
107 × 152.5 × 45 cm (42 × 60 × $17\frac{3}{4}$ in)
First Exh: Middelheim, 1959 (100)
The Artist
This concrete structure, which has been standing in the artist's garden since the early 1960s, was the intended home for 26 lead figures, Cat.S128a-z
see fig.34

S130 Eight and One
1958
Lead
First Exh: WRA, 1958 (59)
not illustrated

S131 Three Seated Figures
1958
Lead
First Exh: WRA, 1958 (60)
S130 and S131 may both have been variations of *Limbo Figures*, Cat.S128
not illustrated

1959

S132 Icarus
1959 (151)
Plaster
248.9 cm (98 in) high
First Exh: Wakefield, 1960 (34)
see fig.38

S133 Rocky Figure
1959 (141)
Lead
39.4 × 21.6 × 22.9 cm ($15\frac{1}{2}$ × $8\frac{1}{2}$ × 9 in)
First Exh: Wakefield, 1960 (25)
Private Collection, Lancashire

S134 Bent Arm Torso
1959 (139)
Lead
34.3 × 28 × 39 cm ($13\frac{1}{2}$ × 11 × 16 in)
First Exh: Wakefield, 1960 (26)
Private Collection, London
not illustrated

S135 Spine
1959 (149)
Concrete
182.9 cm (72 in) high
Exh: Wakefield, 1960 (35)
Illus. in cat.

S136 Survivor
1959 (142)
Concrete
137 cm (54 in) long
First Exh: Wakefield, 1960 (36)

S137 Signature
1959 (145)
Concrete
182.9 cm (72 in) long
First Exh: Wakefield, 1960 (37)
Private Collection, Yorkshire
see also Cat.Sk32
see fig.40

S138 Reject
1959 (152)
Concrete
96.5 cm (38 in) long
First Exh: Wakefield, 1960 (38)

S139 Seated Pair
1959 (148)
Concrete
55.9 cm (22 in) long
First Exh: Wakefield, 1960 (39)
not illustrated

S140 Long Wall
1959 (143)
Concrete
65.5 × 105 × 10 cm ($25\frac{3}{4}$ × $41\frac{1}{4}$ × 4 in)
First Exh: Wakefield, 1960 (40)
The Artist
Fixed to the exterior of the artist's barn
workshop. Cut down in size by him
not illustrated

S141 Squatter
1959 (144)
Concrete, coloured
38.5 × 27 × 24 cm ($15\frac{1}{4}$ × $10\frac{3}{4}$ × $9\frac{1}{2}$ in)
First Exh: Wakefield, 1960 (41)
The Artist
see fig.39

S142 Sleeper
1959 (147)
Concrete
48.3 cm (19 in) long
First Exh: Wakefield, 1960 (42)
not illustrated

S143 Two Squatters
1959 (153)
Concrete
43.2 cm (17 in) high
First Exh: Wakefield, 1960 (43)
not illustrated

S144 Neptune
1959 (140)
Concrete, coloured
37.5 × 71.1 × 27.3 cm
($14\frac{3}{4}$ × 28 × $10\frac{3}{4}$ in)
First Exh: Wakefield, 1960 (44)
Arts Council Collection
see fig.42

S145 The Cudgel
1959 (150)
Bronzed cement
First Exh: Liverpool, John Moores
Exhibition, 1959 (157)
not illustrated

S146 Column
The artist believes he made this in the
late 1950s. It may be later, mid-1960s
(166)
Lead
47.6 × 7.8 × 7.4 cm ($18\frac{3}{4}$ × 3 × 3 in)
The Artist
One of two *Column* sculptures made at
the same time. The artist believes he has
melted the other one down

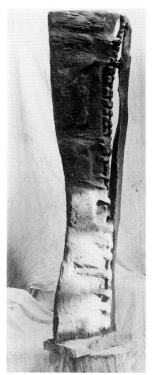

S135

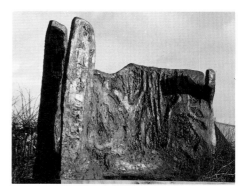

S136

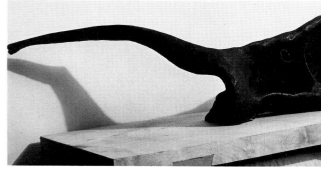

S138

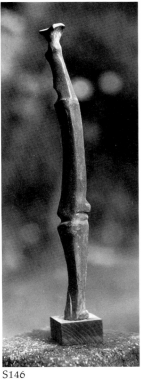
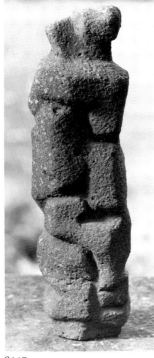

S146

S147

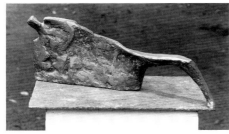

S151

S147 Pair
late 1950s (170)
Concrete
36.3 × 11.5 × 9.5 cm (14¼ × 4½ × 3¾ in)
The Artist

S148 Apostles
late 1950s (169)
Lead: 12 elements [only 9 have come to light]
a: 16.5 × 9 × 12 cm (6½ × 3½ × 4¾ in)
b: 11.5 × 16 × 7 cm (4½ × 6¼ × 2¾ in)
c: 10 × 15.5 × 6.5 cm (4 × 6 × 2½ in)
d: 18 × 9 × 10 cm (7 × 3½ × 4 in)
e: 20 × 10 × 12 cm (7¾ × 4 × 4¾ in)
f: 19 × 11 × 12 cm (7½ × 4¼ × 4¾ in)
g: 7 × 15 × 8 cm (2¾ × 6 × 3¼ in)
h: 18 × 10 × 15 cm (7 × 4 × 6 in)
i: 20 × 10 × 15 cm (7¾ × 4 × 6 in)
Private Collection, Oxfordshire
not illustrated

1960

S149 Remnant
late 1950s – early 1960s (171)
First Exh: Newcastle, 1974 (15)
not illustrated

S150 Lump
late 1950s – early 1960s (172)
Lead
First Exh: Newcastle, 1974 (10)
not illustrated

S151 Arched Leg
1960 (184)
Lead
16.7 × 50.3 × 12 cm (6½ × 19¾ × 4¾ in)
First Exh: Wakefield, 1960 (27)
The Artist
Editioned in bronze. 'Sense of an impregnable wall.' AW

S152 Resurrection
1960
Lead: 9 reclining figures arranged left to right on a narrow wooden base 183 cm (72 in) long;
a: 11 × 40.7 × 15.2 cm (4¼ × 16 × 6 in)
b: 10 × 39 × 12.5 cm (4 × 15¼ × 5 in)
c: 14 × 40.5 × 15.2 cm (5½ × 16 × 6 in)
d: 19 × 34 × 11.5 cm (7½ × 13¼ × 4½ in)
e: 9.5 × 32 × 14 cm (3¾ × 12½ × 5½ in)
f: unknown
g: 14.2 × 23 × 16 cm (5½ × 9 × 6¼ in)
h: 16.3 × 28.5 × 9 cm (6½ × 11¼ × 3½ in)
i: 23 × 24.5 × 11.5 cm (9 × 9¾ × 4½ in)
First Exh: Wakefield, 1960 (28)
The Artist
Some figures have been editioned in bronze

S153 Adam and Eve
1960 (180)
Lead
Adam: 11 × 15 × 11 cm (4¼ × 6 × 4¼ in)
Eve: 9 × 23 × 9 cm (3½ × 9 × 3½ in)
First Exh: Wakefield, 1960 (29)
Private Collection, Cambridge
not illustrated

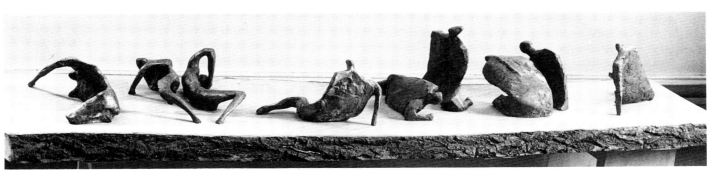

S152

S154 Resting Place
1960
Lead
61 cm (24 in) long
First Exh: Wakefield, 1960 (30)
not illustrated

S155 Tower
1960 (185)
Lead
$36.9 \times 9 \times 22$ cm ($4\frac{1}{2} \times 3\frac{1}{2} \times 8\frac{3}{4}$ in)
First Exh: Wakefield, 1960 (31)
The Artist
not illustrated

S156 Fishermen
1960 (181)
Lead: 2 elements
a: $62.2 \times 26.6 \times 23$ cm
($24\frac{1}{2} \times 10\frac{1}{2} \times 9$ in)
b: $58.4 \times 25.4 \times 17.8$ cm ($23 \times 10 \times 7$ in)
First Exh: Wakefield, 1960 (32)
[One figure only, as *Fisherman*]
Private Collection, London

S157 Crawler
1960 (186)
Lead
$6 \times 48.8 \times 12.4$ cm ($2\frac{1}{4} \times 19\frac{1}{4} \times 4\frac{3}{4}$ in)
First Exh: Wakefield, 1960 (33)
The Artist

S158 Crawling Man
1960 (179)
Lead
51 cm (20 in) long
First Exh: YSP, 1981 (55)
Purchased from the artist by the Friends
of Birmingham City Museum and Art
Gallery in 1962. On loan to the gallery
until 1979 when it was sold by the
Friends at auction.
Private Collection
see fig.35

S159 Seated Figure
1960 (146)
Concrete
122 cm (48 in) long
First Exh: Wakefield, 1960 (45)

S160 Sphinx
1960 (187)
Concrete
116.8 cm (46 in) long
First Exh: Wakefield, 1960 (46)
Rediscovered in a mutilated state by the
artist in a hedge bottom in his garden,
May 1981

S161 Man Leaning Back
1960 (188)
Concrete
63.5 cm (25 in) high
First Exh: Wakefield, 1960 (47)
The Artist [A fragment only survives]
see fig.41

S162 Broad Back
1960 (189)
Concrete
86.4 cm (34 in) long
First Exh: Wakefield, 1960 (48)
not illustrated

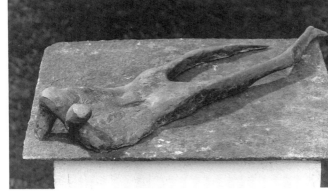

S157

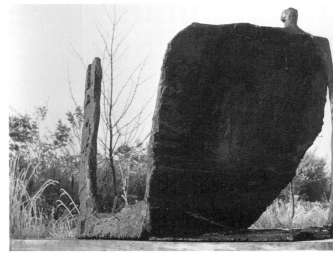

S159

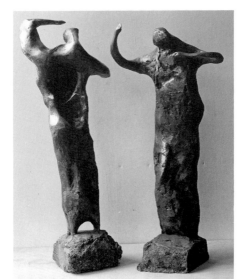

S156

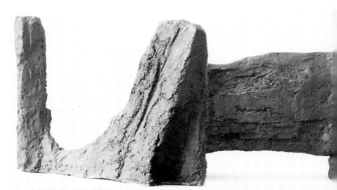

S160

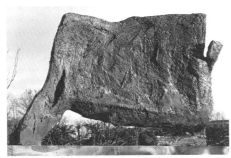

S163

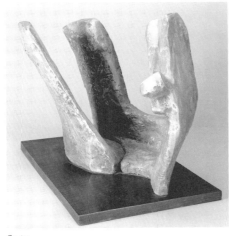

S164

S163 Shield
1960 (190)
Concrete
137.2 cm (54 in) long
First Exh: Wakefield, 1960 (49)

S164 Yawner
1960
Concrete
43 cm (17 in) high
First Exh: Wakefield, 1960 (50)
Cast in aluminium, 1980

S165 Shore Figure
1960 (178)
Concrete
53 × 60 × 42 cm (20¾ × 23½ × 16½ in)
First Exh: Wakefield, 1960 (51) [as *Slab Figure*]
Wakefield City Art Gallery
see fig.36

S166 Scribe
1960 (191)
Concrete
68.6 cm (27 in) long
First Exh: Wakefield, 1960 (52)
see fig.37

S167 Swimmer
1960 (192)
Concrete
76.2 cm (30 in) long
First Exh: Wakefield, 1960 (53)
not illustrated

S168 Thrower
1960 (183)
Concrete
47 × 54 × 20 cm (18½ × 21¼ × 7¾ in)
First Exh: Wakefield, 1960 (54)
The Artist

S169 Egyptian
1960 (193)
Concrete
76.2 cm (30 in) long
First Exh: Wakefield, 1960 (55)

S170 Doubled Sleeper
1960 (194)
Concrete
68.6 cm (27 in) long
First Exh: Wakefield, 1960 (56)

S168

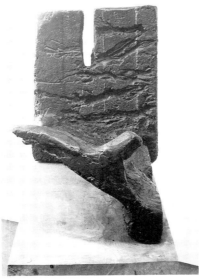

S169

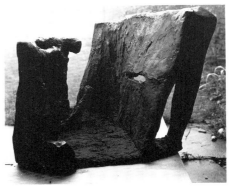

S170

S171 Iris
1960 (195)
Concrete
55.9 cm (22 in) high
First Exh: Wakefield, 1960 (57)
not illustrated

S172 Sleeping Torso
1960 (182)
Concrete
$15 \times 90 \times 136$ cm ($6 \times 35\frac{1}{2} \times 53\frac{1}{2}$ in)
First Exh: Wakefield, 1960 (58)
The Artist
Overgrown in the artist's garden, and in
use as a bird bath
not illustrated

S173 Shell
1960 (196)
Concrete
182.9 cm (72 in) long
First Exh: Wakefield, 1960 (59)

S174 Barricade
1960 (197)
Concrete
129.5 cm (51 in) high
First Exh: Wakefield, 1960 (60)
not illustrated

S175 Hulk
early 1960s (174)
Lead
$9.7 \times 44.5 \times 12.5$ cm ($3\frac{3}{4} \times 17\frac{1}{2} \times 5$ in)
The Artist
'Betrays the last whiffs of body, chest,
pelvis and so on, but no head now. Tun-
nelling through was of great importance
at this period.' AW

S176 Boss
early 1960s (175)
Lead
First Exh: Newcastle, 1974 (9)
not illustrated

S177 Spoon Figure
early 1960s (176)
Lead
First Exh: York, 1973 (19)
not illustrated

1961

S178 Ring and Wall
1961 (209)
Lead: 2 elements on wooden base
$23 \times 40 \times 21$ cm ($9 \times 15\frac{3}{4} \times 8\frac{1}{4}$ in)
First Exh: Leeds, 1962 (27)
The Artist
Editioned in bronze
see also Cat.Sk41

S179 Twisting Torso
1961 Lead
$40.6 \times 8.9 \times 6.4$ cm ($16 \times 3\frac{1}{2} \times 2\frac{1}{2}$ in)
First Exh: Leeds, 1962 (28)
Private Collection, Leeds
see fig.46

S180 Archway
1961 (218)
Lead
38.1 cm (15 in) high
First Exh: Leeds, 1962 (29)
Editioned in bronze

S181 Secret
1961 (217)
Lead
22.9 cm (9 in) long
First Exh: Leeds, 1962 (30)
not illustrated

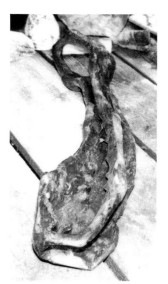

S175

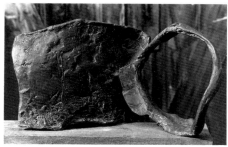

S178

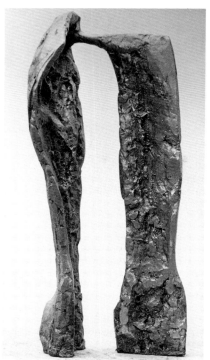

S180

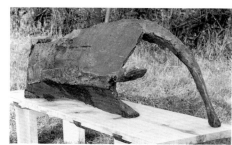

S173

S182

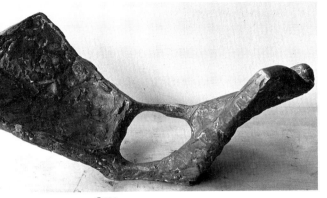

S183

S184

S182 Propeller
1961 (198)
Lead
11 × 39 × 12.8 cm ($4\frac{1}{4}$ × $15\frac{1}{4}$ × 5 in)
First Exh: Leeds, 1962 (31)
The Artist
Editioned in bronze and aluminium
see also Cats Sk40, 41

S183 Ring Torso
1961 (211)
Lead
16.1 × 39 × 18.5 cm ($6\frac{1}{4}$ × $15\frac{1}{4}$ × $7\frac{1}{4}$ in)
First Exh: Leeds, 1962 (32) [listed as
Wing Torso]
The Artist

S184 Coil
1961 (215)
Lead
15.4 × 31.3 × 13.6 cm (6 × $12\frac{1}{4}$ × $5\frac{1}{4}$ in)
First Exh: Leeds, 1962 (33)
The Artist

S185 Dish
1961 (208)
Lead
19 × 75.8 × 26.5 cm ($7\frac{1}{2}$ × $29\frac{3}{4}$ × $10\frac{1}{2}$ in)
First Exh: Leeds, 1962 (34)
The Artist

S186 Threaded Spine
1961 (212)
Lead
20.1 × 34 × 16 cm (8 × $13\frac{1}{2}$ × $6\frac{1}{4}$ in)
First Exh: Leeds, 1962 (35)
The Artist
see fig.47

S187 Balancer
1961 (210)
Lead
22.3 × 56.7 × 16.5 cm ($8\frac{3}{4}$ × $22\frac{1}{4}$ × $6\frac{1}{2}$ in)
First Exh: Leeds, 1962 (36)
The Artist

S188 Rolling Torso
1961 (219)
Lead
22.9 cm (9 in) long
First Exh: Leeds, 1962 (37)
not illustrated

S189 Roller
1961 (214)
Lead
17.4 × 29 × 15.5 cm ($6\frac{3}{4}$ × $11\frac{1}{2}$ × 6 in)
First Exh: Leeds, Queen Square Gallery,
1964
Private Collection, Lancashire
Editioned in bronze
not illustrated

S185

S187

S190 Trio on Beach
1961 (213)
Lead: 3 elements on wooden base
41.5 × 73.4 × 24.5 cm
($16\frac{1}{4} \times 28\frac{3}{4} \times 9\frac{3}{4}$ in)
First Exh: Hull, 1988 (31)
The Artist

S191 Bowling Torso
1961 (204)
Bronze
74 × 36.8 × 40.5 cm (29 × $14\frac{1}{2}$ × 16 in)
First Exh: Leeds, 1962 (26)
Senior Common Room Club, University
of Leeds
Editioned in bronze
see fig.44

S192 Crocodile Play Sculpture, with two abstract mural reliefs
1961
Concrete
40 × 683 cm ($15\frac{3}{4}$ × 264 in)
Rolleston Infant School, Hillsborough
Road, Glen Parva, Leicester
The mural reliefs have been removed

S193 Atlas
1961 (205)
Aluminium
149 × 67.5 × 35.5 cm
($58\frac{3}{4} \times 26\frac{1}{2} \times 14$ in)
First Exh: Leeds, 1962 (21)
The Artist
see also Cat.Sk41
see fig.45

S194 Prop
1961 (207)
Aluminium
94.5 × 46.9 × 30.5 cm (37 × $18\frac{1}{2}$ × 12 in)
First Exh: Leeds, 1962 (22)
The Artist

S195 Flowering Torso
1961 (202)
Aluminium
139.7 × 68.5 × 35.5 cm (55 × 27 × 14 in)
First Exh: Leeds, 1962 (23)
Private Collection, Hampshire

S196 Wall and Ring
1961 (203)
Aluminium
97 × 181.5 × 63 cm (38 × $71\frac{1}{2}$ × 25 in)
First Exh: Leeds, 1962 (24)
The Artist
see also Cat.Sk41
see illustration p.6

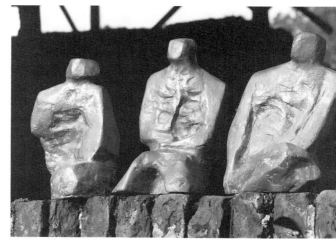

S190

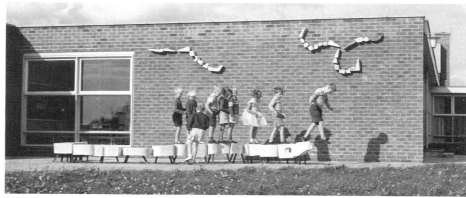

S192

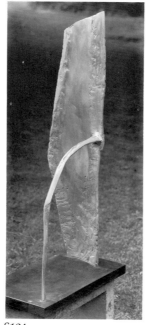

S194

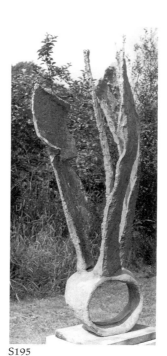

S195

S196

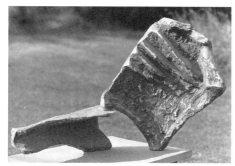

S197

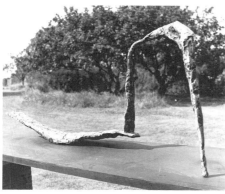

S204

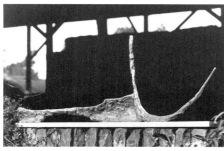

S205

S197 Slatted Torso
1961 (216)
Aluminium
83.8 cm (33 in) long
First Exh: Leeds, 1962 (25)
Destroyed by the artist

S198 Effigy
1962 (239)
Lead
43.2 cm (17 in) long
First Exh: Leeds, 1962 (53)
not illustrated

S199 Hook Torso
1962 (230)
Bronze
177.2 × 40.7 × 52 cm
($69\frac{3}{4}$ × 16 × $20\frac{1}{2}$ in)
First Exh: Leeds, 1962 (52)
Private Collection, Buckinghamshire
There is a further cast of this work in
bronze
see fig.52

S200 Ring Flower
1962 (222)
Bronze
55 × 19 × 10 cm ($21\frac{3}{4}$ × $7\frac{1}{2}$ × 4 in)
First Exh: Menston, 1968 (5)
Private Collection, Yorkshire
see fig.51

S201 Radar Head
1962 (238)
Concrete
78.8 cm (31 in) high
First Exh: Leeds, 1962 (41)
not illustrated

S202 Perspective
1962 (237)
Concrete
182.9 cm (72 in) long
First Exh: Leeds, 1962 (51)
not illustrated

S203 Entrance
1962 (235)
Aluminium
111.6 × 127.3 × 23.1 cm (44 × 50 × 9 in)
First Exh: Leeds, 1962 (38)
The Artist
see fig.53

S204 Square Arch
1962 (234)
Aluminium
53.5 × 117 × 54 cm (21 × 46 × $21\frac{1}{4}$ in)
First Exh: Leeds, 1962 (39)
The Artist

S205 Arc [aka *Arc Torso*]
1962 (221)
Aluminium
48 × 131 × 19.8 cm ($18\frac{3}{4}$ × $51\frac{1}{2}$ × $7\frac{3}{4}$ in)
First Exh: Leeds, 1962 (40)
The Artist
Editioned in bronze

S206 Observer
1962 (220)
Aluminium
183 × 81.3 × 35.5 cm (72 × 32 × 14 in)
First Exh: Leeds, 1962 (42)
Private Collection, New York
see also Cat.S243
see fig.49

S207 Armour
1962 (228)
Aluminium
110 × 120 × 50 cm ($43\frac{1}{4}$ × $47\frac{1}{4}$ × $19\frac{3}{4}$ in)
First Exh: Leeds, 1962 (43) [also
exhibited as *Leaning Trio*; and
Three Backs]
The Artist
see fig.50

S208 Flail
1962 (236)
Aluminium
114.3 cm (45 in) long
First Exh: Leeds, 1962 (44)
Destroyed by the artist.
see also Cat.S230 and Cat.Sk39
not illustrated

S209 Leg
1962 (225)
Aluminium
139.7 cm (55 in) high
First Exh: Leeds, 1962 (45)
Private Collection, York
not illustrated

S210 Leaves
1962 (226)
Aluminium
53.3 × 124.5 × 34.3 cm
($21\frac{3}{4}$ × 49 × $13\frac{1}{2}$ in)
First Exh: Leeds, 1962 (46)
Private Collection, London

S211 Big Leaves
1962 (231)
Aluminium
172 × 145.5 × 100 cm
($67\frac{3}{4}$ × $57\frac{1}{4}$ × $39\frac{1}{4}$ in)
First Exh: Leeds, 1962 (47)
The Artist
see fig.56

S212 Wing
1962 (227)
Aluminium
116.7 × 93.5 × 44.5 cm
(46 × $36\frac{3}{4}$ × $17\frac{1}{2}$ in)
First Exh: Leeds, 1962 (48)
Abbot Hall Art Gallery, Kendal, pur-
chased 1963 with a grant from the
Gulbenkian Foundation

S213 Tower 1
1962 (240)
Aluminium
233.7 cm (92 in) high
First Exh: Leeds, 1962 (49) [as *Tower*]
see also Cat.S245

S214 Moon
1962 (223)
Aluminium
310 × 80 × 42 (122 × $31\frac{1}{2}$ × $16\frac{1}{2}$ in)
First Exh: Leeds, 1962 (50)
Leeds City Art Galleries, purchased
1962

S215 Scoop
1962 (233)
Aluminium
33.8 × 53 × 27 cm ($13\frac{1}{4}$ × $20\frac{3}{4}$ × $10\frac{3}{4}$ in)
First Exh: Leeds, 1962 (54)
Harris Museum and Art Gallery, Preston
Editioned in aluminium
see fig.58

S216 Figures: Flamborough Head
1962 (229)
Aluminium, wall mounted
a: 300 × 72 × 17 cm (118 × $28\frac{1}{4}$ × $6\frac{3}{4}$ in)
b: 280 × 84 × 20 cm ($110\frac{1}{4}$ × 33 × $7\frac{3}{4}$ in)
The Sadler Building, University of Leeds

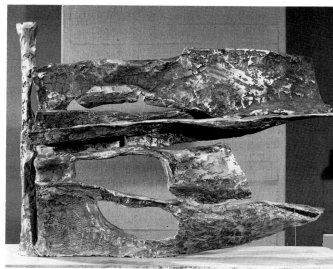

S212

S210

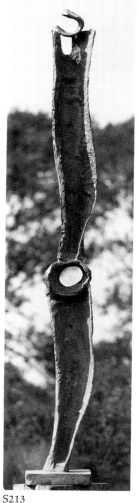

S213

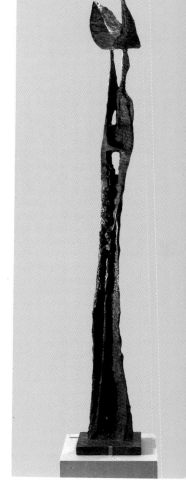

S214

S216a S216b

1963

S217 Fragment
early 1960s; ?1963 (294)
Lead
35 × 121.7 × 28.3 cm
($13\frac{3}{4}$ × $47\frac{1}{2}$ × $11\frac{1}{4}$ in)
First Exh: Menston, 1973 [aluminium
cast]
Cast in aluminium (Coll: The Artist) in
1973 from the lost lead original

S218 Trumpet
1963 (251)
Bronze
43.2 cm (17 in) high
First Exh: Bradford, 1963
not illustrated

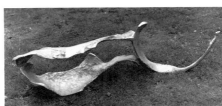

S217

S219 Tower 2
1963 (252)
Bronze
76.2 cm (30 in) high
First Exh: Bradford, 1963 [as *Tower*]
From the evidence of dimensions, it is
likely that Cats S213 and S219 are
separate works, even though they were
both exhibited at different times under
the title *Tower*
not illustrated

S220 Torque
1963 (241)
Aluminium
185.5 cm (69 in) high
First Exh: Bradford, 1963
Private Collection, Yorkshire

S221 Graft
1963 (243)
Aluminium
180 × 30 × 27 cm ($70\frac{3}{4}$ × $11\frac{3}{4}$ × $10\frac{1}{2}$ in)
First Exh: Bradford, 1963
Private Collection, Yorkshire
not illustrated

S222 Relic
1963 (249)
Aluminium
59 × 41.5 × 17.1 cm ($23\frac{1}{4}$ × $16\frac{1}{4}$ × $6\frac{3}{4}$ in)
First Exh: Bradford, 1963
The Artist
Editioned in aluminium

S223 Bow
1963 (245)
Aluminium
222 cm ($87\frac{1}{2}$ in) high
First Exh: Rowan, 1964 (4)
The Artist
see fig.57

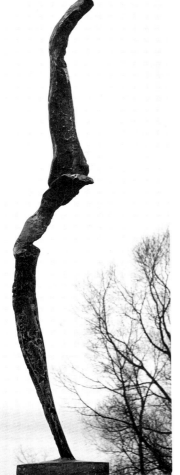

S220

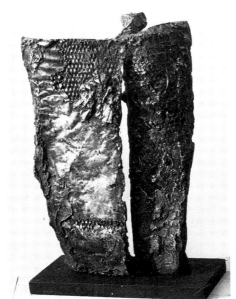

S222

S224 Stalk
1963 (250)
Aluminium
205.7 × 18 × 29.8 cm (81 × 7 × 11¾ in)
First Exh: Rowan, 1964 (5)
Calderdale Museums and Arts, Halifax;
presented by Arthur Haigh, 1982

S225 Frond
1963 (248)
Aluminium
124 × 100 × 55 cm (48¾ × 39¼ × 21½ in)
First Exh: Rowan, 1964 (8)
The Artist
Truncated by the artist in the 1980s
from a larger form, which AW found
'too distracting'. The work had been
exhibited in its original form until at
least 1986
see fig.54

S226 Project
1963 (246)
Aluminium
198 cm (78 in) high
First Exh: Rowan, 1964 (18)
The Artist

S227 Wound
1963 (243)
Aluminium
205 × 67.5 × 39.5 cm
(80¾ × 26½ × 15½ in)
First Exh: Rowan, 1964 (19)
The Artist
see fig.59

S228 Guillotine [aka *Sector*]
1963 (247)
Aluminium
105 × 34.5 × 36 cm (41¼ × 13½ × 14 in)
First Exh: York, 1973 (55)
The Artist
AW changed the title of this work to
Sector in the 1980s
see fig.60

1964

S229 Ring and Wall
1964 (203)
Aluminium
100 × 250 × 70 cm (39½ × 98½ × 27½ in)
Commissioned for Bretton Hall College
of Education, installed March 1964
Bretton Hall College, Yorkshire
see fig.61

S230 Flail
1964 (255)
Aluminium
259 × 40.6 × 30.5 cm (102 × 16 × 12 in)
First Exh: Rowan, 1964 (6)
Private Collection, Cheshire
Shares title with the destroyed work,
Cat.S208
see also Cat.Sk39

S231 Corona
1964 (259)
Aluminium
160 × 107 × 64 cm (63 × 42 × 25¼ in)
First Exh: Rowan, 1964 (7)
The Artist
see fig.64

S232 Split Back
1964 (257)
Aluminium
197 × 44 × 30.5 cm (77½ × 17¼ × 12 in)
First Exh: Rowan, 1964 (9)
The Artist
see col.pl.IV and fig.48

S233 Mace
1964 (260)
Aluminium
121.9 cm (48 in) high
First Exh: Rowan, 1964 (10)
Private Collection, Leicestershire

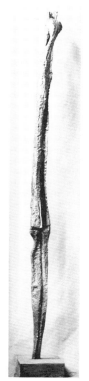
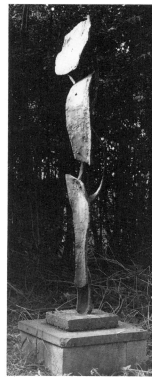

S224 S226

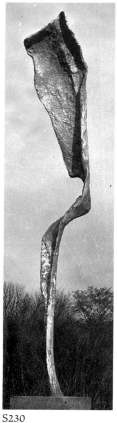
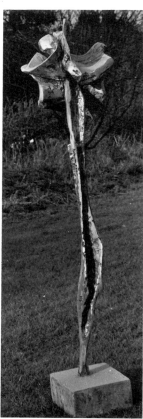

S230 S233

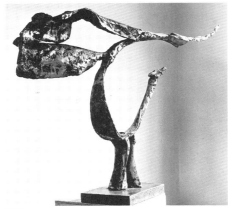

S234

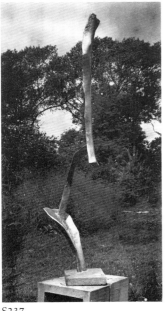

S237

S234 Flower
1964 (256)
Aluminium
94 cm (37 in) long
First Exh: Rowan, 1964 (11)
Private Collection, Sussex

S235 Tenement
1964 (261)
Aluminium
200.7 cm (79 in) high
First Exh: Rowan, 1964 (16)
not illustrated

S236 Husk
1964 (254)
Aluminium
190.5 cm (75 in) high
First Exh: Rowan, 1964 (17)
Private Collection, Buckinghamshire
see fig.55

S237 Damocles
1964 (253)
Aluminium
$174 \times 61 \times 61$ cm ($68\frac{1}{2} \times 24 \times 24$ in)
First Exh: York, 1973 (48)
Private Collection, Yorkshire

S238 Eye
1964
Aluminium
First Exh: Leeds, Queen Square Gallery, 1964
not illustrated

S239 Habitat
1964 (258)
Aluminium
$70 \times 59.5 \times 47.3$ cm
($27\frac{1}{2} \times 23\frac{1}{2} \times 18\frac{1}{2}$ in)
First Exh: Tate, CAS, 1965
The Artist
see fig.62

1965

S240 Flower
1965
Bronze
42 cm ($16\frac{1}{2}$ in) high
Private Collection

S241 Sign
1965 (263)
Aluminium
71.1 cm (28 in) high
First Exh: Menston, 1968 (12)
see fig.63

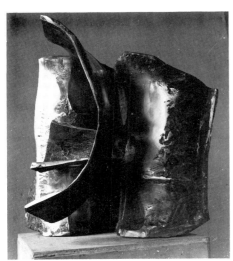

S240a

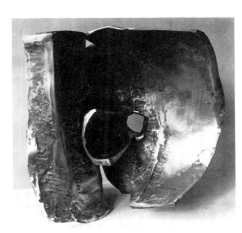

S240b

S242 Voyeur
1965 (264)
Aluminium
32.7 × 41 × 26 cm (12¾ × 16¼ × 10¼ in)
First Exh: Manchester, 1971 (20)
Cartwright Hall, Bradford City Art Galleries; purchased from Peterloo Gallery

S243 Ring
1965-9 (295)
Aluminium
190.3 × 186.6 × 35.5 cm
(75 × 73½ × 14 in)
First Exh: Aldbourne, 1969 (32)
The Artist
Editioned in aluminium
'This is my whoop of joy, when I circled
my arms in the air on hearing that an
American collector had bought one of
my sculptures.' [Cat.S206] AW
see fig.65

S244 Juggler and Trick
1965 (281)
Aluminium: 2 elements on stone bases
each 115 × 12.5 × 12.5 cm
(45¼ × 5 × 5 in)
First Exh: Menston, 1968 (14 & 15)
Private Collections, London and Sussex
Editioned in aluminium
see fig.67

S245 Fountain
mid-1960s (265)
Aluminium
This and Cat.S213 are recorded as
having been sited at Morley School,
Leeds. In 1993 the school authorities
had no knowledge of the sculptures ever
having been there

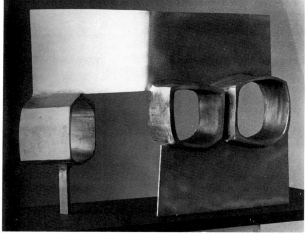

S242

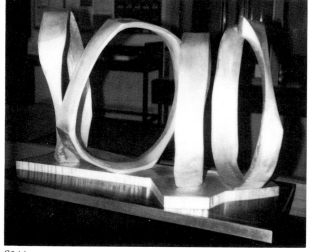

S246

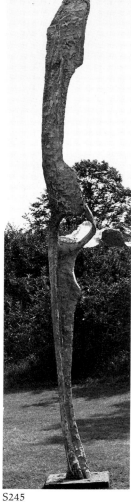

S245

1966

S246 Four Rings
1966 (266)
Aluminium
46.5 × 73 × 44 cm (18¼ × 28¾ × 17¼ in)
Exh: Menston, 1968
Bosworth College, Leicestershire,
presented by Timothy and Eva Rogers
in memory of their son
Editioned in aluminium. A further cast is
at the University of Sheffield, presented
in 1982 by the Sheffield Fine Art Society
to commemorate the centenary of Firth
College

1967

S247 Sign of the Blessing
1967 (267)
Aluminium
243.8 × 25.4 × 20.3 cm (96 × 10 × 8 in)
First Exh: Whitechapel, 1967/68 (59)
St John Fisher R.C. Primary School,
Wigston, Leicestershire (Leicestershire
Education Authority Collection)
Vandalised and removed, 1992

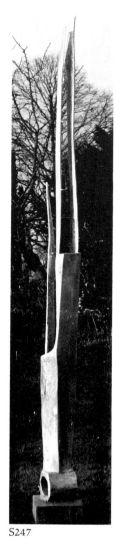

S247

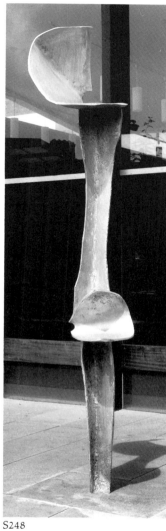

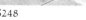

S248

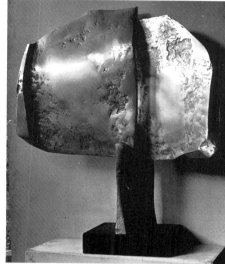

S249

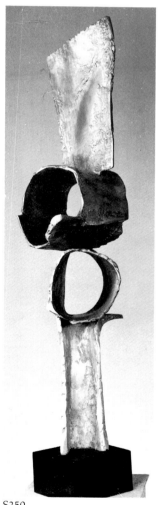

S250

S248 Time Piece
1967 (268)
Aluminium
270 cm (106¼ in) high
Illus W. J. Strachan: *Open Air Sculpture in Britain*; Zwemmer/Tate Gallery, 1984, pp.40/41
Southwark College (Waterloo Centre, The Cut, London SE1)

S249 Heliograph
1967 (269)
Aluminium
96.5 × 76.2 × 28 cm (38 × 30 × 11 in)
First Exh: Whitechapel, 1967/68 (60)
Leicestershire Education Authority Collection: formerly Anstey Latimer Primary School

S250 Word
1967 (299)
Aluminium
Leicester Education Authority Collection

S250a Flower Head
1967
Aluminium
120 × 37 cm (47½ × 14½ in)
King Edward VII Upper School, Burton Road, Melton Mowbray
not illustrated

S251 Untitled
1967 (272)
Aluminium: 2 elements
252 × 167 × 167 cm
(99¼ × 65¾ × 65¾ in)
Illus: Strachan, p.189
University of York. Commissioned for a
site on the turn of the ramp leading to
the University Library.
'The idea started from seeing a big split-
ting rock with a round hole tunnelled
through it on a Devon beach. I com-
bined this with the form of an apple core
left by birds who had pecked all the fruit
away.' AW

S252 Phase
1967 (273)
Aluminium
81 × 66 × 67 cm (32 × 26 × 26¼ in)
First Exh: Menston, 1968 (1)
The Artist
see fig.66

S253 Eclipse
1967 (274)
Aluminium, with paint
177 × 44.5 × 40 cm (69¾ × 17½ × 15¾ in)
First Exh: Menston, 1968 (2)
The Artist
see fig.68

S254 Newton Wonder
1967 (275)
Aluminium
159 × 39.2 × 63.2 cm
(62½ × 15½ × 25 in)
First Exh: Menston, 1968 (3)
The Artist
Variations on the forms of leaf, stem and
fruit. 'Newton Wonder' is a variety of
apple
see fig.68

S255 Gemini
1967 (270)
Aluminium
177.8 × 127 × 86.4 cm (70 × 50 × 34 in)
First Exh: Menston, 1968 (6)
Private Collection, Hertfordshire

S256 Greeting
1967 (262)
Aluminium
99 × 31.5 × 26.5 cm (39 × 12½ × 10½ in)
First Exh: Menston, 1968 (17)
Cartwright Hall, Bradford City Art Gal-
leries; presented by Arthur Haigh
see fig.70

S257 Sunset
1967 (271)
Aluminium
69 × 37 × 105.5 cm (27¼ × 26¼ × 41½ in)
First Exh: Menston, 1968 (18)
Private Collection, Nottinghamshire

1968

**S258 Leeds City Art Gallery Façade:
Idea for Sculpture**
1967-8 (276)
Aluminium, mounted on board
60.6 × 63 cm (23¾ × 24¾ in)
First Exh: Leeds, 1968
Arts Council Collection
Maquette in ten components for a pro-
posed design for a façade relief at Leeds
City Art Gallery. See p.142
not illustrated

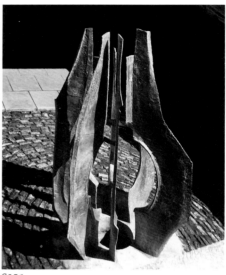

S251

SCULPTURE
IN A
LANDSCAPE
1969

Austin Wright
Gemini 1967

S255

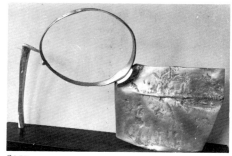

S257

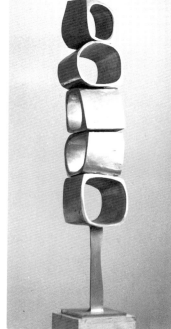

S262

S266

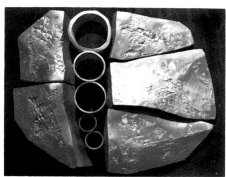

S267

S259 Relief Model of Leeds City Art Gallery Façade, incorporating idea for relief sculpture
1967-8 (277)
Wood and Aluminium
65.4 × 170.2 cm (25¾ × 67 in)
First Exh: Leeds, 1968
Arts Council Collection
See p.142
see fig.69

S260 Flag
1968 (290)
Aluminium
96.5 cm (38 in) high
First Exh: Menston, 1968 (4)
Destroyed
not illustrated

S261 Eye of the Needle
1968 (280)
Aluminium
162.5 × 28 × 28 cm (64 × 11 × 11 in)
First Exh: Manchester, 1975
Royal Northern College of Music, Manchester
not illustrated

S262 Housing Scheme
1968 (278)
Aluminium
201.8 × 11.9 × 12.5 cm (79½ × 4¾ × 5 in)
First Exh: Menston, 1968 (8)
University of Leeds

S263 High Hat
1968 (282)
Aluminium
114 × 54 × 23 cm (45 × 21¼ × 9 in)
First Exh: Menston, 1968 (9)
Private Collection, Oxfordshire
not illustrated

S264 Vane
1968 (317)
Aluminium
76.2 cm (30 in) high
First Exh: Menston, 1968 (11)
Private Collection, Yorkshire
not illustrated

S265 Pair Impair
1968 (289)
Aluminium: 2 elements on wooden base
77 × 62.2 × 45.8 cm (30¼ × 24½ × 18 in)
First Exh: Menston, 1968 (13)
The Artist
see fig.68

S266 Five Tower
1968 (279)
Aluminium
85.5 × 14 × 14 cm (33¾ × 5½ × 5½ in)
First Exh: Menston, 1968 (19)
Private Collections, Devon and Yorkshire
Editioned in aluminium

S267 Split Five
1968 (284)
Aluminium relief on black-painted wood
61 × 60.6 × 8.5 cm (24 × 23¾ × 3¼ in)
First Exh: Menston, 1968 (20)
Private Collections, York
Editioned in aluminium

S268 Mao's Pillow
1968 (291)
Aluminium
14.5 × 23.5 × 36 cm (5¾ × 9¼ × 14¼ in)
First Exh: Menston, 1968 (25)
Private Collection, York
Editioned in aluminium
not illustrated

S269 Spondee
1968 (288)
Aluminium
132 × 46.5 × 39.2 cm
(52 × 18¼ × 15½ in)
First Exh: Manchester, 1971 (4)
The Artist
A spondee is a word of two equal syllables – such as 'spondee'
see fig.68

S270 Conoid
1968 (287)
Aluminium
101 × 34 × 35.6 cm (39¾ × 13½ × 14 in)
First Exh: Manchester, 1971 (5)
The Artist
see fig.68

S271 Clock
1968 (285)
Aluminium on painted wood
138 × 22.8 × 13.3 cm (54¼ × 9 × 5¼ in)
First Exh: Manchester, 1971 (19)
The Artist

S272 Wallscape
1968 (297)
Aluminium on painted wood
130.5 × 40 × 11.8 cm
(51¼ × 15¾ × 4¾ in)
Exh: York, 1973 (69)
The Artist
see fig.75

S273 Tidal
late 1960s (315)
Aluminium on concrete base
121.1 × 28.5 × 9.5 cm
(47¾ × 11¼ × 3¾ in)
The Artist
AW found this in 1992 behind his barn where it must have been lying for more than twenty years
see also Cat.Sk51

S274 Twins
1968 (286)
Aluminium: 4 elements
63 × 158 × 54.5 cm (24¾ × 62¼ × 21½ in)
First Exh: Hull, 1988 (78)
The Artist
not illustrated

S274a Fountain
1968
Aluminium
approx 300 cm (120 in) high
Loughborough University of Technology

1969

S275 Main Road
1969 (293)
Aluminium
303.5 × 39.5 × 30.5 cm
(119½ × 15½ × 12 in)
First Exh: Aldbourne, 1969 (31)
The Artist
Editioned in aluminium

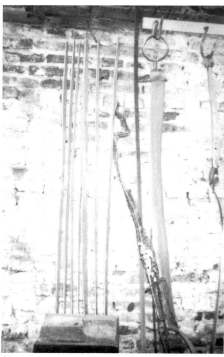

S273

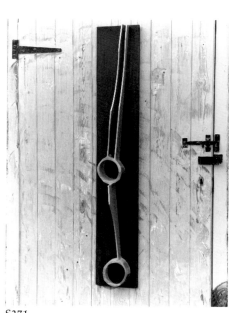

S271

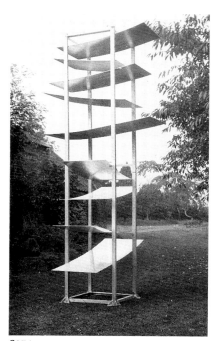

S274a

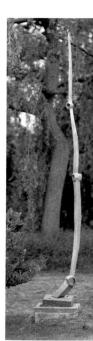

S275

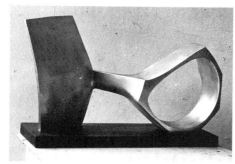

S276

S276 Pusher

1969 (292)
Aluminium
19.5 × 10.5 × 29 cm ($7\frac{1}{2}$ × $4\frac{1}{4}$ × $11\frac{1}{2}$ in)
First Exh: Manchester, 1971 (12)
The Artist
Editioned in aluminium

S277 Resurgence

1969
Aluminium
Maquette for proposed Civic Sculpture
for Darlington (unexecuted). Maquettes
were also submitted by John Hoskin,
John Milne, William Tucker and
Derwent Wise
not illustrated

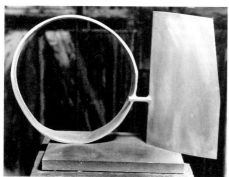

S278

1970

S278 Double [aka *Coastguard*]

1970 (309)
Aluminium
35.5 × 16.5 × 17 cm (14 × $6\frac{1}{2}$ × $6\frac{3}{4}$ in)
First Exh: Richmond Hill Gallery, 1970
The Artist
Editioned in aluminium

S279 Pomona

1970 (310)
Aluminium
35.5 × 54.5 × 15 cm (14 × $21\frac{1}{2}$ × 6 in)
First Exh: Manchester, 1971 (7)
The Artist
Editioned in aluminium

S280 Plant

1970 (312)
Polished brass
42 × 20.3 × 16.5 cm ($16\frac{1}{2}$ × 8 × $6\frac{1}{2}$ in)
First Exh: Manchester, 1971 (17) [as
Plant II]
Private Collection, Hertfordshire
Editioned in brass

S281 Ikones

1970 (308)
Aluminium: 5 hanging elements on
wooden mount
226 × 140 × 32 cm (89 × 55 × $12\frac{1}{2}$ in)
First Exh: Manchester, 1971 (21-6)
The Artist
see fig.72

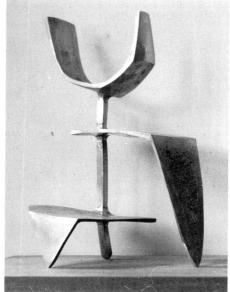

S280

S282 Stance
1970 (307)
Aluminium
156.5 cm (61½ in) high
First Exh: Manchester, 1971 (27)
The Artist

S283 Rotor
1970-1 (313)
Aluminium
First Exh: Menston, 1971 (14)
Private Collection, Yorkshire
not illustrated

**S284 Maquette for unexecuted
sculpture for the University of Hull,
Social Science and Law Building**
1970 (306)
Aluminium: 3 elements on wooden base
23 × 45.5 × 44 cm (9 × 18 × 17¼ in)
First Exh: Hull, 1988 (80)
University of Hull Art Collection,
presented by Professor J.S.G. Wilson,
1988
not illustrated

1971

S285 Semaphore
1971 (314)
Aluminium
Exh: Menston, 1971 (15)
not illustrated

S285a Gordian Knot
1971
Aluminium
450 cm (15 ft approx.)
Bradford Magistrates Court
(installed 1992)
not illustrated

S286 Overture
1971 (318)
Aluminium
91.5 × 81.3 × 35.5 cm (36 × 32 × 14 in)
First Exh: Manchester, 1971 (6)
Curriculum and Professional Develop-
ment Service, Gedling House Resources
Centre, Nottingham

S287 Spout
1971 (319)
Aluminium
56.3 × 49 × 35.2 cm
(22¼ × 19¼ × 13¾ in)
First Exh: Manchester, 1971 (9)
Private Collection, Yorkshire
Editioned in aluminium

S288 Ned Kelly
1971 (320)
Aluminium
25.5 × 14 × 14.5 cm (10 × 5½ × 5¾ in)
First Exh: Manchester, 1971 (15)
Private Collection, Hertfordshire

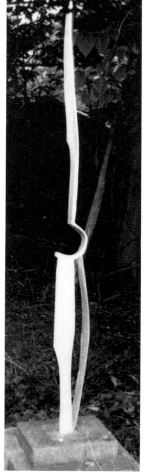

S282

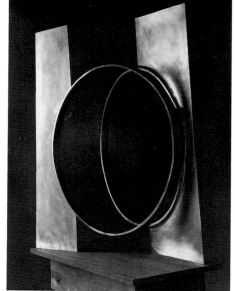

S286

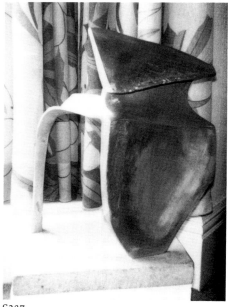

S287

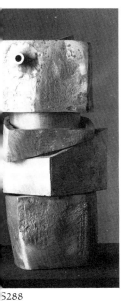

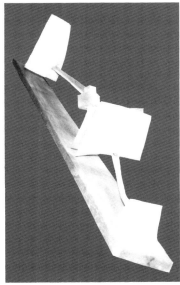

S288

S291

S295

S289 Sculpture in memory of Philip Andrews
1971 (316)
Aluminium on concrete base
174 × 30.5 × 30.5 cm (68½ × 12 × 12 in)
St John's Churchyard, Gressingham, Lancashire
not illustrated

1972

S290 Sarn
1972 (321)
Aluminium and piano wire
290 × 37 × 25 cm (114¼ × 14½ × 9¾ in)
First Exh: York, 1973 (83)
The Artist
not illustrated

S291 Span
1972 (322)
Aluminium on wooden base
31.5 × 171.7 × 23.5 cm
(12½ × 67½ × 9¼ in)
First Exh: York, 1973 (89)
The Artist

1973

S292 Seer
1973 (302)
Aluminium
First Exh: York, 1973 (59)
not illustrated

S293 Anatomists
1973 (327)
Aluminium: 5 elements on wooden mount
278 × 134 × 34 cm
(109½ × 52¾ × 13½ in)
First Exh: York, 1973 (80)
The Artist
not illustrated

S294 Botanical Garden
1973 (326)
Aluminium: 5 elements on concrete bases
a: 276.8 × 30.6 × 28.5 cm
(109 × 12 × 11¼ in)
b: 306.5 × 23.2 × 23 cm
(120¾ × 9¼ × 9 in)
c: 319.5 × 30 × 30.5 cm
(125¾ × 11¾ × 12 in)
d: 262 × 31.3 × 28.3 cm
(103¼ × 12¼ × 11¼ in)
e: 289 × 30.6 × 37 cm
(113¾ × 12 × 14½ in)
First Exh: York, 1973 (81)
The Artist
see also Cat.Sk55
see fig.76

S295 Neigwl
1973 (325)
Aluminium
339.8 cm (133¾ in) high
First Exh: York, 1973 (82)
The Artist

S296 Cilan
1973 (329)
Aluminium
416.5 × 16.5 × 15.2 cm (164 × 6½ × 6 in)
First Exh: York, 1973 (84)
Wakefield City Art Gallery
see also Cat.Sk55
see fig.77

S297 Hanger
1973 (305)
Aluminium
First Exh: York, 1973 (85)
not illustrated

S298 Aquarius
1973 (324)
Aluminium hanging sculpture
238 × 200 × 162 cm
(93¾ × 78¾ × 63¾ in)
First Exh: York, 1973 (86)
The Artist
see also Cat.Sk55
see fig.74

S299 Obst
1973 (323)
Aluminium hanging sculpture
244 × 90 × 90 cm (96 × 35½ × 35½ in)
First Exh: York, 1973 (87)
The Artist
'Obst' is German for 'fruit'
see also Cat.Sk55
see fig.73

1974

S300 Butcher
1974 (328)
Aluminium
260 × 55 × 75 cm (102¼ × 21¾ × 29½ in)
First Exh: Newcastle, 1974 (46)
The Artist
not illustrated

S301 Thread
1974
Aluminium
First Exh: Newcastle, 1974 (55)
not illustrated

S302 Paternoster
1974 (303)
Aluminium
First Exh: Newcastle, 1974 (56)
[*Paternoster 1, 2 & 3* were exhibited in
Manchester, 1974 (33)]
not illustrated

S303 Specimen
1974 (301)
Aluminium
First Exh: Newcastle, 1974 (57)
not illustrated

S304 Napoleon
1974
Aluminium
First Exh: Manchester, 1974 (12)
not illustrated

S305 Unit
1974
Aluminium
First Exh: Manchester, 1974 (24)
not illustrated

S306 Rigg
1974
Aluminium
First Exh: Manchester, 1974 (32)
not illustrated

S307 The Nun
1974 (331)
Aluminium mounted on log
51.5 × 41 × 41 cm (20¼ × 16¼ × 16¼ in)
First Exh: Menston, 1975 (25)
The Artist
Assembled using a cast-off piece from
another work of the 1960s or 1970s

S308 Lleyn
1974 (330)
Aluminium hanging sculpture
587 × 77 × 28 cm (231 × 30¼ × 11 in)
First Exh: YSP, 1981 (26)
The Artist

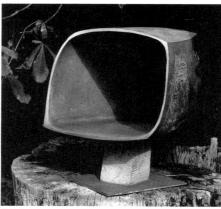

S307

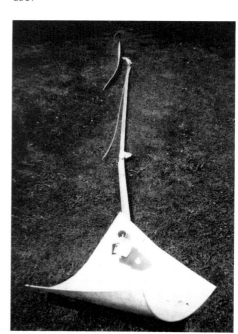

S308

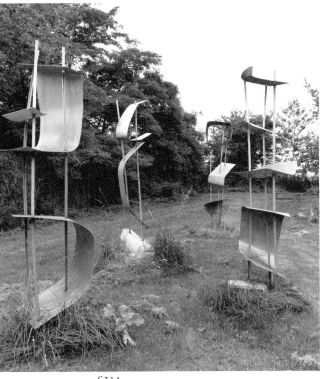

S314

S309 Riffli
1974 (332)
Aluminium
400 cm (157½ in) high
First Exh: Hull, 1988 (88)
The Artist
Inspired by a view in North Wales from
the farm of Riffli Williams
see also Cat.Sk55
see fig.78

1975

S310 Sleeve
1975 (304)
Aluminium
First Exh: Menston, 1975 (20)
not illustrated

S311 Maquette for North Yorkshire Moors Sculpture
1975 (335)
Aluminium: 2 elements
26.5 × 25.5 × 20.5 cm (10½ × 10 × 8 in)
First Exh: YSP, 1981 (23)
The Artist
see fig.79

S312 Sculpture on the Moors: Two Rings
1975-7. Installed 1977 (334)
Aluminium
255 cm (100 in) high
Commissioned by Yorkshire Arts
Association
Sited at Roppa Bank, near Helmsley
Vandalised; now incomplete
see fig.81

1976

S313 Sundial
1976-9. Installed 1979 (296)
Aluminium, laid on gravel
*c.*200 cm (78¾ in) high
Commissioned for Broughton Hall,
Mottramdale, Cumbria
Destroyed
see fig.82

S314 Plantation
1976 (336)
Aluminium: 4 elements
a: 265 × 86 × 86.3 cm
(104¼ × 33¾ × 34 in)
b: 281 × 60.5 × 53 cm
(110½ × 23¾ × 20¾ in)
c: 274 × 75.2 × 74.5 cm
(107¾ × 29½ × 29¼ in)
d: 274 × 81.5 × 82.5 cm
(107¾ × 32 × 32½ in)
First Exh: opening exhibition, YSP,
1977 [as *Quartette*]
The Artist
see also Cat.Sk55

1978

S315 Fountain
1978; installed 1979 (335)
Aluminium
610 × 910 × 910 cm
(240 × 358 × 358 in) (approx)
Commissioned by E.J.Arnold and Son
Ltd to stand in a sprinkler tank in front
of their factory and store in Hunslet,
Leeds
Destroyed
see also Cat.Sk62
see fig.80

1979

S316 Norber
1979 (339)
Aluminium
23 cm (9 in)
First Exh: YSP, 1981 (indoors, 25)
not illustrated

S317 Palazzo Vecchio
1979 (337)
Aluminium
33.5 × 72 × 8.5 cm (13$\frac{1}{4}$ × 28$\frac{1}{4}$ × 3$\frac{1}{4}$ in)
First Exh: YSP, 1981 (indoors, 27)
The Artist

S318 Palazzo del Sol
1979 (338)
Aluminium
27 × 63 × 21 cm (10$\frac{1}{2}$ × 24$\frac{3}{4}$ × 8$\frac{1}{4}$ in)
First Exh: YSP, 1981 (indoors, 28)
Private Collection, London

1980

S319 Perched Couple
1980 (342)
Aluminium
36 × 96.5 × 39.5 cm (14$\frac{1}{4}$ × 38 × 15$\frac{1}{2}$ in)
First Exh: YSP, 1981 (indoors, 26)
The Artist

1981

S320 Checkmate
1981 (344)
Aluminium: 4 elements, each with concrete base
a: 229 × 47 × 37.2 cm
(90$\frac{1}{4}$ × 18$\frac{1}{2}$ × 14$\frac{3}{4}$ in)
b: 236 × 38.2 × 37.4 cm
(93 × 15 × 14$\frac{3}{4}$ in)
c: 307.5 × 33.5 × 34 cm
(121 × 13$\frac{1}{4}$ × 13$\frac{1}{2}$ in)
d: 258.5 × 35.5 × 30.5 cm
(101$\frac{3}{4}$ × 14 × 12 in)
First Exh: YSP, 1981 (outdoors 29)
The Artist
see fig.84

S321 Japanese Garden
1981 (346)
Aluminium
23 × 40.6 × 24 cm (9 × 16 × 9$\frac{1}{2}$ in)
First Exh: YSP, 1981 (indoors 29)
The Artist
see fig.86

S322 Untitled Wall Relief
1981 (345)
Aluminium and steel
720 × 1800 cm (24 × 60 ft)
Illus: Strachan, p.191
University of Northumbria
see fig.83

1982

S323 Sentinel
1982 (348)
Aluminium
56.3 × 37.7 × 31 cm
(22$\frac{1}{4}$ × 14$\frac{3}{4}$ × 12$\frac{1}{4}$ in)
First Exh: Harrogate, 1982 (36)
Private Collection, Yorkshire
not illustrated

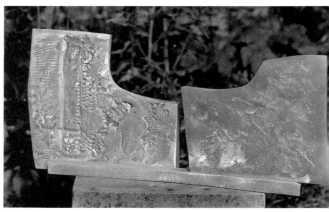
S317

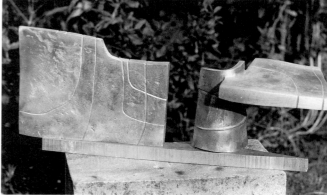
S318

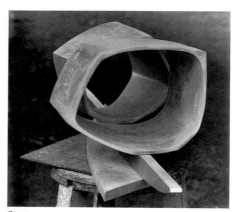
S319

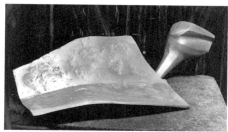

S326

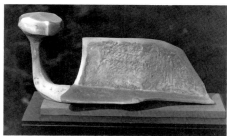

S327

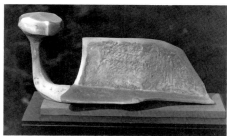

S329

S324 Nail
1982 (355)
Aluminium
44.5 × 32.1 × 28.2 cm
($17\frac{1}{2}$ × $12\frac{1}{2}$ × 11 in)
First Exh: Harrogate, 1982 (37)
The Artist
see fig.87

S325 Spike
1982 (351)
Aluminium
27 × 28.5 × 41.5 cm
($10\frac{1}{2}$ × $11\frac{1}{4}$ × $16\frac{1}{4}$ in)
First Exh: Harrogate, 1982 (38)
[as *Listener*]
The Artist
see fig.89

S326 Sleeper
1982 (356)
Aluminium
13.5 × 21 × 49.5 cm ($5\frac{1}{4}$ × $8\frac{1}{4}$ × $19\frac{1}{2}$ in)
First Exh: Harrogate, 1982 (39)
The Artist

S327 Blade
1982 (354)
Aluminium
75 × 56.2 × 31.6 cm ($29\frac{1}{2}$ × 22 × $12\frac{1}{2}$ in)
First Exh: Harrogate, 1982 (40)
[as *Utensil*]
The Artist

S328 Knob
1982 (353)
Aluminium
38.5 × 41.5 × 33 cm (15 × $16\frac{1}{4}$ × 13 in)
First Exh: Harrogate, 1982 (41)
The Artist
see fig.88

S329 Watchtower
1982 (352)
Aluminium
30 × 62.5 × 21.6 cm ($11\frac{3}{4}$ × $24\frac{1}{2}$ × $8\frac{1}{2}$ in)
First Exh: Harrogate, 1982 (42)
The Artist

S330 Yockenthwaite Five
1982 (349)
Aluminium
74.5 × 69.5 × 23.3 cm
($29\frac{1}{4}$ × $27\frac{1}{4}$ × $9\frac{1}{4}$ in)
First Exh: Harrogate, 1982 (43) [as *Kit*]
see Cat.Sk67
see fig.90

S331 Kudd
1982 (357)
Aluminium: 6 elements on wooden base
28.3 × 88.7 × 29.4 cm
($11\frac{1}{4}$ × 35 × $11\frac{1}{2}$ in)
First Exh: Harrogate, 1982 (44)
The Artist
Made after a trip to the Wye Valley.
Prompted by the low-lying extended
forms of sheep-nibbled vegetation

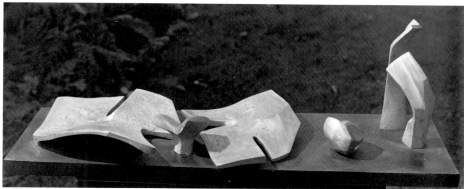

S331

S332 Pommel 1
1982 (350)
Aluminium
36 × 16 × 16.6 cm ($14\frac{1}{4}$ × $6\frac{1}{4}$ × $6\frac{1}{2}$ in)
First Exh: Harrogate, 1982 (45)
The Artist
see fig.94

1983

S333 Watcher
1983 (358)
Aluminium on wooden base
22.2 × 38 × 25 cm ($8\frac{3}{4}$ × 15 × $9\frac{3}{4}$ in)
The Artist
A forerunner to Cat.S335

S334 Pommel 2
1983 (360)
Aluminium
236.5 × 63 × 75 cm (93 × $24\frac{3}{4}$ × $29\frac{1}{2}$ in)
First Exh: Margam, 1983 (7)
The Artist
see fig.95

S335 Dryad
Commissioned 1983; installed 1984
(359)
Aluminium
141 × 239.5 × 151 cm
($55\frac{1}{2}$ × $94\frac{1}{4}$ × $59\frac{1}{2}$ in)
Yew Garden, University of York
see fig.85

1985

S336 Sphinx
1985 (361)
Aluminium
24.3 × 26.5 × 31.5 cm
($9\frac{1}{2}$ × $10\frac{1}{2}$ × $12\frac{1}{2}$ in)
First Exh: Hull, 1988 (101)
The Artist

S337 Rondo
1985 (370)
Aluminium: 4 elements on wooden base
52.5 × 30.5 × 33 cm ($20\frac{1}{2}$ × 12 × 13 in)
First Exh: RA Summer exhibition, 1985
[as *Dance of Death*]
The Artist

1986

S338 Maquette for unexecuted sculpture
1986 (372)
Plaster
28 × 4.4 × 4.4 cm (11 × $1\frac{3}{4}$ × $1\frac{3}{4}$ in)
The Artist
not illustrated

S339 Mute 1
1986 (362)
Aluminium
52.8 cm ($20\frac{3}{4}$ in) high
The Artist
Editioned in aluminium
not illustrated

S340 Six Seed Heads
1986 (364)
Aluminium: 6 elements on wooden base
a: 61.3 × 12 × 12 cm ($24\frac{1}{4}$ × $4\frac{3}{4}$ × $4\frac{3}{4}$ in)
b: 44 × 8.5 × 6.8 cm ($17\frac{1}{4}$ × $3\frac{1}{4}$ × $2\frac{3}{4}$ in)
c: 52 × 6.5 × 8 cm ($20\frac{1}{2}$ × $2\frac{1}{2}$ × $3\frac{1}{4}$ in)
d: 61 × 14 × 14 cm (24 × $5\frac{1}{2}$ × $5\frac{1}{2}$ in)
e: 65.5 × 10.5 × 10.5 cm
($25\frac{3}{4}$ × $4\frac{1}{4}$ × $4\frac{1}{4}$ in)
f: 49.7 × 9.8 × 7.2 cm ($19\frac{1}{2}$ × $3\frac{3}{4}$ × $2\frac{3}{4}$ in)
First Exh: Hull, 1988 (104)
The Artist
Editioned in aluminium
see fig.91

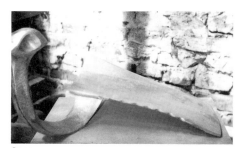

S333

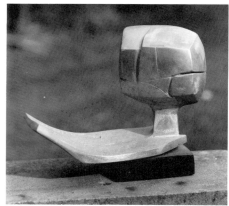

S336

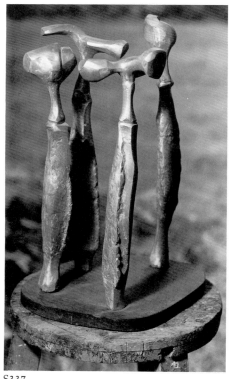

S337

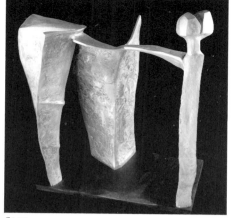

S341

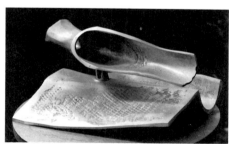

S342

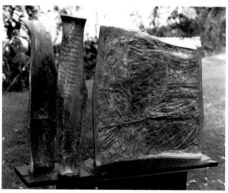

S343

S344

S341 Inscape
1986 (363)
Aluminium on wooden base
74.6 × 68 × 40.5 cm ($29\frac{1}{4}$ × $26\frac{3}{4}$ × 16 in)
First Exh: Hull, 1988 (105)
Ferens Art Gallery, Hull

1987

S342 Span
1987 (373)
Aluminium
76.8 × 84 × 44.3 cm ($30\frac{1}{4}$ × 33 × $17\frac{1}{2}$ in)
First Exh: Hull, 1988 (106)
The Artist

S343 Sensor
1987 (376)
Aluminium on wooden base
23.3 × 54 × 54 cm ($9\frac{1}{4}$ × $21\frac{1}{4}$ × $21\frac{1}{4}$ in)
First Exh: Hull, 1988 (107)
The Artist

S344 Encounter
1987 (375)
Aluminium: 3 elements
78 × 102.4 × 22.1 cm
($30\frac{3}{4}$ × $40\frac{1}{4}$ × $8\frac{3}{4}$ in)
First Exh: Hull, 1988 (108)
The Artist

S345 Mute 2
1987 (374)
Aluminium
314.9 × 30.5 × 29.2 cm
(124 × 12 × $11\frac{1}{2}$ in)
First Exh: Hull, 1988 (109)
The Artist

S346 Hieroglyph
1987 (377)
Aluminium
203 × 51 × 28 cm (80 × 20 × 11 in)
Commissioned privately, for a Yorkshire collection
At the commissioners' suggestion, the artist visited Monte Sansovino in Italy where he saw and drew Canna Lilies. These flowers were the inspiration for this piece, which can be viewed from high up in the attic of the owners' house
not illustrated

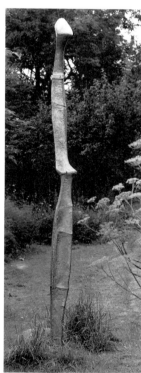

S345

1988

S347 Voyager
1988 (378)
Aluminium on wooden base
23 × 67.3 × 23.5 cm (9 × 26½ × 9¼ in)
First Exh: Hull, 1988 (110)
The Artist

S348 Wall and Tower
[aka *Ensemble*]
1988
Aluminium: 3 elements on a wooden
base
81.5 cm (32 in) high
First Exh: Hull, 1988 (111)
Considered unfinished by the artist, who
renamed it *Ensemble* in 1992
The Artist
see fig.93

S349 Intruder
1988-9 (379)
Aluminium
26 × 33 × 29 cm (10¼ × 13 × 11½ in)
The Artist
'Exploring the intrusion of fruit into leaf
and stem – shoving out or pushing in.'
AW

1989

S350 Equipoise [aka *Grinder*]
1989 (380)
Aluminium
15 × 31.5 × 14.5 cm (6 × 12½ × 5¾ in)
First Exh: Kirkby Lonsdale, 1989 [as
Grinder]
Private Collection, Yorkshire
not illustrated

S351 Bract
1989 (381)
Aluminium
17 × 16.5 × 32.5 cm (6¾ × 6½ × 12¾ in)
First Exh: Grape Lane Gallery, 1989 [as
Seed Head and Leaf]
Private Collection, Yorkshire
not illustrated

1990

S352 Untitled
begun 1990 (382)
Aluminium on wooden base
95.2 × 41.5 × 24 cm (37½ × 16¼ × 9½ in)
The Artist
Unfinished. 'If I do it, I'll do it very big.'
AW
see col.pl.VIII

S353 Marske Field
1990 (384)
Aluminium
31.8 × 53 × 53 cm (12½ × 20¾ × 20¾ in)
The Artist
see figs 92 and 114

S354 The Norns – Urg, Verdandye, Skuld
1990-1 (385)
Aluminium: 3 elements
a: 245.5 × 44 × 44.5 cm
(96¾ × 17¼ × 17½ in)
b: 248.9 × 38.1 × 47 cm
(98 × 15 × 18½ in)
c: 247 × 38.1 × 38.1 cm
(97¼ × 15 × 15 in)
First Exh: 80th Birthday exhibition,
Upper Poppleton, 1991 (3)
The Artist
The Norns were three Fates from
Scandinavian legend. The work carries
further reference to aged trees at the top
of a hill. Two of the pieces were made
up from discarded tongues of aluminium
left over in the barn from other works
see also Cat.Sk88
see col.pl.III

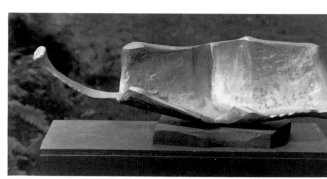

S347

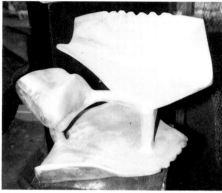

S349

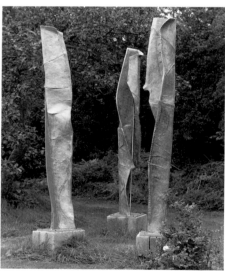

S354

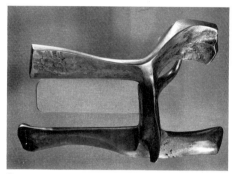

S358

S359

1992

S355 Stalk
1992 (387)
Aluminium
518.2 cm (17 ft) high
The Artist
illustrated on back cover

S356 Stem
1992 (388)
Aluminium
518.2 cm (17 ft) high
The Artist
illustrated on back cover

Sculpture for Architecture

S357 Wyverns
late 1950s (167)
Fibreglass and concrete, wall mounted
121.9 × 45.7 × 106.7 cm
(48 × 18 × 42 in)
Commissioned by Sir William Worsley,
Bt to replace decayed limestone carv-
ings on the pediment of the east
entrance façade of Hovingham Hall,
North Yorkshire. *In situ*
not illustrated

S358 Pair of Door Handles
1965
Aluminium
25 × 40 × 15 cm (9¾ × 15¾ × 6 in)
Formerly Yorkshire Evening Post
Offices, Gawthorpe, Selby, now missing

S359 Pair of Door Handles
1966
Aluminium
20 × 40 × 12.5 cm (8 × 15¾ × 5 in)
Yorkshire Press Office, Yorkersgate,
Malton, now missing

S360 Pair of Cat Door Handles
1975 (341)
Aluminium
30 × 10.7 × 28 cm (11¾ × 4¼ × 11 in)
Site Office, St Lawrence Court,
University of York

S361 St Lawrence's Tears
1977
Aluminium
Mounted on the roof of the Common
Room, St Lawrence Court, University of
York
not illustrated

S360

Addendum

The titles, dimensions and location of the following sculptures are unknown. They came to light after the catalogue had been prepared.

S362 Standing Figure
*c.*1950
Wood

S363 Big Hand
*c.*1960
Concrete

S364 Reclining Figure
*c.*1960
Plaster

S365 Lunging Figure
*c.*1962
Concrete

S366 Two Standing Forms
*c.*1962
Aluminium

S362

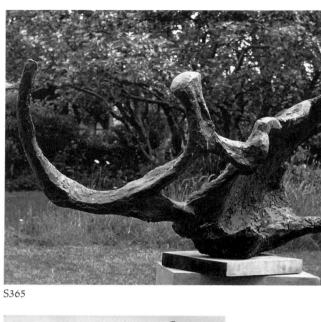
S365

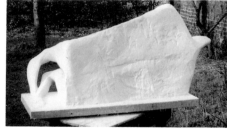
S364

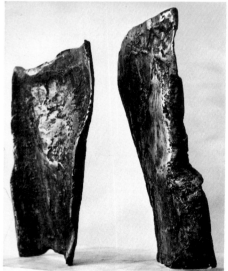
S366

S363

not illustrated

A. Wood Rubbings

P1-P9 The Forest
Suite of nine prints made from rubbing
conté onto shaped pieces of plywood
each 76 × 50.7 cm (30 × 20 in)
The suite was made by Wright at New-
castle Polytechnic in 1974, and first
exhibited at his retrospective exhibition
at the Newcastle Polytechnic Gallery in
the same year.

B. Lithographs

P10 Leaf Forms
1975
32 × 47 cm (12½ × 18½ in)
Edn of 10

P11 Hadrian's Villa: Urn and Cloud
1975
36.8 × 24.8 cm (14½ × 9¾ in)

P12 Hadrian's Villa: Pillars
1975
43 × 20 cm (17 × 7¾ in)

P13 Dry Sunflower Head
1975
29.5 × 36.5 cm (11½ × 14½ in)

P14 White Holes
1975
32 × 47.6 cm (12½ × 18¾ in)

P15 Black Hole
1975
32 × 47.6 cm (12½ × 18¾ in)
2 states; 2nd state edn of 16

P16 Dividing Tree Group
1975
31.5 × 47.6 cm (12½ × 18¾ in)

P17-P22 Cherry Tree Suite
1975
Six lithographs inspired by the cherry
tree in Wright's garden were exhibited
at the Park Square Gallery, Leeds, in
1976
The images sizes vary:
39 × 28 cm (15¼ × 11 in);
28.6 × 32 cm (11¼ × 12½ in);
33.1 × 38.1 cm (13 × 15 in);
27.8 × 36.5 cm (11 × 14¼ in);
40 × 35.5 cm (15¾ × 14 in);
39 × 28.5 cm (15¼ × 11¼ in)

P23-P26 Pant y Refail Suite
*c.*1976
Four states of one lithograph abstracted
from a view across the valley at Towyn,
Merioneth, North Wales
each 27.3 × 35 cm (10¾ × 13¾ in)

P27 Five Trees, Pant y Refail
*c.*1976
29.5 × 36 cm (11½ × 14¼ in)

P28 Tree Forms – 1
*c.*1976
23.5 × 31 cm (9¼ × 12¼ in)

P29 Tree Forms – 2
*c.*1976
32 × 43.3 cm (12½ × 17 in)

P30 Tree Group
*c.*1976
27.3 × 35.5 cm (10¾ × 14 in)

P31 Leaf Mass
1976
29.5 × 39.5 cm (11½ × 15½ in)
Edn of 5

P32 Bull's Eye
1976
29.5 × 35.8 cm (11½ × 14 in)
Edn of 10

P33 Leaf Balance
1977
29.8 × 44.7 cm (11½ × 17½ in)
Edn of 10

P34 Floating Leaves
1977
30 × 33.2 cm (11¾ × 13 in)
Edn of 10
[Some proofs inscribed 'Leaves']

P35 Stone Bird
1977
32 × 48 cm (12½ × 19 in)
2 states

C. Etchings

At the invitation of Yorkshire Print-
makers Ltd in the late 1980s, Wright
made two etchings on copper, each
9.3 × 15.4 cm (3¾ × 6⅛ in). The plates
were printed by Yorkshire Printmakers
Ltd, but the etchings have not been
approved, titled, signed or editioned by
the artist.
 The images are:
 i. Three horizontal lines with rock-like
 shapes
ii. Curled leaf composition

D. Poster, Record Sleeve and T-Shirt

The Beautiful South: *Choke*
Compact Disc; Tape; Long Playing
Record
Design incorporates *Trio*, 1957
(Cat.S100), used without the artist's
knowledge

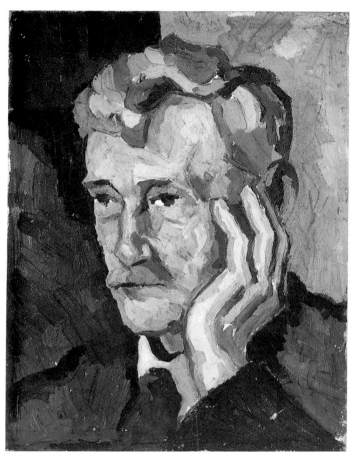

ABOVE LEFT fig.96 *Portrait of the Artist's Father* Oil on card, *c.*1927, 36 × 26.8 cm

ABOVE RIGHT fig.97 *Portrait of Susi* Oil on canvas, *c.*1945, 45.8 × 30.4 cm

LEFT fig.98 *View over Cardiff Rooftops* Oil on panel, *c.*1927, 31.1 × 20.4 cm

ABOVE fig.99 *Laying Pipes, Poppleton* Pen and ink and wash, late 1940s, 56.5 × 77.8 cm

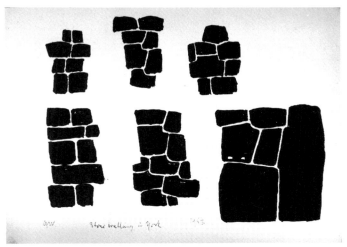

TOP LEFT fig.100 *Back of Green View* Pencil, pen and ink, late 1940s, 46.5 × 55.8 cm

TOP RIGHT fig.101 *Lendal Bridge* Pen, ink and wash, 1950, 35.4 × 25.4 cm

ABOVE LEFT fig.102 *Figure Studies*

ABOVE RIGHT fig.103 *Stone Walling* Ink, 1953, Cat.Sk19

LEFT fig.104 *Three Fishermen* Ink, wash and white, 51 × 63.4 cm

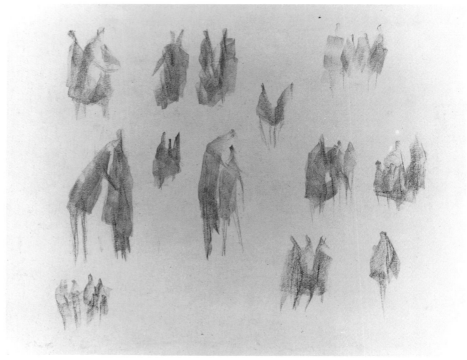

TOP LEFT fig.105 *Exhibition Square, York* Pen and ink, pencil, conté and crayon, 1955, 51 × 63.8 cm

TOP RIGHT fig.106 *Leaf Study* Felt-tip pen, 1970, 50.8 × 40.5 cm

ABOVE fig.107 *Choke*, by the Beautiful South – record album cover. See Cat.S100

ABOVE RIGHT fig.108 *Figure Groups* Conté, 1955, 51 × 63.5 cm

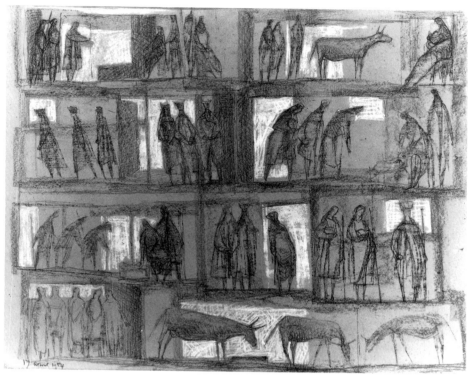

TOP LEFT fig.109 *Rock Forms at Angle,*
Pembrokeshire Conté, 1961, 41 × 50.8 cm

TOP RIGHT fig.110 *Crib Study* Conté and crayon, 1954

ABOVE fig.111 *Brush and Ink Form* 1974, 35.6 × 50.6 cm

ABOVE RIGHT fig.112 *Study for Limbo* Ball-point pen and Conté, 1957/8, 38 × 50.5 cm

Catalogue of Sketchbooks

Austin Wright has always had a sketchbook to hand, and in these he works out streams of ideas for sculptures, or makes landscape drawings or plant studies which may either be elaborately hatched works, or groups of elegantly spare line drawings in conté or felt-tip pen. Wright's sketchbook drawings appear in series: a book may contain many sheets of rock studies, or pages of drawings of a laurel bud. They are intense and intensive, and are the natural consequence of Wright's joy at the form of things. Colour is infrequently used by Wright in his sketchbooks. Although he may add wash to pencil or ink studies, strong colour such as that in the figures of bathers in the Collioure sketchbook (Cat.Sk11) is rare. Here, the influence of the place seems to have brought on the influence of an earlier visitor to Collioure, Matisse.

Sk1 1939/40. 15.6 × 10 cm (6¼ × 4 in). Blue hardback.
Cardiff and Penarth. Figures and mountain studies. Also 'Ideas for Chessmen for boys at Bootham School', [ie 1939/40]. These include head of a horse, which became a preliminary idea for the mahogany horse's head, 1941 [Cat.S8]. Lake District. Seaside, South Wales. Studies for larger drawings with colour notes.

Sk2 1945. 17.4 × 11 cm (6¾ × 4¼ in). Black hardback.
Honeymoon, summer 1945. Wye Valley. Polzeath. Monmouth. Auction. Cardiff. Pencil studies of figures and landscapes: Trelbeck, Wye Valley, Whitchurch, Ross on Wye, Brookweir, Henchfield. York subjects, including Poppleton. First beginnings at Green View.

Sk3 1946-7?. 17.8 × 25.4 cm (7 × 10 in) Rowney spiral bound.
In the barn. View across Elmers [farm next to Green View]. Poppleton Road – school. Waterworks. Susi. Leeman Road. Bootham School evening prep. Spiral form, page 1 [stone carving made from it *Savage Growth*, Cat.S44].

Sk4 1946-7. 25.8 × 18 cm (10¼ × 7 in). Rowney spiral bound.
Petal figures. Wire figures. Ideographs. Poppy Head. Flower studies in line wash. Susi. Drawings for wood carvings.

Sk5 Oct 1948. 17.7 × 25.7 cm (7 × 10 in). Rowney fawn hardback.
Home and Susi. [Black ink wash. Much cross hatching, some scratching.] Shell on a rug. Leeman Road area. Upper Poppleton Church. Boroughbridge Road. York Station.

Sk6 1948-9?. 26 × 21 cm (10¼ × 8¼ in) Winsor and Newton red hardback.
Nude studies, one in chalk, the rest pencil and ink. Made at York Art School.

Sk7 1949 and 1954/55. 12 × 18.2 cm (4¾ × 7¼ in). Fawn spiral.
Train to Oxford [dated 6.4.1949]. Upper Poppleton. Heads. Ideas for tapestry designs, wax resist – collaboration with Theo Moorman, Wakefield, Manchester.

Sk8 Autumn 1949. 12.5 × 18 cm (5 × 7 in). Rowney pale blue hardback.
Iris flowers. Stones on beach. Susi. Self portrait studies [?]. Poultry. Black ink, pencil, gouache.

Sk9 Feb-Dec 1949. 25.5 × 35 cm (10 × 13¾ in). Rowney B75 fawn sketchbook.
Susi and Crispin. Poppleton in the snow. Shells. Blind boys in back of van.

Sk10 1949. 25.5 × 35.8 cm (10 × 14 in). Rowney spiral, brown hardback.
Susi and guitar. Bear Park trees. Lower Falls group. Filey. Wire abstract forms. Pen and ink open line, wash, pen and ink.

Sk11 1950. 31 × 24.9 cm (12¼ × 9¾ in). Winsor and Newton Charcoal sketchbook, cream hardback.
Collioure beach scenes and figures. Brush drawings in white and colour; pen and ink. Variously loosely painted languid figures; others hatched.

Sk12 April 1951. 29.1 × 23.4 cm (11½ × 9¼ in). Winsor and Newton Educational Drawing Book, green soft back.
Susi and house views. Susi asleep. Heads and plants. Sun and trees. Iris [?]. Susi reading. Building study – rectangles. Susi playing piano with cello. Abstracted figure. Seated figure. Abstracted head.

Sk13 Easter 1951.
Bear Park Upper Falls Out West. Wensleydale. Waves. River bank with slab of rock. Roots and Rocks. Pen and ink, pencil and wash.

Sk14 July 1951. 8.7 × 13 cm (3½ × 5 in). Reeves Kingsland sketchbook, green hardback.
Cardiff. figure groups, beach groups, *cf* early tall wood carvings. Pages numbered 1-30. 'Some of these we enlarged in a Reeves book of dark colored paper. They are brush drawings in chinese white; using rather dry paint.' see also Cat.Sk17

Sk15 1951-2. 8.7 × 13 cm (3½ × 5 in). Reeves sketchbook, green hardback.
Filey and Polzeath. Figures on beach. Boat. Rocks. Bull at Rockcliffe. Pencil, indian ink, black and white. 'Enlarged in Greyhound Pastel Book, labelled FILEY 1951-2.'

Sk16 1952. 26.5 × 20.5 cm (10½ × 8 in). Papeterie Joseph Gilbert, fawn spiral. Ideas for wire sculpture [one dated 19.2.52]. Heads. Garden planting scheme. Studies for Hull Relief in Dock [Cats S121, S122].

Sk17 1952. Reeves sketchbook. Filey. Beach scenes, figures, bathers, donkeys, deckchairs. All against heavy fretted backgrounds. Undercut figures, out of relief backgrounds. 'Enlarged from drawings in Kingsland Sketchbook size 5″ × 3½‴' [ie Cat.Sk14].

Sk18 Nov 1952. 35.5 × 25.3 cm (14 × 10 in). Wayside Educational Drawing Book, white softback. 4 sheets only. Tree forms moving to ideas for wire sculpture. Head.

Sk19 Summer 1953. 17.8 × 24.8 cm (7 × 9¾ in). Spirollo, mottled yellow hardback.
Christian Ellis's house. Misc. figures. Stone walling in York in blockey black ink. Related vertical forms. *Cf Lear* [Cat.S57] and sculpture for Poundswick School, Manchester [Cat.S96].

Sk20 1954. 24.5 × 17.5 cm (9¾ × 7 in). Wayside Educational Drawing Block, white softback.
Brimham Rocks. Figure groups. Blockey black forms as spaces round figures. Full brush figures.

Sk21 July 1954. 21 × 13 cm (8¼ × 5 in). Winsor and Newton red hardback. Figure drawings, some in town, some on beach. Pencil and pen. Art history notes. Lists of artists' names; quotations, incl: 'A picture requires as much rascality, malice and perversity as the perpetration of crime.' Degas.
'The model is only there to set me alight, to let me dare things I could never imagine without it … and it makes

me come a cropper if ever I go too far.' Renoir.
'One should not paint from nature.' Degas.
'All good and genuine draughtsmen draw according to the picture in their brains and not according to Nature.'

Sk22 1954. 35.5 × 26 cm (14 × 10¼ in). Winsor and Newton Educational Drawing Block, blue/green.
8 drawings of Susi, seated, reading, sewing. Heads of Gordon Gilliat. Ballet costumes [7.4.55].

Sk23 Sept 1954. 22.8 × 29.5 cm (9 × 11½ in). Roberson Art School, brown hardback. Life drawings made at York Art School. Pen, ink and pencil.

Sk24 Undated (c.1954/55)
27.5 × 18.5 cm (10¾ × 7¼ in). Reeves Greyhound no.2, grey softback. Numbered 2 by AW.
Tapestry designs for Theo Moorman. Compartmented, skein-like block areas. Pastel, wax.

Sk25 Undated (c.1954/55)
27.5 × 18.5 cm (10¾ × 7¼ in). Reeves Greyhound no.2, grey softback. Numbered 5 by AW.
Tapestry designs for Theo Moorman.

Sk26 July & Aug 1955. 13 × 18 cm (5 × 7 in). Winsor and Newton Rathbone series, mottled brown hardback. Gower Coast, Wales. Reclining figures. Ball-point pen, brush. Preliminary ideas for concrete slab figures.

Sk27 1950s. 35.2 × 25.4 cm (13¾ × 10 in). Wayside Educational Drawing Block.
Rocks. Polzeath, Cornwall. Figures in brush, groups of figures wandering off home. Slab-like rocks, preliminary ideas for concrete slab figures. Ink ideograph figures. 8 sheets only.

Sk28 15 Aug 1956. 22.8 × 14 cm (9 × 5½ in). Winsor and Newton Educational Drawing Block, blue softback. Chapman's Pool. 20 sheets of figure drawings in ball-point pen. Quick studies, humpy groups. ['Some of these drawing were enlarged in brush and ink on sugar paper.' – AW, 1993.]

Sk29 Aug, Sept 1957 & 58.
17.7 × 25.2 cm (7 × 10 in). Royalty Sketchbook, grey hardback.
Anglesea, Traeth Bychan [30.8.57], Bull Bay, Benllech [31.8.57], Cemaes Bay. ['Summer storms of great violence. Had to stay indoors for day. Nothing to draw but landscapes from pepperpots.' – AW, 1993]. Florence, Venice Giudecca, and other Italian subjects. [AW went to Italy on a trip supported by the British Council directly after the family holiday in Anglesea. He travelled also to Siena, Arezzo, Ravenna.] Brimham Rocks, 4.5.[?58].
see fig.113

Sk30 Aug, Sept 1957. 9.2 × 13 cm (3½ × 5 in). Reeves Kingsland, green hardback.
Anglesea and Italy. Forms of rushing clouds in Anglesea, figures in Italy. San Stefano, 29.9.57. Milan. Briefer pen and ink sketches than in Cat.Sk29. ['Some of the landscapes are enlarged as oil paintings. Others, figure groups, much enlarged on dark paper with white conté.' – AW, 1993.]

Sk31 1957-8. 25 × 36 cm (9¾ × 14¼ in). Winsor and Newton Rathbone mottled brown hardback.
Venice etc. Strings of figures extended over sheets in red ball-point and wash; followed by different manner – crumbling rock-like forms, close compressed with fissure lines, compartmented and scaly. Standing and seated figures.

Sk32 1958-9. 22.8 × 29 cm ($8\frac{3}{4}$ × $11\frac{1}{2}$ in). Daler spiral, green softback.
Susi – figure drawings, predominantly of Susi sewing, reading etc. Then group of compressed rocky forms [1959] and figures. Ball-point pen studies for slab figures, particularly *Signature* [Cat.S137].

Sk33 July 1958[?]. 25.3 × 35.4 cm (10 × 14 in). Daler spiral, green softback.
Cornwall. Reclining figures on beach. Seated figures. Kynance July. Crantock. Sennen. Praa [Prah Beach]. West Pentire. Gunwalloe. Maenporth. Page of figures set in compartments. Inscr. Praa Limbo. Studies for Cats S128 and S129.

Sk34 1959. 25.5 × 36 cm (10 × $14\frac{1}{4}$ in). Daler spiral, green softback.
Cornwall. Many sheets of quick figure sketches, with beach name – Gunwalloe [outlines emphasised with pencil shading], Maenporth, Poldu, St Ives, West Pentire, etc.

Sk35 Undated [late 1950s?] 18.4 × 13.4 cm ($7\frac{1}{4}$ × $5\frac{1}{4}$ in). Reeves Greyhound no.6, grey softback.
Brush drawings in white wash of figures/rocks. Figure forms merging into rock.

Sk36 1960-1. 26 × 20.3 cm ($10\frac{1}{4}$ × 8 in). Roberson's Layout Pad, green softback.
Studies for the later lead figures, followed by large-scale concrete figures and various abstract designs hinting at later larger works in aluminium. An important transitional sketchbook with many ball-point studies of figures reclining, sitting and standing. Many concrete figures can be seen developing here.

Sk37 1960. 17.8 × 25 cm (7 × $9\frac{3}{4}$ in). Daler spiral, green softback.
Brush exercises – ideographs, chinesey leaf and bud forms. Then later [1970s]

sequence of 5 sheets of studies for hanging and 'hole and block' sculptures.

Sk38 1960.
Plants – leaf, stem, flower. 'Thin line pen drawings – some in terms of commercial aluminium – plate and T & L rods. Some tube and box sections ⬭ ⬜, but also some suggestions of casting process.'

Sk39 April 1961. 28.2 × 21.5 cm (11 × $8\frac{1}{2}$ in). Daler Layout Pad, buff.
'Origins of some lead figure pieces and some later aluminium (*eg Flail*, Cat.S208 and Cat.S230).'

Sk40 May 1961. 8.5 × 21 cm ($3\frac{1}{4}$ × $8\frac{1}{4}$ in). Buff sketchbook with brown tape spine.
Amsterdam. Full-page studies of long figure/plant works. Two pages which seem to be plans of exhibition or park, turning into sculpture. Various ideas forming, *eg* for *Propeller* [Cat.S182]. 'Sketch book bought on departure from Amsterdam in the market. It was cheap. Sketches done on train to the port, Hook of Holland. In was quite hard to draw in the train' – AW, 1993. The Wright family went to Holland together. The holiday included a visit to the Kröller-Müller Museum, Otterlo. AW was very impressed by Dutch museums, which he found to be well laid out and highly revealing. The Pelvis idea may have begun in this sketchbook.

Sk41 1961. 19.8 × 25.2 cm ($7\frac{3}{4}$ × 10 in). Winsor and Newton Swift Layout Pad, green softback. Pages numbered by AW 1-100.
Pembrokeshire. Fecund sequence of ball-point pen studies streaming out. Every inch of every page filled. Some which gave rise to later sculptures have been named – *eg Propeller*, p.18 [Cat.S182]; *Wall and Ring* ['Body as a wall'], p.20 [Cats S178, S196]; 'Bodies in the ground',

p.21; *Towards Atlas*, p.38 [Cat.S193]; *Wall* ['from Wall and Ring which includes small hole as well as ring'], pp.52, 81. Some dated in August, Angle [Pembrokeshire].

Sk42 1961. 29 × 23 cm ($11\frac{1}{2}$ × 9 in). Wayside Educational Drawing Block, white softback.
Trees. Beach figures. Diagram plans – ground layout *cf* Japanese gardens, skeletal remains, wall reliefs. Brush and ink drawings.

Sk43 May 1962. 25 × 20 cm ($9\frac{3}{4}$ × $7\frac{3}{4}$ in). Winsor and Newton Swift Layout Pad, green.
Pembrokeshire, ball-point and conté.

Sk44 1963. 17.8 × 25 cm (7 × $9\frac{3}{4}$ in). Daler spiral, green softback.
Brush figures in pen and ink on wetted paper. Tall plant/bone forms in ball-point pen.

Sk45 1964. 20 × 27.5 cm ($7\frac{3}{4}$ × $10\frac{3}{4}$ in). Silvine Drawing Book, white softback.
'Gorgeous day at Bainbridge. Sat. Aug. 29th 1964.' Felt-pen landscape/figure studies abstracted from landscape.

Sk46 1964. 51 × 41 cm (10 × $16\frac{1}{4}$ in). Daler Layout Pad, buff.
Iris, bud and petals. Flower heads. Poppy, wide open.

Sk47 1965-6. 21.5 × 27.7 cm ($8\frac{1}{2}$ × 11 in). Daler Layout Pad, white softback.
Ireland etc. Daisy fragments, Sligo 23 August. Tall slender verticals. Also conté drawings made with broadside of crayon – frottages over torn pieces of tissue paper.

Sk48 June – Dec 1966.
Quantities of stem and pod forms, variously ball-point and conté. Tall, spikey, urgent, pushing upwards. Some inscribed, *eg*, 'Chariot', 'Warrior'.

Sk49 1965-70. 55 × 44.5 cm
(21¾ × 17½ in). Daler Layout Pad, buff.
Plants. Frottage. Marrows. Neiwgl
(1967). Burnham Overy Staithes (1968).
Conté, ball-point and felt-tip pen.

Sk50 Late 1966-70. 51 × 40.5 cm
(20 × 16 in). Daler layout Pad, buff.
Vesalius and derivations. Plants. Ball-
point, conté and felt-tip pen.

Sk51 1967. 22.8 × 29.4 cm (9 × 11½ in).
Roberson's Wire-O Sketch Book, grey-
green hardback.
Metal Shapes, Metal Landscapes, Porth
Oer Landscapes, Forerunner of Tidal.
[Riffli July 1967, Porth Oer. One study
marked 'Forerunner of TIDAL' [Cat.S273].
Flanges, shapes and bow-like shapes
emerging. Brush drawings.]

Sk52 1968. 22.8 × 29.5 cm (9 × 11½ in).
Daler spiral, buff softback.
Ceriad Landscapes [Earliest dated
21.4.68]. Hole and petal, opening and
closed, gap and wall. Landscapes – Riffli,
Hell's Mouth, Ceiriad. Conté, flat end.

Sk53 1969 to Aug 1970.
25.2 × 35.2 cm (10 × 13¾ in). Daler
spiral, green softback.
Yorkshire, Scotland, Wales. Landscapes.
Trees (Colsterdale). Landscape
(Helmsley). Plants. Drawings done from
Plockton – looking across to Cairn-
gorms. Bainbridge (Roman Road), Cilan
and Riffli landscapes. [First drawing
dated 24.5.69. Plant forms, clouds over
landscape, field patterns, skeins of lines
making compartments like cloisonné.
Ball-point and flat side of conté.]

Sk54 Undated. [Inside '1950-60', but
probably later, c.1970.]. 16 × 10 cm
(6¼ × 4 in). Lion Brand, red softback.
Misc. landscape studies in fountain-pen
and ink.

Sk55 1970-71-72. 29.7 × 21 cm
(11¾ × 8¼ in). Daler A4 Layout Pad,
black.
'Thin line drawings leading to sculptures
in sheet aluminium and also cf com-
mercial section aluminium T section Γ
angle etc. Very light sculptures and
eventually hanging pieces. York Festival
Show, St Martin's 1973. Riffli landscapes
provided some starting points – leading
to the tall thin pieces – Cilan [Cat.S296],
Botanical Garden [Cat.S294], Plantation
[Cat.S314] and also Obst [Cat.S299],
Aquarius [Cat.S298], Riffli [Cat.S309],
transforming landscape into tall vertical
features.'

Sk56 1970-3. 13 × 20 cm (5 × 7¾ in).
Spiral, white softback.
Ball-pen studies. Squared forms. Flanges.
Aluminium sections. Hanging
sculptures.

Sk57 1970-71-74. 55 × 44.5 cm
(21¾ × 17½ in). Daler Layout Pad, buff.
'Towards hanging pieces. Use of sheet
metal and commercial sections. The first
hanging pieces were ready for
St Martin-cum-Gregory show, York
Festival, 1973, Cutting aluminium plate.'

Sk58 1971. 12.6 × 17.7 cm (5 × 7 in).
Rowney sketchpad, red softback.
Sedbergh, Aug 1971. Riffli, 3 Sept 1971.
Lleyn Landscapes. Hanging forms,
joined and jointed. Emerging from land-
scape patterns – horizon and field
patterns running down hillsides. Brush
and ink.

Sk59 1974. 23 × 29 cm (9 × 11½ in).
Daler spiral, yellow softback.
'PURE LINE DRAWING, YEARSLEY.' Arncliffe,
Halton Gill, Yearsley. Landscape into
sculpture. Vertical lines, hanging forms.
First page dated Yearsley 12 Feb 74.

Sk60 1976. 20.8 × 30 cm (8¼ × 11¾ in).
Daler A4, black softback.
Very many studies – Ring and Block;
flanges, plants, stems, Pantyrefail, Aug
1976. Quotations from The Return of the
Native (Thomas Hardy) on verso of
cover – ref. the wild mallard at Egdon.

Sk61 1974-7, 1980 & 84.
'Book bought in Bath prior to Devon
holiday.' Bude 5; Norber 9, 1977;
Leaves 4; Apple; Forsythia; Grass;
Laurel 1980; Pot of flowers, 1984;
Apple and leaves, 1982; Bransdale;
Sedbergh. [Pages numbered 1-36. Rock
formations, flats and verticals July 74.
Then, March 75 Bramsdale, Sedbergh,
Ravenstonedale, Cantley, Cowhouse
Bank July 76, Norber 3 Aug 77. Great
rearing rocks, large one and smaller.
Lilac, Poppleton Easter Sunday 6.4.80.
Apple; forsythia; grass.

Sk62 Up to 1978? 12.5 × 20.2 cm
(5 × 8 in). W H Smith orange & green
Reporter's Spiral Notebook.
E. J. Arnold Fountain [Cat.S315 com-
pleted 1979.] Studies and technical notes
for the water flow. Notes re. cost (total
£1920). Weight: 5 cwt approx. Studies
of Norber Stones – a source for the
fountain. Notes:
'Jets. One for each section of the leaf.
2 for leaf. Total of 4 in all. Jets to be
installed within the cylinder on small
brackets, set fairly close to the leaf
bracket to fire out along the leaf plates.
Possibilities. Either (1) strong jet for each
section A 360 cm or A 420 cms.
or, (2)
To obtain varied flow, strong jet to
lower curve and gentler force for upper
curve, on both leaves. The gentler force
being operable indefinitely in windy
conditions.
If (2) not feasible, use equal strong jets,
4 in all, on both leaves.
Modified flow? Gentler on upper curve.
Two leaves, extending outwards 7 ft to

either side of the central column, angled at approx [150°].

Each leaf composed of 3 sections, a supporting bracket, and 2 lengthwise sections 8 × 1½ ft each, welded to the bracket, one section having a shallow curve and the other a deeper curve, the shallow curve being welded along the upper edge of the bracket and the deeper curve along the lower edge. Each section is cut to fit in a semicircle round the cylinder.

Sk63 1977-9 & 82. 17.6 × 25.4 cm (6¾ × 10 in). Daler spiral, yellow softback. 5 Laurel; 6 Bramley Trees. Rosedale 8 Feb 77. Open line drawings. Landscape lines traversing the sheets. 'Possibilities for Humphrey Boyle's Garden, not accepted.' Lilac, May 82. Bramley, June 82. Cherry, June 82. Interlocking plant forms.

Sk64 1979-82. 9.7 × 12.5 cm (3¾ × 5 in). Sri Aurobirdo Ashram Pondicherry, handmade marbled paper. 'From Crispin, Xmas 1978.' Landscape and plant studies. All open line studies, spare, sparse and elegant. First page dated 22 Jan 78 [*sic*; *ie* 1979] River Kyle, Tollotson; Nun Monkton, 18.3.79; Above Askrigg, 30.6.79; Linton – clear sky – warm – lovely walk by river 20 Jan 80; Rievaulx Terrace, 12 Oct 80; Stanton Lacey, Ludlow, 24 Oct 80; Golden Valley, Herefordshire, 26 Oct 80; Snow, Ouse, opposite B[...], 30 Nov 80; Reflections and Reeds, Ouse, 30 Nov 80; Fountains, Sunday 15 March 81; Dovedale, 3 April 81; Bournemouth, 24 May 81 [Tom's 1st birthday]; Waves, Bournemouth, 24 May 81; Magnolia, Clare's Garden, 26 May 81; Hengistbury, 26 May 81; Back Lane, 19 Dec 81; Solomon's Temple, Smilesworth Moor, 28.2.82; Bowling Green, 14.4.82; Rievaulx with Florence, 16.5.82; Colsterdale – Alder with Susi, Crispin, Marie, Bryony, 30.5.82.

Sk65 1978-80. 59.4 × 42 cm (23½ × 16½ in). Daler A2 Layout Pad, black.
35 numbered drawings, misc. studies for sculpture and fruit.

Sk66 July 1979 – Sept 81.
14.1 × 26.2 cm (5½ × 10¼ in). Handmade book by Sue M. Wright, black and yellow marbled paper [used from the back]. Herrsching (July 79). Plant forms. Beginnings of *Dryad*, York University 29 July 79 [Cat.S335]. Pont y Refail, 15 Aug 80.

Sk67 Jan 1980 – May 82.
17.8 × 12.7 cm (7 × 5 in). John Dickenson Artists Sketchbook, off white, softback.
Felt-tip pen bud and leaf drawings. Poppleton, Linton, Grassington, Yockenthwaite, Langstrothdale 26 March 82 'See sculpture Yockenthwaite 5' [Prelim. study for this Cat.S330]. Magnolia, Clare's garden. Laurel.

Sk68 1981-2. 10.8 × 29.5 cm (4¼ × 11½ in). Blue and white marbled paper hardback, black spine. Llantony Sept-Oct 1981. Pantyrefail, Tefriew 1982, Bodnant 1982. Long drawings of trees, walls, stile fence, rock reflections, making advantage of length of book.

Sk69 Unbound sheets in envelope, A4 21 × 30 cm (8¼ × 11¾ in).
1981-8, variously. Leaves, landscape, sculpture ideas. Pen and brush. Envelope inscr. 'Originals from Simplon Pad and Apples (in drawings).'

Sk70 Jan-Dec 1982. 23 × 29.2 cm (9¾ × 11½ in). Daler spiral, green softback.
Whixley – trees etc.; Pantyrefail (trees); Conway Valley (Tanygrisian, Crafnant [?]); Poppleton (Bramley trees); reflected stones; rocks and trees; clouds and

woods above Rowen. Open line, felt-tip drawings.

Sk71 1982-84-85-86. 21 × 29.7 cm (8¼ × 11¾ in). Daler A4 Layout Pad. Black softback.
Multitude of plant and figure forms. Developing ideas. Pages numbered 1-52.

Sk72 1983. 21 × 13.8 cm (8¼ × 5½ in). Pink handmade paperback, red spiral bound.
Whixley; Arncliffe; Mount Grace; Husthwaite. Landscape studies; group of studies of Mount Grace Priory 'sculpturised', 16.4.83.

Sk73 1983-4. 17.8 × 25.2 cm (7 × 10 in). Roberson R30 Sketchbook, blue hardback.
Mount Grace; Talley Abbey; Magnolias; Iris and seed heads 1984 (castings); Middleton-in-Teesdale 1984; *Pots of Flowers 1984*, [Studies of Mount Grace Priory and Talley Abbey. Brush drawings of leaf and plant forms. Landscape, plant ideas; flowers in pot].

Sk74 16 Dec. 1983. 20.5 × 16.5 cm (8 × 6 in). W H Smith Exercise Book, green softback.
Poppleton Station. Luggage trolleys; railway carriage interiors; pillars at York Station; piles on trolleys. Then studies of knife-like plant forms, Pantyrefail.

Sk75 1983-4. 11.5 × 17.5 cm (4½ × 6¾ in). Roberson Bushey Sketchbook, black hardback.
'Book bought in Longacre, London. Day of visit to Cubist exhibition.' Studies – Paris Trocadero, 30.7.83; Barden Moor, 10.8.83; Pebbles, Barnsdale 13.8.83; Boughs and bubbles, Wharfe; Burnsall; Yockenthwaite; Brimham; Kersey, Suffolk 14.10.84. Pages numbered 1-77.

Sk76 1984-6. 21.7 × 15.1 cm
(8½ × 6 in). Goldline Sketchbook, red
hardback.
Burghley 12.10.84; going down to
Moray's wedding; plants and land-
scapes. Open pen line, felt-tip, ball-
point. Husthwaite; Berwick; Ettrick;
York Hospital Casualty. Quote from
Klee at back: '"Nature can afford to be
prodigal in everything, the artist must
be frugal down to the last detail. Nature
is garrulous to the point of confusion, let
the artist be truly taciturn." Written in
1909.'

Sk77 1985-7. 15.5 × 10.9 cm
(6 × 4¼ in). Goldline Sketchbook, red
hardback.
Newby Hall. 8.8.85. Plants and land-
scapes in Yorkshire; then Beaugency,
France, Sept 86; Barberini, Fiesole,
Florence; Hameau de l'Eglise.

Sk78 1986-7. 20.5 × 15.4 cm
(8 × 6½ in). W H Smith Exercise Book,
green softback.
Plant and landscape studies, mainly in
pencil.

Sk79 1986. 11 × 22.7 cm (4¼ × 9 in).
Olive-green leather, blocked in gold on
cover AUSTIN A. WRIGHT. Inscr. inside
'Birthday 4th June 1986'. Castle Howard
4.6.86; then Arezzo; Sansovino; Pog-
gibonsi; San Miniato; Malacene;
Loches; Falaise, all Sept 86. All plants
and landscapes – could be anywhere –
eg Yorkshire!

Sk80 1985. 21 × 30 cm (8¼ × 11¾ in).
Rowney A4. Pink softback.
Cherry tree, garden, leaves, Teesdale
April 96, Fountains (trees and rocks).
Pencil studies, plants etc.

Sk81 1986. 17.8 × 25.4 cm (7 × 10 in).
Bloxworth spiral bound, yellow softback.
Fiesole, geraniums, leaves. Fiesole 1968.
Trees and rocks Rievaulx; Pateley

Bridge; Nidderdale; Topfield;
Poppleton. Plants, landscapes. Two
sheets of leaves inscr. Fiesole 13 Sept
and Poppleton 12 Oct.

Sk82 1986-7. 50.8 × 20.6 cm
(20 × 8 in). Daler Spiral sketchbook,
green.
Trees. Laurel leaves. Iris seed heads.
Brimham Rocks. Apple and Leaf.
Geranium. Leaf Heads. Flower Heads
(Brains).

Sk83 1987, 88, 89. 21 × 30 cm
(8¼ × 11¾ in). Derwent A4 sketchbook,
white softback.
Burrell, Tangley, Nidderdale,
Wensleydale, Topfield, Sidgarth (?);
trees Poppleton garden; 5 of Brimham.
[Two sheets of studies of jugs in Burrell
Collection, Glasgow, and leaves in Pol-
lok Park. Other leaves and landscapes in
Yorks.]

Sk84 1988. 10.5 × 14.8 cm (4¼ × 5¾ in).
Daler A4 spiral bound, yellow and red
softback.
Newby Hall, Bear Park 'Out West',
Brithdir, Pantyrefail, Marske, Nether
trees.
Small open line plant studies. Aug-Sept
88.
see fig.114

Sk85 1988. 10.5 × 14.8 cm (4¼ × 5¾ in).
Daler A6 Sketchbook, yellow softback.
Blandford 88, Lyme Regis, Pantyrefail,
Brimham Rocks. [Also Hambledon,
Bulbarrow, Lyme (waves), Poppleton,
Beningborough, Hospital Ward 5,
Brimham Xmas Day 89.]

Sk86 1988-9. 32 × 41 cm
(12½ × 16¼ in). Cagrain Cason
sketchbook.
Brimham Rocks.

Sk87 1988-90. 11.6 × 21.8 cm
(4½ × 8½ in). Blue marbled hardback with
black spiral and corners. Labelled 'The

Handmade Book. Sue M. Wright.'
Sheets at front and back only used.
Newby Hall; Tobacco flower; Castle
Howard.

Sk88 1989. 41 × 30 cm (16¼ × 11¾ in).
Traidcraft A3 sketchpad, white.
The Norns, Cat.S354.

Sk89 1989-92. 20.3 × 22.9 cm
(8 × 9 in). Rowney Pastels Sketchbook,
green softback.
5 Brimham, Trees, Yew Poppleton
Churchyard, Burghley, Yew Churchyard
Peterborough.

Sk90 1989. 30.5 × 45.7 cm (12 × 18 in).
Daler Ingres Pastel Paper, grey/pink
softback.
Brimham Oct 10 89 [One drawing only].

Sk91 1990-3. 11.2 × 17.5 cm
(4½ × 7 in). Roberson Bushey sketch-
book, black hardback.
Buds, leaves, landscape. Open line draw-
ings. Pages numbered 1-76.

TOP fig.113 *Landscape of Pepperpots, Anglesey*, Pen
and ink, Sk29, 1957

ABOVE fig.114 *Field at Marske*, Sk84, 1988

Chronology of Exhibitions

One-Man Shows

1955	Wakefield Cathedral: Crib [displayed annually]
1960	Wakefield, City Art Gallery: *Retrospective exhibition* [also shown at Cartwright Hall, Bradford]
1962	Leeds, City Art Gallery: *Gregory Fellows Exhibition*
1962	Kendal, Abbot Hall
1962	Bradford, Lane Gallery
1963	York, University
1963	Sheffield, University
1964	London, Rowan Gallery
1965	Selby Abbey (Selby Festival)
1966	Macclesfield Festival
1968	Menston, Goosewell Gallery
1969	Bradford, Lane Gallery
1970	Nottingham, Gallery 359
1970	Richmond-on-Thames, Richmond Hill Gallery
1971	Manchester, Peterloo Gallery
1971	Menston, Goosewell Gallery
1973	Menston, Goosewell Gallery
1973	York, St Martin-cum-Gregory (York Festival)
1974	Sheffield, University
1974	Newcastle upon Tyne, Polytechnic: *Retrospective*
1975	Menston, Goosewell Gallery
1976	York, University
1977	Wakefield, City Art Gallery
1981	Yorkshire Sculpture Park: *70th Birthday Retrospective*
1983	Harrogate, Arcade Gallery
1988	Hull, Ferens Art Gallery: *Retrospective*
1988	Manchester, Castlefield Gallery
1989	Kirkby Lonsdale, Gallery North
1989	York, Grape Lane Gallery
1991	Upper Poppleton: *80th Birthday Exhibition*
1994	York, City Art Gallery

Group Shows

1941 1942 1943 1944 1946 1948	Wakefield, City Art Gallery: *West Riding Artists*
1950	York, City Art Gallery: *Two Modern Artists* [with Dudley Holland]
1952	Wakefield, City Art Gallery: *West Riding Artists*
1953	Wakefield, City Art Gallery: *Modern Art in Yorkshire*
1954	London Group
1954	Wakefield, City Art Gallery: *West Riding Artists*
1955	Wakefield, City Art Gallery: *Modern Art in Yorkshire*
1955	York, Austen Hayes Gallery
1956	Aldeburgh Festival: *Some Contemporary British Sculpture* (Arts Council; subsequent tour)
1956	York, City Art Gallery: *Three Modern Artists* [with Norman Adams and Russell Platt]
1956	London, Roland, Browse and Delbanco [with Philip Sutton]
1956-7	Sweden, Gothenburg, Sandviken, Linkoping, Tranas, Lund, Halsingborg, Halmstad, Falkenberg, Orebro and Stockholm: *Younger British Sculptors* (British Council) [with Robert Adams, Kenneth Armitage, Reg Butler, Lynn Chadwick, Robert Clatworthy, Hubert Dalwood, Elisabeth Frink, Bernard Meadows, Eduardo Paolozzi, Leslie Thornton and William Turnbull]
1957	London, Holland Park: *Sculpture 1850 and 1950* (LCC)
1957-8	South America, São Paulo, Rio de Janeiro, Buenos Aires, Montevideo, Santiago, Lima and Caracas: *Ten Young British Sculptors* (British Council) [with Robert Adams, Kenneth Armitage, Reg Butler, Lynn Chadwick, F.E.McWilliam, Bernard Meadows, Eduardo Paolozzi, Leslie Thornton and William Turnbull]
1957	Cardiff, National Museum of Wales: *Contemporary Welsh Painting and Sculpture*
1958	London, Roland, Browse and Delbanco [with Norman Adams]
1958	*Sculpture in the Home* (Arts Council)
1958	London, Leicester Galleries: *Artists of Fame and Promise*
1958	Wakefield, City Art Gallery: *West Riding Artists*
1959	Antwerp, Middelheim Park: *V Biennale of International Sculpture*
1959	Liverpool, Walker Art Gallery: *John Moores Exhibition*
1960	*Northern Artists* (Arts Council)
1960	Newcastle upon Tyne, Hatton Gallery: *Five Sculptors* [with Elisabeth Frink, F.E.McWilliam, Uli Niptsch and Eduardo Paolozzi] (also shown at Manchester, Leicester, Nottingham and Birmingham)
1961	Norwich Festival: *Contemporary British Sculpture*
1961	Nottingham, Midland Group: opening exhibition
1962	Nottingham, Midland Group: *Sculptors Today*
1962	London, New Art Centre: Festival of Labour

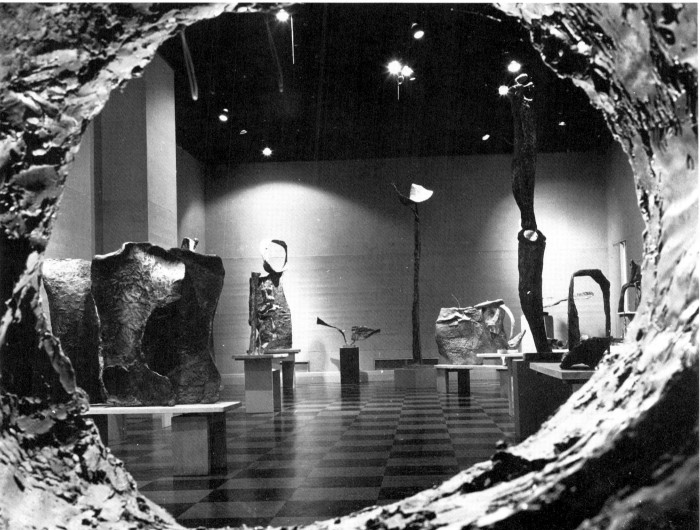

TOP LEFT fig.115 Austin Wright photographed when an undergraduate, c.1931

TOP CENTRE fig.116 Austin Wright with Crispin, winter 1949

TOP RIGHT fig.117 Austin Wright (left) with his father-in-law and brother-in-law hoeing the Nursery Garden at Green View, 1946

ABOVE fig.118 Installation of Austin Wright's exhibition at Leeds City Art Gallery, 1962

1962	Coventry, Herbert Art Gallery: *Artists Serve the Church*
1963	Oxford, Bear Lane Gallery [with Francis Moreland and Clive Sheppard]
1963	Bradford, Lane Gallery [with Willi Tirr]
1964	*The Gregory Fellows* (Arts Council touring exhibition)
1964-5	*Contemporary British Sculpture* (Arts Council)
1964	Newcastle upon Tyne, The Stone Gallery: *Modern British Sculpture*
1964	Leeds, Queen Square Gallery: *Gregory Fellows*
1964	Leeds, Queen Square Gallery: Summer Exhibition
1965	London, Tate Gallery: *British Sculpture in the Sixties* (Contemporary Art Society exhibition)
1965	Henley-in-Arden, Arden Gallery: *Four Sculptors* [with Robert Clatworthy, Elisabeth Frink and F.E.McWilliam]
1968	Leeds, City Art Gallery: *Three Ideas for Sculpture* [with Neville Boden and Hubert Dalwood]
1969	Aldbourne, Wiltshire: *Sculpture in a Landscape*
1969	Darlington: Maquettes for Civic Sculpture
1970	Leeds, Park Square Gallery: *Small Sculpture for the Home* [with Neville Boden, Roger Leigh, Margaret Lovell, Michael Marsden and John Milne]
1971	Bradford, Cartwright Hall: *Three Yorkshire Artists* [with Marie Walker Last and Laimonis Mierins]
1972	Hull, Ferens Art Gallery: Winter Exhibition
1972	Leeds, Park Square Gallery: *More Love than Money – the collection of Ronnie Duncan*
1973	Manchester, Peterloo Gallery [with Peter Collingwood]
1974	Sunderland, Art Gallery: *Peter Stuyvesant Northern Painters and Sculptors Exhibition*
1974	Sunderland, Arts Centre: *British Sculptors' Attitudes to Drawing*
1974	Manchester, Peterloo Gallery [with Peter Collingwood]
1975	Manchester, Royal Northern College of Music [with Theo Moorman]
1976	Burnley, Townley Hall Art Gallery: *20th Century British Sculpture from Northern Public Collections*
1976	Leeds, Park Square Gallery: *Drawing and Prints* [with Ainslie Yule]
1977	Yorkshire Sculpture Park: Opening Exhibition
1979	Manchester, Whitworth Art Gallery: *British Drawings Since 1945*
1979	London, Covent Garden: *Artists' Market*
1980	Newcastle upon Tyne, Polytechnic Gallery: *900 Festival Exhibition*

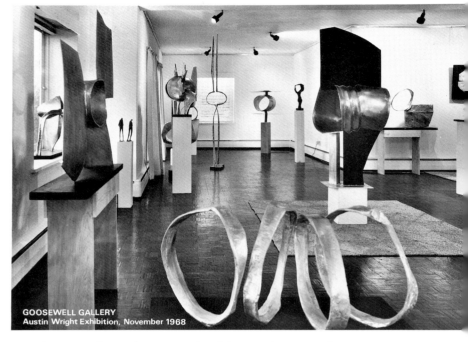

GOOSEWELL GALLERY
Austin Wright Exhibition, November 1968

ABOVE fig.119 Installation of Austin Wright exhibition at the Goosewell Gallery, Menston, 1968

OPPOSITE fig.120 Austin Wright in his workshop, 1993

1980	Rotherham, Sandbeck Park: *Sculpture in the Open Air*
1982	Bosworth, Leicestershire: Bosworth Festival
1982	Margam, Welsh Sculpture Trust: *Maquettes for Public Sculpture*
1983	Ilkley, Manor House: *Yorkshire Art at the Manor House*
1983	Yorkshire Sculpture Park: *International Sculpture Symposium*
1983	Margam, Welsh Sculpture Trust: *Sculpture in a Country Park*
1984	Leeds, University Gallery: *Sara Gilchrist Personal Choice*
1986	Harrogate, Harlow Carr Gardens: *Sculpture for the Garden*
1986	London, Royal Academy: Summer Exhibition
1990	Yorkshire Sculpture Park: *Sculpture in the Bothy Garden*
1991	London, Royal Academy: Summer Exhibition

Transcript of 'The Critics'

Broadcast on the BBC Home Service on Sunday, 23 March 1958

The text that follows is a BBC transcript, reprinted with permission.

Chairman: John Summerson
Critics in order of speaking:
Basil Taylor
Margaret Lane
Lance Sieveking
Richard Findlater
Edgar Anstey

CHAIRMAN: This week we welcome to the programme Basil Taylor as art critic, and Lance Sieveking as radio critic. Art is our first subject, and we've seen an exhibition of sculpture and drawings by Austin Wright at the Roland Browse and Delbanco Gallery. Basil Taylor?

TAYLOR: Austin Wright is a rather late arrival in the company of rather notable English sculptors who have emerged since the war. Although he's in his late forties, his work has only been generally seen I think in the past five years or so.

The theme of his sculpture is, on the whole, human behaviour, the ways in which physical activity reflects man's moods and intentions – to take an example: a single figure in this exhibition shows a man striding, or then there are groups of figures, drawings of crowds, and I think these groups are perhaps his more personal, his more characteristic work and they tend to have subjects like 'Disrupting Trio' or 'Huddle' or 'Gossip Game'. And such groups of figures are often seen as a lump – humanity in a lump – a lump in which the component figures have only a very partial individuality. Wright's view of people in action is somewhat impressionist; his way of using angled planes to take the light and give activity to the figures – that's also I think somewhat impressionist.

At a time when so much sculpture shows either an experimental use of materials or is aggressively rough in its textures, Wright's work is conservative and quiet. There, again, I think are reminders of certain sculptures by Henry Moore in his sculpture, and perhaps more directly he reminds one of the sculpture of Kenneth Armitage.

CHAIRMAN: Yes, thank you, Basil. (CHAT) Margaret Lane?

LANE: I was very much attracted by these sculptures. They seemed to me in a strange way rather romantic and evocative – perhaps Austin Wright wouldn't like them to be called so, but these very squat, solid, monumental figures, sitting on lonely beaches, perhaps extending a surprising long delicate leg on the sand in front of them, or standing like – what are those pink birds? Not storks …

CHAIRMAN: Flamingoes?

LANE: Flamingoes, yes – standing in shallow water on long, stalky legs and chunky little watching bodies on top, I thought very moving; and the only thing I didn't care for, and I think perhaps this is just conservatism on my part, was the medium – this lead, which is polished until it looks rather like stainless steel. I think it's only because one's grown up with wood and stone and bronze as sculptural media, and to see them looking like, perhaps something you might have picked up off a machine workshop floor, some of them, polished steely lumps, I found a little putting off, but I do think that's – that I'm not used to it.

CHAIRMAN: Yes. Now, look, Margaret Lane, you said you found these groups very moving; do you really mean that? Do you mean that when you left the exhibition, they haunted you and possessed your mind in some way?

LANE: I was moved by those lonely groups that – all of them seemed to me to be either sitting on hillsides or lonely seashores with their feet just in the water, and it may just be a hark back to childhood and one's feeling about … places.

CHAIRMAN: I see, but they did evoke something …?

LANE: Oh, yes, they evoked something; that's why I have called them romantic; they were evocative to me.

CHAIRMAN: Yes. Good. Right, you've explained yourself. Sieveking?

SIEVEKING: It seems to me that Wright is a perceptive rather than conceptive artist. He seems to me to be, as you might say, the equivalent of the mass observation idea, where you go up to people and pretend to be reading a newspaper and listen to everything they say; none of these people are posed. He's taken them all just as they – as he saw them, absolutely naturally, and I must say that I found lead a very sympathetic medium, much more so than aluminium or silver or iron, or indeed of any other metal, except possibly gold, and he seems to me to have used it with immense sensitiveness and success. I liked best the sculptures which were – which had been more worked upon.

CHAIRMAN: Yes. Now, look, what I'm rather concerned to ascertain is the extent of the impression these sculptures made on all the critics, you see? I mean, we've got one art critic here, but we've got four others who are not art critics and are – in respect of this exhibition – laymen. Margaret Lane says she was moved by them. Were you? Did they haunt you? Did they mean anything to you?

SIEVEKING: Well, they interested me very much. As someone who, as far as his money from time to time has permitted, has been a buyer of modern pictures.

SIEVEKING: … I certainly would like to have bought one of these.

CHAIRMAN: Findlater?

FINDLATER: Yes, indeed, I'd love to have bought one or two of the groups, I think they're quietly, sardonically witty 'Huddle' and 'The Critics' and the disintegrating trio whatever they were called.

CHAIRMAN: 'The Critics' is the title of one of the sculptures?

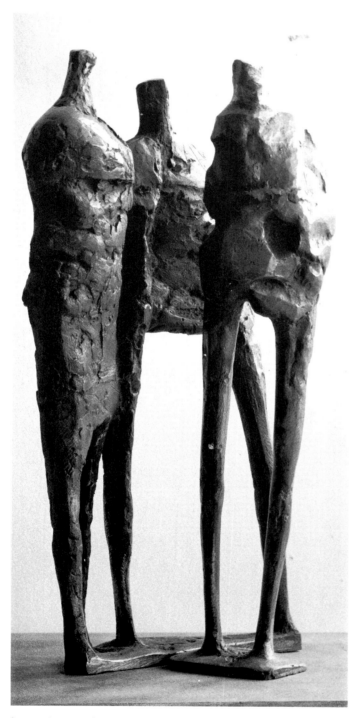

fig.121 *Critics* Lead 1957 (Cat.S106)

FINDLATER: Indeed, yes …

CHAIRMAN: Yes …

ANSTEY: The one with spindley legs, chunky bodies and small heads as Margaret Lane described …

CHAIRMAN: I see …

ANSTEY: May I make a correction?

CHAIRMAN: Yes …

ANSTEY: The name of the thing that you referred to is not 'THE Critics', but 'Critics' – very different matter …

CHAIRMAN: A very different matter, yes, all right. Now – having disposed of that, and everybody seems to like these sculptures, what about the material? How much of the merit of these sculptures depends on the handling of the material?

TAYLOR: I think that there's been this tendency for many years now to take the view that sculptors – any artist must be not perhaps simply respectful of the material he uses but must in fact derive a part of his inspiration from the nature and quality and character in that material, and I think that in certain hands this has become rather a tiresome business; it's become – resulted in a rather self-conscious affectatious use of materials, and I think that Wright seems to me to use this material, which is appropriate for what he's trying to do, and use it directly, simply, without affectation, without fuss and it seems to me an admirable use of a particular material for a particular vision.

CHAIRMAN: Yes. I do agree with that. My only experience of lead is in building work, and I love lead – it's a material very sympathetic to me and Wright in making it speak – making it eloquent, I quite agree that he has done something rather – rather special and very appropriate to the material. Findlater?

FINDLATER: Well, unlike you, Mr Chairman, I've got no particular feelings about lead, but it did seem to one walking around the exhibition that this was exactly the right medium for the kind of thing he was trying to express (yes) he was interested, at his best, in the strains and connections, the pulling away and of – towards figures in a group, and lead seemed to me to have the right kind of malleability and at the same time enough resistance to communicate this experience of his towards figures and associations …

CHAIRMAN: I think you obviously have a feeling for lead, yes. And – Anstey?

ANSTEY: Well, I certainly have a feeling for the relationship between lead and the kind of human behaviour which he is trying to express, and the titles are revealing, aren't they, on this? He uses, I notice, in his titles, the words 'cubic', 'disrupting', 'crumbling' and 'geared' which apply equally

I think to human behaviour and to the behaviour of lead, and I think that these titles are all appropriate. He has found a connection between his medium and the human behaviour he's trying to depict. I thought this was most impressive work.

CHAIRMAN: That's an interesting light on it, yes. Basil Taylor?

TAYLOR: I agree that he has. I don't find this so conscious a thing that I'm terribly aware of it. When I ask myself the question how he used the material, I find I'm very satisfied by it, but I don't feel that he has been over-conscious of this in a way which I wouldn't like. I do think he's a very good sculptor indeed. I'm only left with the doubt in my mind as to whether the quietness of these works is a positive characteristic, or whether it is a certain lack of vitality and eloquence.

CHAIRMAN: Well, I think that doubt we must leave to your consideration. It seems to me that all the critics have been, to a considerable extent, susceptible to the sculpture of — of Wright.

Austin Wright's Address

to the Degree Convocation at the University of York
8 July 1977

[Given extempore, without notes.]
Transcribed from a tape recording

My Lord Chancellor, Members of the University and friends, this is only an occasion for gratitude of a very touching kind. It is deeply warming to both Dr Shannon and myself.

We share the common characteristic of 'belonging'. We should not be here unless we'd already been here and I know that I carry with me a sense of gratitude to York and Yorkshire which is the measure of all our feelings. It's a region that you come to know: like a face, you cannot assess it in one look – you build it; it builds you. Regions always have their blurred areas, and to the south, coming up the A1, there used to be (it wasn't there the last time I came) a notice which plainly said, and it said alone, 'The North'. Already inside the Yorkshire boundary, here is this blunt announcement, not particularly welcoming in sound, which, I've no doubt, required some kind of Committee to decide where to put it. On the other side of the road, going south, there's no comparable sign. But it is particularly the land that flows out from York which has held me as York itself has held Dr Shannon, and if I went anywhere else – if I had to go anywhere else – it would only be to carry it in my head. It's the one place that I needed to return to to work. In a sense, I do not understand anywhere else. I could take all the journeys to fabled Shiraz and Samarkand without meaning. I am no tourist. It is here. I have always believed that, artistically, the real thing is under your feet. You don't need to go far. This seems much the most important thing. It's 'Here'. But this is an area which you can grasp – I know now when I'm moving out of it.

There's a wonderful phrase in a poem by Goethe, which I can only translate loosely. While thinking, conjecturing about the Creation, he depicts our Creator as an old man: the age old Holy Father, as he created the world, and then follows a very curious phrase: 'mit gelassener Hand'. Now, I'm not quite sure about this word 'gelassener' and there may be rows of Linguists in front of me who are chafing to tell me; but in my own way, I translate it as 'loose': 'With a loose hand'. I may be wrong, but I hope you'll leave me in my error because it's a very serviceable error if it is one. It's a remarkable way to create. The eyelash was not set in the eyelid with a 'loose hand'. It's this big gesture. I was fortunate enough, years ago when we first came to Poppleton, to see a man sowing corn by hand with the bag out in front and this striding walk; with the right hand free and the left hand free (he wasn't wearing anything like this when he did it [here AW referred to his gown]) and that is just the gesture in which this landscape has been laid out, right and left, with a big free gesture – a generous gesture – 'Here it is' – right hand, left hand. And facing roughly in this direction as you look up the A1, this great road, this great rail-track where they test the fast trains, you've got this great cleavage – the Vale of Thirsk, and right and left of that, the right hand down here, the Wolds, the left hand, the Dales, and the right hand the Moors and this vast vale coming between the two and running out sideways to the sea. This is like a powerful word of four syllables, syllables distinct in their sound and character and in the way syllables articulate with the one next door and build each other. The Wolds – chalk, flaked, dry; corn best seen in the autumn with the stubble, all glowing. Or if you take the road down to Hull and turn right at Market Weighton, you undulate there over the corn into the Wolds, and in the distance, you will see the gleaming of the Humber. And, if you're lucky, you often will be, the whole of the sky sweeping at you from the south-west. As soon as you're up a little distance, you take in these vast views. As often as not, the whole of Gainsborough sky coming in pale blue, pale grey, sweeping across thirty or forty miles. Or if you take the upper road, going on the way to Beverley, once you're up, just outside Market Weighton, the road undulating again will suddenly give you a view to the left of these huge, wide, ploughed areas, with the one single spire of North Dalton sticking up like a spoke in the middle of a dished cartwheel – a nineteenth century spire, one of these great architectural shots put there, isolated and alone. Where the lands dips away, far away, to the sea. You know it's there. And moving farther up, as time is short, I'll go for Filey Brigg, where these last rocks of Yorkshire slither into the sea obliquely, steep on the north, shelving down on the south, where colonies of periwinkles, starfish and thousands of mussels, and the final heads of shaggy seaweed nodding away there in the waves, waving goodbye – 'This is where we go into the sea.' This shelves down deep.

And coming quickly across the North Yorkshire Moors, the Wolds you go through by road; this is not walking country, it's ploughed. The Moors are walking country watered by streams. The green fingers of the valleys leaning northwards. It takes these long leaps up to a vantage point and down: up and down. Lean, cold, with the land in the valleys carved cleanly from the heather. The shape round the farms of the fields battening on the land. They are the lungs. And the North Yorkshire Moors, since

fig.122 Dr Austin Wright (left) with (left to right) Dr Morris Carstairs, Vice-Chancellor; Lord Clark of Saltwood, Chancellor; and Dr John Shannon at the University of York Degree Convocation, 8 July 1977

it's walking country, is a place of great interest for me. The places where you stop, and if you put a pin-prick on the map where that place was, you will smother it many times over; so tiny it is, where the sound of water, things growing and you have coincided.

Then you move on to the edge, the North Yorkshire Moors form a natural boundary to the north – an escarpment – and to the west even more pronounced an edge, where that great wide drove road, nibbled close by sheep, and bordered by lowish stone walls, treks its way across this ancient country, and you have to stand by this wall looking over, and all the west comes into view (again thirty or forty miles away, with a vast sky above it) to the Dales. All this country is breathing country. There is a way

by which we assess, by which we measure – this is in our lungs. You shift air from that far away after all. When Duncan arrives at Macbeth's castle, his first words: 'This castle hath a pleasant seat. The air doth nimbly, sweetly recommend itself unto our gentle senses.' That's it. And as you look across from that point, buried somewhere in that blue before you, which you cannot see, and which you cannot see till you get to it, is Fountain's Abbey. And here is one of these 'places'. One of these great gems where men put down, in what was a tiny, unnoticed, unmemorable little valley, but lying, miraculously, on an east-west line, they put down their vast abbey. What was it like to be there when they found the place? When they decided that you can fare so well amongst undergrowth and

overgrowth? It shall be here and it just fits. And now, when this building is ancient it seems to breathe better than it ever has done. You really feel that building and place is more perfect than it's ever been when it had its roof. The roof fell off, the tower is only a frame, you can look up the kitchen chimney, you look at it down the long, drafty solarium. The air penetrates the whole thing. Small weedy flowers grow in niches. This is a thing which we may have lost the art of doing: to build with this degree of recognition and sympathy, form the thing which breathes back to you to complement this. There's a perfect marriage in this place.

But I'd like to push on in two directions. One is up Wensleydale because I married into Wensleydale, and in depth in that dale an example of this miraculous disposition of dwelling within the rhythm of a landscape which the villages can illustrate. There is in places always a first building. Here, and in bigger towns, there must somewhere be a first building, and I know roughly where I would go to find it. And so in the villages, this kind of thing declares itself. 'Where shall we first settle, put our backs into the wind and our fronts into the sun?' And you arrive at Leyburn onto a domed square, just as you do at Richmond, onto a great domed square — this centrum at the head of the dale, and as soon as you've swung round the corner, because you swing down steeply going up the valley, you command the view of the valley; it is there swinging right and left in front of you. The road hanging on to gradients that can be managed — old foot gradients. The river winding and the swing from either side as the limestone escarpments jut forth. And there is this marvellous changeability. You cut the corner of Wensley and let's go by the north road, the north side of the valley, you just touch the first house and swing up to the north and it takes you round slightly up in a zig-zagging slope still you come to Redmire and here a veritable miracle happens: for Redmire was, I believe, rebuilt after the Plague and by an incredible miracle of, I presume, democratic adjustment, democratic planning, if that's the awful word one would have to use about it, 'You here, I'll go there. Well I'll go over here,' the village is dispersed. It has no centre, no pocket. But you get this miraculous distribution of dwellings running back from the road, slightly back from the road, right on the road, way off the road, forming a triangle; this tiny little street the village has formed just at one corner. The road zig-zags through the village. You are sent down to a sharp elbow at the bottom; there's no logic, there's no plan of going straight through the village. You drift through it and you go on with the great stud

of Bolton Castle on your right, and you come to Carperby and Carperby is a sort of poor relation of Aysgarth opposite on the other side, which has the church and the hotels and the much bigger pubs and the distinction of streets, which poor Carperby has not got. Carperby is a set of old teeth, nowhere fitting. They couldn't think past the street and they didn't get that right. The road goes straight through except for Oliver Wiseman's workshop at the end which butts in like an old tooth, jagged out, which I hope no planner will remove to straighten the joint. But here we have a crisp, ready-made sort of adjustment for the ease of living. And then on a longish way along this little populated route we swing through Askrigg. Now, Askrigg is the reverse of Carperby. Suddenly the buildings are three storeys high, the street is formed, you go through on a swinging S, the street is narrow, substantial in building, with a church down the slope, right opposite the flat mountain top of Addleborough in relation to which it stands looking across, pitched against that. And so cut to Bainbridge at the end where again, everything is flung wide apart. The roads criss-cross from the valley like braces and you get buildings flung out round a wide oblong with no kind of plan, distributed with this 'loose hand'.

And one more place, right at the extreme end where, over the Pennines, where the valley runs strongly north-west, south-east, and are filled with big rivers, at the top you get a sudden change of direction which is the demarkation line — the end of the district, where the long straight edge of Mallerstang runs north and south and beyond that, the gleaming of Howgill Fells, different in quality, like fat pigs settled together with great snouts and rounded backs, different in quality, and that is the end, from there it ends and you look out beyond, and in the distance is the Lake District. Within this area you've got consistent, coherent patterns which teach me again and again.

Bit by bit we have filled in some of the sections of this jigsaw and there's a lot still to do. Artists often have to travel, there are the famous journeys to the great centres where the catalyst worked and away from them to where the individuals can work. There is some sense of rooted place which sustains and this is what I feel strongly, I could not be without it.

So the University, in kindly honouring us both in this way, links us to this place which has sustained us, and, in being invited to be a member of your University, this is an extraordinary, rounded fulfilment for our being here. There could be no other University which could give us more pleasure, and for this I know we are both deeply grateful.

Statements about his work by Austin Wright

From the exhibition catalogue *Three Modern Artists: Norman Adams, Russell Platt, Austin Wright*; York City Art Gallery 1956

Sculpture is to be explored – like a building, a ruin, a landscape, a town. Think how you would cross it, climb it; where you would rest and where you want to get in the end.

Two contrasted kinds of structure: *eg* the carcase and the landscape – two kinds of 'order' – 'order' and 'disorder'. The one fixed in form, balanced, 'ordered', the other changing, strewn, haphazard, weathered.

The hand as the measurer of sculpture – joining the structural elements, grasping mass, balance, tension, textures. Pick up a man by the ankles, so that he remains standing, catch him by the left leg or left wrist and throw him down the stairs.

The strength and frailty of human beings.

From the exhibition pamphlet *Three Ideas for Sculpture: An Exhibition of Projects*; Leeds City Art Gallery 1968

[Wright's text below describes his approach to the proposal, made to three artists by Leeds City Council with assistance from the Arts Council, to create a relief sculpture for the 120 feet long blank façade of Leeds City Art Gallery (see Cats S258 and S259). The other artists who submitted ideas were Neville Boden and Hubert Dalwood. None of the artists was ultimately commissioned, and the Art Gallery façade remained undecorated until the 1980s when the Henry Moore Sculpture Gallery was built.]

To take first the relationship of sculpture with building: the blank wall on which it is placed is made to play a continuous part as an element running through the design, but, as this wall is divided vertically by pilasters, the sculpture is planned in sections to correspond with these divisions. The doorways at either end are marked by separate emphatic features, while the three middle sections are linked together, and diversify the original material.

The work is designed to be seen from below by people moving past it, the forms changing shape at different angles. The forms themselves owe something to the semicircles, squares and oblongs of the windows below. They refer also to landscape: stone, field and wall patterns, pothole formations and at the same time organic growth and a plant-life cycle. How these references to landscape were worked out and transformed into a sculptural idea can be seen in the drawings, which are of two kinds. On the

one hand are small sketches which are really simply 'notes' of ideas for the sculpture itself, suggestions for a way of filling the given space.

The 'starting-point' for the final idea was not always the last drawing in a series. It could as well be a return to an earlier idea – it was sometimes rather wonderful to go back to what had become a 'point of departure' and find it again as an idea in its own right. It is important to grasp this continuous process of evolvement when considering this as a 'model for sculpture' since it is clear that with this kind of sculpture a 'maquette' can really only be another 'point of departure'. For one thing relationships of size and weight – fundamental ones for sculpture – can only really be decided finally on site, since they will change when worked out in a different material and on the vastly different scale demanded by a wall 120 feet long.

The maquette is really a sketch model, one stage in the work. In the same way it would be diffiult to 'explain' the sculpture in words in any more detail. The references to landscape and natural forms are there. One cannot be more specific than this – one hesitates to make statements because these too then become too final – once they are in print they seem to need modifying and developing like the model itself. 'Statements' about works of art do not explain, though they can be illuminating, sometimes in an unexpected way.

From the exhibition catalogue *British Sculptors: Attitudes to Drawing*; Sunderland Arts Centre 1974

Drawing is a kind of diary. Some of the drawings come from times when I have suddenly seen what I had never noticed before. A batch of drawings occurs spontaneously – there is a sudden exciting find. I am recording ways of travelling across new territory and the result has to look after itself. There is a quirkiness about the actual object which is beyond anything I could invent and I can feel there's a potential of great subtlety and riches. Also the experience of seeing for the first time is unique. Some drawings belong to precise times and can't be repeated. No sculpture may result for some time, if at all. In the meantime there is another phase when ideas are turned over, in small line drawings, playing with proportions and structure, hardening the forms. This may go on obsessively, spasmodically, for years.

The earliest drawings here (1964) merged with a later series (1969-70-71) and from about 1967-73 a series of sculptures was made with similar elements.

The drawings contain only hints. By the time the sculpture starts I have turned my back on all the drawings, and the actual structure belongs entirely to other materials when the jump is made. Ultimately the drawings separate off from the sculpture. Each activity has its distinct sphere but, taken together, they seem part of an organic process of coagulation and separation, amoeba-like and cross-fertilisation happens both ways.

A text displayed in an exhibition of Wright's drawings and prints at Park Square Gallery, Leeds 1976

Drawing is a kind of diary – material you may or may not use some other way.

This set of drawings of the same cherry tree occurred between March and May 1975 spontaneously. In previous years I had drawn it in winter – gradually simplifying the central framework.

A tree is a prime sculptural form – developing freely in space, air from an approximate centre – a volume of air held aloft.

From within it is a compound eye with a thousand different outlets. I once saw two blackbirds go screaming through the tree at 40 mph by different paths, without touching a twig. Within there is a continuous circulation – each bit of structure feels for its own space – as between horizontal and vertical, keeping the relaxed balance. Air is created in the structure. It must breathe.

This time I went on drawing it into the flowering time – the framework drowned and all the surface came to the boil – a kind of structure new to me – not yet absorbed.

TOP fig.123 *Trees* Conté, 1975, 42 × 59.7 cm

CENTRE fig.124 *Trees, Colsterdale, Easter Monday* Conté, 1968, 44.8 × 55 cm

ABOVE fig.125 *Husthwaite* Pen and ink, 1974, 35.6 × 50.5 cm

Bibliographies

A. Writings by or about Austin Wright in Exhibition Catalogues

Eric Taylor: Introduction to exhibition catalogue *Dudley Holland & Austin Wright: Two Modern Artists*; City Art Gallery, York 1950

Hans Hess: Introduction to exhibition catalogue *Norman Adams, Russell Platt, Austin Wright: Three Modern Artists*; City Art Gallery, York 1956. This catalogue includes a statement by Austin Wright, reprinted above

H.K. [Helen Kapp]: Foreword to exhibition catalogue *Austin Wright Sculptures and Drawings*; Wakefield City Art Gallery 1960

Austin Wright: Statement in exhibition pamphlet *Three Ideas for Sculpture: An Exhibition of Projects*; Leeds City Art Gallery 1968, reprinted above

Austin Wright: Statement in exhibition catalogue *British Sculptors: Attitudes to Drawing*; Sunderland Arts Centre 1974, reprinted above

Gillian Spencer: Introduction to exhibition catalogue *Austin Wright Sculptures, Drawings and Prints*. Wakefield City Art Gallery 1977

James Hamilton: Introduction to exhibition catalogue *Austin Wright Retrospective*. Yorkshire Sculpture Park, 1981. The introduction was reprinted in the exhibition catalogue *New Work by Austin Wright*; Arcade Gallery, Harrogate, nd [1983]

Louise West: Introduction to exhibition catalogue *Austin Wright Sculptures, Drawings and Prints Retrospective*; Ferens Art Gallery, Hull 1988

Anon: 'A Full Eighty Years'. Essay in *Austin Wright, 1911-1991 [sic] 80th Birthday Exhibition*. Organised by Yorkshire Sculpture Park at Upper Poppleton

B. Reviews of Exhibitions, and Small Notices
Cuttings are collected in the two volumes of Austin Wright's newspaper cuttings

Reviews of 'Two Modern Artists – Dudley Holland and Austin Wright' at York Art Gallery, June/July 1950

R.C.S.
'Two gifted York artists'
Yorkshire Post, 16.6.50

UNSIGNED
'Highest praise for exhibition by York modern artists'
Yorkshire Evening Press, 17.6.50

A.G.C.
'Modern artists' work on view'
York Evening Press, late June, 1950

J.W.
'Pictures in Yorkshire'
Manchester Guardian, 7.7.50

Reviews of Modern Art in Yorkshire, Wakefield Art Gallery, Oct/Nov 1955

MARGARET ROBERTS
'18 young artists get their chance'
News Chronicle, 8.10.55

WILMA MOY-THOMAS
'They really love their Yorkshire'
News Chronicle, 21.10.55

A.C.S. [A.C. SEWTER]
'Modern art in Yorkshire'
Manchester Guardian, 10.10.55

W.T. OLIVER
'Modern art in Yorkshire'
Yorkshire Post, 10.55

Austen Hayes Gallery exhibition, York, Oct 1955

JOHN ORCHARD
'Discovering the work of York artists'
Yorkshire Evening Press, 7.10.55

Wakefield Cathedral Crib, installed Dec 1955

UNSIGNED
'Nativity scene for Wakefield Cathedral'
Yorkshire Post, 19.10.55
[Front page article and photograph]

WILMA MOY-THOMAS
'Reverence and excitement'
News Chronicle, 16.12.55

R.P.M.
'Original treatment of Cathedral's new crib'
Wakefield Express, 17.12.55

Photograph, *Times Educational Supplement*, 23.12.55

BASIL TAYLOR
'Church Patronage'
The Spectator, 6.1.56, p.20

Three Modern Artists Exhibition, York, Oct 1956

A.C.S. [A.C.SEWTER]
'Three Serious Artists'
Manchester Guardian, 8.10.56

Poundswick School sculpture, installed 1957

UNSIGNED
'Council likes the Mitzi sculpture'
Manchester Evening News, 6.2.57

UNSIGNED
'Man of Bronze in wire and plaster'
Manchester Evening Chronicle, 6.2.57

UNSIGNED
'Council sees model groups'
Daily Telegraph, 7.2.57

UNSIGNED
'What is it? asked the fourth form'
Manchester Evening News, 26.6.57

Holland Park Sculpture Exhibition, Summer 1957

Photograph of *Trio*
The Times, 22.5.57

Exhibition at Roland, Browse and Delbanco [with Norman Adams] March 1958

STEPHEN BONE
'Truly sculptural figures'
Manchester Guardian, 11.3.58

UNSIGNED [David Thompson]
'Sculpture with charm'
The Times, 13.3.58

RAY WATKINSON
Art News and Review, 15.3.58

UNSIGNED
Observer, 23.3.58

Retrospective exhibition at Wakefield Art Gallery, Sept 1960

FREDERICK LAWS
'Living sculpture'
The Guardian, 19.9.60. *Limbo* illus.

UNSIGNED [David Thompson]
'Distinctively Personal Sculpture by Mr. Austin Wright'
The Times, 26.9.60

Sculpture in Rolleston School, Leicester 1961

UNSIGNED
'New-Look School Layout'
Yorkshire Evening Press, 14.12.61

Gregory Fellows exhibition, Leeds, Oct 1962

W.T.OLIVER
'Gregory Fellows show influence of the North'
Yorkshire Post, 18.10.62

ANTHONY TUCKER
'Gregory Fellows'
The Guardian, 26.10.62

UNSIGNED
'The Sacred Art'
Union News, University of Leeds, 26.10.62

Rowan Gallery exhibition, May 1964

ERIC NEWTON
'Sculpture by Heron and Wright in London'
The Guardian, 8.5.64

IAN E. F. MORTON
'The moderns – Austin Wright'
Yorkshire Life, May 1964. 3 illus.

Sculpture at Bretton Hall, 1964

Yorkshire Post, 21.3.64. *Wall and Ring* illus.

Sculpture at Preston

UNSIGNED
'Heavy going, this scoop'
Preston Evening Post, 19.2.65. *Scoop* illus.

British Sculpture in the Sixties exhibition, Tate Gallery, Feb 1965

UNSIGNED [David Thompson]
'British Sculptors at a Time of Adaptation'
The Times, 25.2.65

FREDERICK LAWS
'British sculpture in the sixties'
The Guardian, 26.2.65

Henley-in-Arden exhibition, June 1965

MYFANWY KITCHEN
'Four Sculptors Exhibition'
The Guardian, 2.6.65

Selby Festival, June 1965

UNSIGNED
The Guardian, 7.6.65

W. T. O. [W. T. OLIVER]
'Sculpture based on leaf forms blends with Abbey lawns'
Yorkshire Post, 14.6.65

MICHAEL MCNAY
'Austin Wright at Selby'
The Guardian, 14.6.65

Menston exhibition, Nov 1968

W. T. O. [W. T. OLIVER]
'Living up to the Tate'
Yorkshire Post, 11.68

HELEN KAPP
'Austin Wright'
The Guardian, 3.12.68

RONALD WILLIS
'Image – The Artist's World. Power of metal holds sculptor in thrall'
Yorkshire Evening Press, 12.68

Darlington civic sculpture project, Jan 1969

'Sculpture finalists'
Northern Despatch, 10.1.69

'Viewpoint'
Northern Despatch, 13.1.69

Letters on the subject appeared in subsequent editions of the paper

Aldbourne exhibition, Summer 1969

FREDERICK LAWS
'Territory for sculpture'
The Guardian, 6.69

Park Square Gallery, Leeds exhibition, Jan 1970

W. T. O. [W. T. OLIVER]
'Sculpture for the home'
Yorkshire Post, 14.1.70

MERETE BATES
'Small sculptures'
The Guardian, 24.1.70

F. W. FENTON
'Wide range in small sculpture'
Daily Telegraph, 1.70

Peterloo Gallery, Manchester exhibition, April 1971

CAROL KROCH
'Sculpture inspired by anatomy'
Daily Telegraph, 15.4.71

Menston exhibition, May 1971

HELEN KAPP
'Yorkshire exhibitions'
The Guardian, 5.71

Three Yorkshire Artists exhibition, Bradford, Aug 1971

W. T. OLIVER
'Threefold impact'
Yorkshire Post, 2.8.71

Menston exhibition, April 1973

W. T. O. [W. T. OLIVER]
'Ideas from a folding cabinet'
Yorkshire Post, 17.4.73

St Martin-cum-Gregory exhibition, York, June 1973

Yorkshire Evening Press, 11.6.73

J. I. [JOHN INGAMELLS]
'The unvarnished work of anti-commercial hands'
Yorkshire Evening Press, 6.73

Sculpture on the Moor, 1975–7

Yorkshire Post, 4.4.75. Photograph, by George Stott, of maquette

LORD FEVERSHAM
'Art against the planners'
Yorkshire Post, 10.4.75

LORD FEVERSHAM
'The place for art is in our lives'
Yorkshire Post, 11.4.75

LORD DERAMORE
'Who dares be arbiter of public taste?'
Yorkshire Post, 4.75

MICHAEL PARKIN
'Future of arts scheme in doubt'
The Guardian, 29.4.75

Northern Echo, 29.4.75. Photograph of maquette with Planning Committee

Letters, *Yorkshire Evening Press*, 30.4.75

UNSIGNED
'"Eyesore" sculpture to be put to test'
Yorkshire Evening Press, 20.9.75

UNSIGNED
'"Scrapyard" sculpture takes root on moors'
Yorkshire Post, 24.9.77

Letters on the subject from Margaret Read, J. E. Jones, Patrick Nuttgens, Robert Rowe, Norman Adams, Willy Tirr published in *Yorkshire Post*, 28.9., 7.10., 11.10., 16.10.77

Park Square Gallery exhibition, March 1976

W. T. OLIVER
'Drawings by Austin Wright and Ainslie Yule'
Yorshire Post, 18.3.76

University of York exhibition, Summer 1976

STEPHEN CHAPLIN
Arts Yorkshire, June-July 1976

Wakefield Art Gallery exhibition, July 1977

W. T. O. [W. T. OLIVER]
Yorkshire Post, 25.7.77

Yorkshire Sculpture Park opening exhibition

UpFront, Observer Colour Magazine, 13.8.78

Sculpture for E. J. Arnold factory, 1978-9

Yorkshire Post, 12.4.79 (with photograph)

70th Birthday Retrospective Exhibition, Yorkshire Sculpture Park, Summer 1981

JAMES HAMILTON
'One of the best kept secrets in modern art'
Arts Yorkshire, June-July 1981

IRENE MCMANUS
'Wright emerges from the shadows'
The Guardian, 4.8.81

MARY READER
'The sculpture of Austin Wright'
The Friend, 7.8.81, p.999

GEOFFREY WINTER
'Obscure influence'
Yorkshire Post, 1.9.81

EVA ROGERS
'Pa afstand af kunstens markedsplads'
Kristeligt Dagblat (Denmark), 3.9.81

Harrogate exhibition, Feb 1983

KEN ROWAT
'Austin Wright'
The Guardian, 11.2.83

Ferens Art Gallery, Hull exhibition, June 1988

J.M.C. [J.M.COOKE]
'Austin Wright'
Yorkshire Post, 1.6.88

W.T.OLIVER
'Might in Wright'
Yorkshire Post, 13.6.88

MEDINA HAMMOND
'Austin Wright'
Arts Review, 17.6.88

ROBERT CLARK
'Wright to the point'
Yorkshire Artscene, June-July 1988

Grape Lane Gallery, York exhibition, May 1989

M.S. [MARY SARA]
'Austin Wright'
Yorkshire Post, 9.5.89

Yorkshire Sculpture Park, Bothy Garden exhibition

Yorkshire Post, 7.2.90

University of York exhibition, cancelled before opening

ELAINE WILLIAMS
'Wright wronged by campus yobs'
Yorkshire Evening Press, 7.6.90

MARY SARA
'Profile: Austin Wright'
Yorkshire Artscene, June 1991

Film

The Secret Middle, 1973

A film about the sculpture of Austin Wright, made by Harry Duffin (sound by Jim Hawkins) and financed through the Arts Council, was first shown at the York Festival during Wright's exhibition at St Martin-cum-Gregory, Micklegate, 1973.

Photographic Credits

Reference numbers are to S catalogue numbers, except where stated.

A suite of new photographs of Austin Wright's work was specially commissioned for this book from Jerry Hardman-Jones.
These are: 3, 4, 7-9, 12, 19, 24-31, 33, 34, 38, 41-4, 49, 50, 53, 54, 57, 58, 81, 82, 84-6, 89, 123, 127-9, 141, 146, 147, 151, 157, 175, 178, 183, 186, 190, 191, 193, 194, 196 [see p.6], 199, 204, 205, 215, 217, 222, 223, 225-9, 239, 243, 252-4, 259, 265, 269-71, 275, 279, 282, 294, 295, 298, 307, 309, 314, 317-21, 324-32, 334, 336, 337, 340, 342-5, 347, 348; *figs 75, 96-114, 120, 123-6*; all colour plates incl. front and back cover

Other photographs are by:
David Bocking frontispiece, p.2
Cambridge, Fitzwilliam Museum 59
Sarah Davenport 1, 4, 14, 37, 40, 45, 79, 105, 117, 168, 175, 182, 184, 185, 187, 246, 273, 287, 291, 308, 333, 349
East Yorkshire News Service 210, 234
Keith Gibson 281, 299, 251, 335, 358, 359, 360
Greater London Council 248
Hull, Ferens Art Gallery 341
Kendal, Abbot Hall Art Gallery 212
Leeds City Art Galleries 24
Valerie Macready 197, 203, 211, 213, 245
Professor Irene Manton *fig.43*, p.38
W.E. Middleton 192
Photographer unknown 1, 17, 32, 42, 56, 63, 65, 66, 67, 68, 68a, 71, 74, 75, 76, 77, 84a, 86a, 88, 91, 92, 93, 95, 96, 100, 102, 106, 110, 112, 115, 116, 120, 124, 125, 126, 132, 133, 135, 136, 137, 138, 144, 152, 156, 158, 159, 160, 161, 163, 164, 165, 166, 169, 170, 173, 179, 180, 183, 195, 200, 204, 206, 207, 220, 224, 230, 231, 232, 233, 236, 237, 240, 241, 242, 244, 247, 249, 250, 255, 256, 257, 266, 267, 274a, 276, 280, 286, 288, 322, 362, 363, 364, 365, 366; *figs 115, 116, 117*, p.133; *fig.120*, p.134
University of Leeds 216, 262
University of York *fig.122*, p.140
Vaughan Hazlehurst 312
Wakefield Art Gallery 296
Barry Wilkinson 315
Martin Willescroft 313
Yorkshire Post 311; *fig.118*, p.133

Index

Index of works mentioned in text

OVERLEAF
fig.126 Austin Wright at Green View,
Upper Poppleton, 1993